The Dickinsons of Amherst

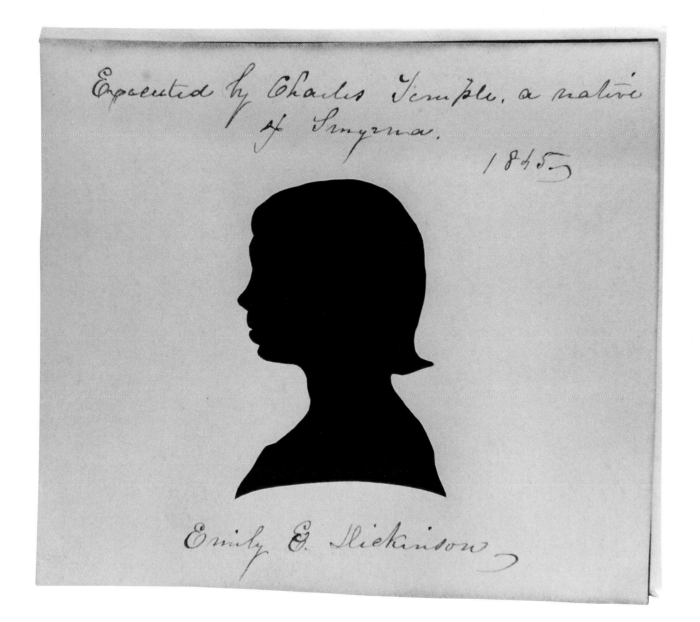

Executed by Charles Temple, a native of Smyrna.

1845

Emily E. Dickinson

The Dickinsons

Photographs by Jerome Liebling

University Press of New England

HANOVER AND LONDON

of Amherst

ESSAYS BY

Christopher Benfey,

Polly Longsworth, and

Barton Levi St. Armand

University Press of New England, Hanover, NH 03755

Photographs © 2001 by Jerome Liebling

Text © 2001 by University Press of New England

Printed and bound in Spain by Bookprint, S.L., Barcelona

5 4 3 2 1

Library of Congress Cataloging-in-Publication Data

Liebling, Jerome.

 The Dickinsons of Amherst / photographs by Jerome Liebling ; essays by Christopher Benfey, Polly Longsworth, Barton Levi St. Armand.

 p. cm.

 ISBN 1–58465–068–0 (alk. paper)

 1. Dickinson, Emily, 1830–1886—Homes and haunts—Massachusetts—Amherst—Pictorial works. 2. Dickinson, Emily, 1830–1886—Homes and haunts—Massachusetts—Amherst. 3. Dickinson, Emily, 1830–1886—Family—Pictorial works. 4. Poets, American—19th century—Biography. 5. Dickinson, Emily, 1830–1886—Family. 6. Dickinson family—Pictorial works. 7. Amherst (Mass.)—Pictorial works. 8. Amherst (Mass.)—Biography. 9. Dickinson family. I. Benfey, Christopher E. G., 1954– II. Longsworth, Polly. III. St. Armand, Barton Levi. IV. Title.

 PS1541.Z5 L43 2001

 811'.4—dc21

 2001001810

Acknowledgments

Pages i, 27, 93, 172, and 203: Amherst College Archives and Special Collections.

Image of the center of Amherst ca. 1875 (p. 55), and image of ED's dress (p. 208): Courtesy of the Amherst History Museum, Amherst, MA.

Pages viii, 2, 8, 12, 19, 38, 45, 68–69, 71, 73, 74, 75, 76, 79, 80, 102, 111, 113, 115, 116, 117, 119, 120, 123, 124, 125, 128, 129, 131, 134, 140, 143, 154, 174, 178, 179, 180, 181, 182, 184–85, 186, 187, and 192–93: Courtesy of the Martha Dickinson Bianchi Trust, Amherst, Mass.

Page 197: Permission to photograph courtesy of Seth M. Bostock.

Pages 67, 103, 122, 141, 142, 146, 147, 150, 153, 155, 159, 163, and 166: Courtesy Brown University Library.

Pages vi, 5, 9, 10, 11, 17, 20, 29, 32, 39, 42, 43, 47, 50, 51, 52, 57, 59, 63, 77, 82–83, 188–89, 191, 206, and 207: Permission to photograph courtesy of the Dickinson Homestead, Trustees of Amherst College, Amherst, Massachusetts.

Page 100: The District Court, Northampton, Massachusetts.

Pages 7, 25, 62, and 92: Reproduced by permission of the Houghton Library, Harvard University.

Pages 16, 28, 72, 87, 98–99, 101, 110, 162, 173, 198, and 200: By permission of the Jones Library, Inc., Amherst, Massachusetts.

Page 21 (Emily Norcross Dickinson): Courtesy of the Monson Free Library, Monson, Mass.

Pages 35, 104, 127, 135, and 152: © 2001 Barton Levi St. Armand.

Pages 26, 34, 60, 61, 65, 66, 88, 89, 90, 91, 137, 158, 196, and 199: Todd-Bingham Picture Collection, Manuscripts and Archives, Yale University Library.

Lines from poems 519 (p. 1), 372 (p. 6), 466 (p. 6), 804 (p. 11), 1114 (p. 64), 256 (p. 15), 487 (p. 183), 390 (p. 171), 124 (p. 176), 1163 (p. 209), 320 (p. 205), 753 (p. 169, 183), 1428 (p. 54), 1489 (p. 177), 591 (p. 177), 1100 (p. 204), 578 (p. 205), 995 (p. 205), 962 (p. 209), 383 (p. 22), 321 (p. 36), 772 (p. 78), 545 (p. 44), 769 (p. 58), and 1091 (p. 107): Reprinted by permission of the publishers and the Trustees of Amherst College from *The Poems of Emily Dickinson*, Ralph W. Franklin, ed., Cambridge, Mass.: The Belknap Press of Harvard University Press, Copyright © 1998 by the President and Fellows of Harvard College. Copyright © 1951, 1955, 1979 by the President and Fellows of Harvard College.

Lines from letters 115 (p. 24), 268 (p. 201), 298 (p. 37), 432 (p. 48), 459A (pp. v, 183), 562 (p. 59), and 692 (p. 205): Reprinted by permission of the publishers from *The Letters of Emily Dickinson*, edited by Thomas H. Johnson, Cambridge, Mass.: The Belknap Press of Harvard University Press, Copyright © 1958, 1986 by the President and Fellows of Harvard College.

*

Deep thanks are expressed to the Dickinson Homestead and the Trustees of Amherst College and to the Martha Dickinson Bianchi Trust for permission to photograph at the Homestead and the Evergreens.

Nature is a Haunted House –

but Art –

a House that tries to be haunted

—Emily Dickinson, L.459A to Thomas Wentworth Higginson

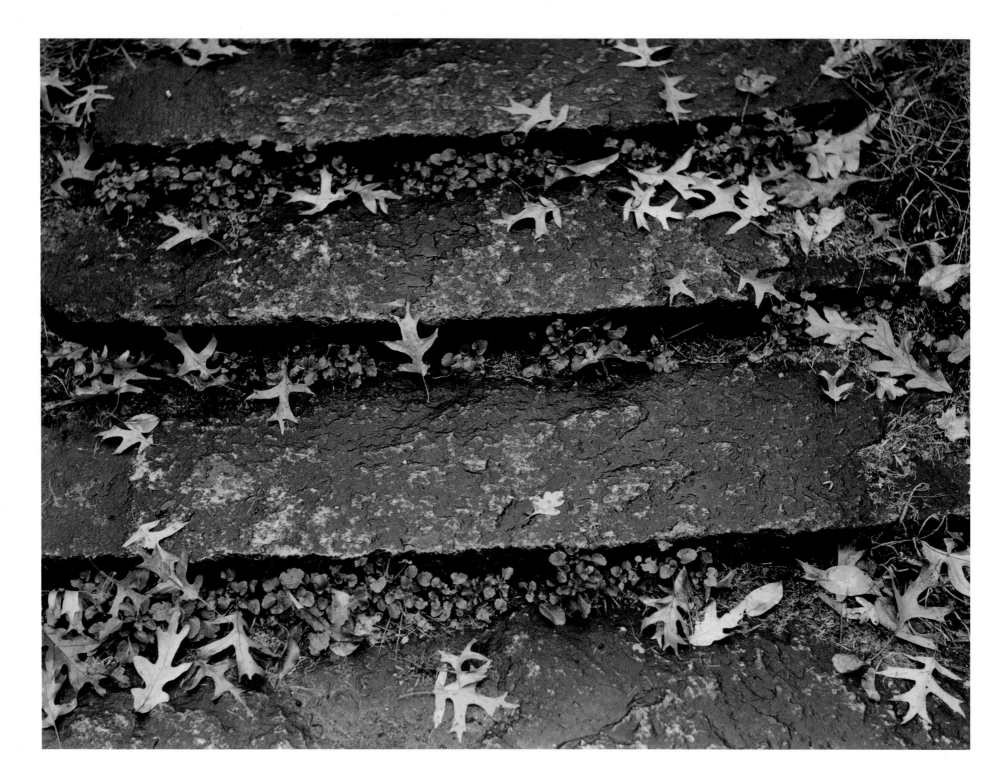

Steps to Emily's garden.

Contents

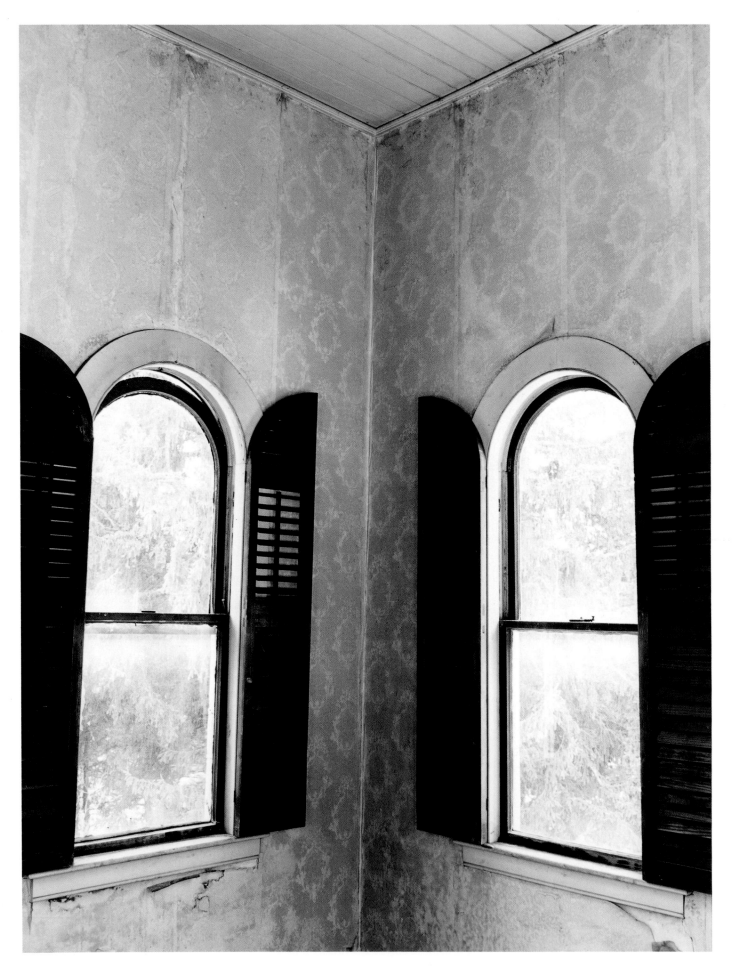

Cupola at the
Evergreens.

The Dickinsons of Amherst

Introduction:
A Lost World Brought to Light

Christopher Benfey

The Dickinsons of Amherst began with the photographs.

The challenge was to allow the extraordinary visual materials at hand—the two Dickinson houses on Main Street in Amherst, the trees and rocks and paths around them, the clothes and pictures and pianos within, the slant of light and shade—to provoke questions and responses, stories and memories. Ever present in the consciousness of photographer and writers was the paradoxical achievement of Emily Dickinson herself. In so many ways the most intensely local of writers—no one could have lived more deliberately in Amherst—Dickinson is one of the handful of American writers with a truly international reach. "This is my letter to the World," she wrote. The world now comes to Amherst in search of her.

Ten years after he moved to Amherst in 1970, the photographer Jerome Liebling first visited the Homestead, the big brick house in which Emily Dickinson was born and wrote nearly two thousand poems and died. It seemed only a matter of time before Liebling, one of the foremost American photographers, set out to take the visual measure of one of the greatest American poets—Amherst artists both. At the Homestead, Liebling took his first pictures of Emily Dickinson's world. He started with a few iconic images: the white dress; the picket fence; the woven basket in which,

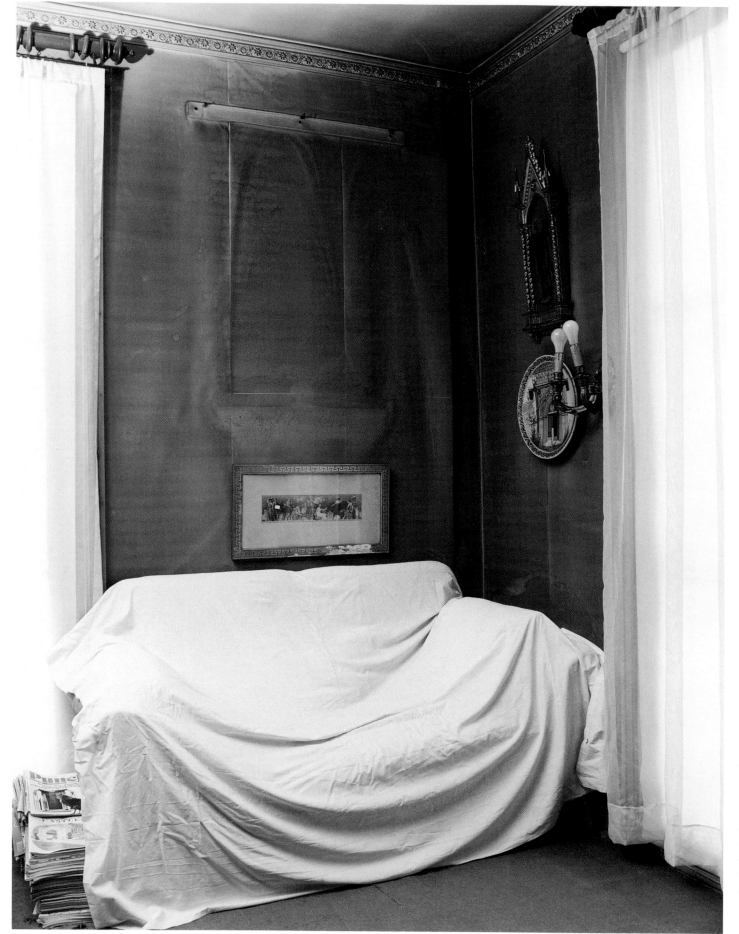

Front parlor, the Evergreens, circa 1994. A strange commingling of Italian Renaissance pictures, bare electric bulbs, piles of old *Punch* magazines, discolored wallpaper, and a white sheet on the sofa, as though someone has died.

according to legend, Dickinson lowered gingerbread to neighborhood children playing beneath her window. These photographs, with their hard-edged clarity and mysterious play of light, are among the best-known and best-loved images associated with Emily Dickinson. Liebling's long training in the stripped-down aesthetic of the Bauhaus in Germany and the strangely kindred Shaker aesthetic of New England found a perfect setting in Dickinson's right-angled world.

Another ten years went by, and Liebling learned that the Evergreens, the lovely and decrepit Italianate villa next door to the Homestead, was no longer occupied. He was invited to photograph its ghostly contents. No sooner was the Evergreens open to his camera, however, than there was a clear danger that it might be lost forever. The house had belonged to Emily Dickinson's brother, Austin, who had bequeathed it in turn to his daughter, Martha—the last of the Dickinsons. Martha, whose memories of what had occurred in the house were the stuff of nightmares, had asked in her will that it be razed to the ground. Liebling's photographs from this period have a special urgency. They are as much an act of visual preservation as of emotional and aesthetic response. "I'm smelling every aroma from 1886 on." Liebling remembers, "every piece of dust. While I'm taking the pictures, everything is being inventoried and shipped off. The clothing was piled around. The kids' shoes."

It seems an extraordinary piece of luck that when the time-capsule interior of the Evergreens was pried open after decades of invisibility, Liebling was there to photograph it. But luck, of course, had nothing to do with it. The photographer who knows his art recognizes his occasions and seizes them. Mortality and dilapidation—the steady erosions of time—had always figured in Liebling's work. Likewise, for decades before he entered the Dickinson houses, Liebling had been fascinated with clothes, the ways in which, like photographs, they register the imprint of the body. He recalls his first visit to Emily Dickinson's bedroom: "I walked into the room, looked around, and there was the dress hanging there. Hot damn, that woman is in that dress!"

Liebling's photographs of the Dickinson houses fall into two distinct groups, corresponding roughly to his two periods of engagement with them. His early images of the Homestead and of Emily Dickinson's bedroom and favorite objects have a distinct visual decorum. This is a world of right angles, of black and white, of clarity and cleanness. We sense a life lived deliberately, where lightning insights strike when waited for. We feel in these photographs what many visitors to the Homestead feel—that the Homestead is a shrine to artistic vocation and commitment. This is the meaning of Liebling's photograph of Emily Dickinson's writing desk—the camera, lens, and darkroom of her own artistic divination. Here is the source of her "letter to the World." Liebling shoots the desk from above so that its polished working surface takes up almost the whole photograph. The open drawer, like an open door, seems to say: "Yes, there may be mysteries and darkness here, but you are welcome. I will guide you."

Liebling's photographs of the Evergreens, taken ten years after most of his Homestead pictures, are in a totally different key. Color explodes in these photographs, especially lurid reds, against a background of dark greens. Passions balked and embraced are everywhere palpable, as well as the sheer visual appetites of Austin Dickinson and his wife, Susan. The clean white walls of the Homestead are replaced with torn and faded wallpaper, still bearing vigorous William Morris patterns—red, always red. Everything is decrepit, showing its age, but vividly imprinted with history and with lives passionately lived.

Liebling's visual journey from the Homestead into the Evergreens corresponds, interestingly, to a similar move among Emily Dickinson scholars and biographers. During the 1980s and early 1990s, when these pictures were taken, it was becoming increasingly clear that the puzzle of Emily Dickinson's life and work could not be "solved" without a thorough understanding of what went on in the Evergreens. The passions unleashed in Austin's marriage with Susan

Black Cake -

2 pounds Flour -
2 Sugar -
2 Butter -
19 Eggs -
5 pounds Raisins -
1½ Currants -
1½ Citron -
½ pint Brandi -
 Molasses -
½ 2 Nutmegs -
5 Teaspoons
Cloves — Mace -
Cinnamon -
2 Teaspoons Soda -
Beat Butter
and Sugar

Emily Dickinson as provider: her handwritten recipe for black cake; her bedroom window, with basket at the ready.

Gilbert; Susan's intimate friendship with Emily; Austin's affair with the stylish Mabel Loomis Todd, wife of the Amherst College astronomer, and so on, were part of the emotional fabric of Emily Dickinson's daily life. She did not live in some cloistered haven of social ignorance, perpetual renunciation, and repressed sexuality. She lived, instead, in a grown-up and recognizably modern world of passion and flawed marriages, abortion and adultery, financial difficulties and debt.

To enter the visual (and, by extension, emotional) world of the Evergreens was to see the Homestead with new eyes. The difference is moral as well as visual. The relative formality of the Homestead assumes new meaning. "After great pain," as Dickinson wrote, "a formal feeling comes." In a late print of Emily Dickinson's bedroom, Liebling records the orderliness of the Homestead, but we also feel the light pushing in at the windows. The bed is the place of sleep and death, but it is also the site of passion and of dream.

Liebling's three collaborators on *The Dickinsons of Amherst* came to this material in idiosyncratic ways. All are well-known Emily Dickinson scholars who have published extensively on the poet and her circle. By an odd coincidence, all three published books in 1984 that extended our understanding of Emily Dickinson.

Polly Longsworth, in her landmark work *Austin and Mabel* (1984), first revealed to the world the full extent of the love affair that tore the Dickinson family apart, split the loyalties of the town of Amherst, and divided the legacy of Emily Dickinson. Longsworth explored the emotional terrain of these houses in astonishing detail. Her recent research on Emily Dickinson's life is full of new discoveries and insights concerning Emily Dickinson's mental health and the behavior of her immediate family. We now know, for example, that Dickinson's father, Edward, once considered a pillar of correct deportment in his work as an attorney, played fast and loose with private funds entrusted to him and late in his career made a hash of the finances of Amherst College.

Barton St. Armand was a pioneer in the study of the Dickinsons' participation in Victorian American culture: the plush furnishings, the taste in popular sentimental fiction, the paintings of American and European landscapes on the walls. His book *Emily Dickinson and Her Culture* (1984) included an important analysis of Austin Dickinson as obsessive art collector, who almost bankrupted his family in pursuit of the very latest in European and American painting. From this scholarly exploration of the visual world of the Dickinsons, Barton St. Armand ended up as a trustee of the Evergreens. The whole unlikely story is told for the first time in St. Armand's essay in this volume, "Keeper of the Keys." Liebling's gothic photographs of the Evergreens— "the whole place looked and felt like a tomb," he remembers —find a perfect counterpart in St. Armand's Poe-like tale.

Christopher Benfey's book *Emily Dickinson and the Problem of Others* (1984) examined the idea of privacy in the poet's life and work. Benfey noted that, for Dickinson, the writing of poetry involved a carefully maintained balance of protective places—houses, rooms, tombs—and the possibility of expansive flights of imagination. In one of her definitive poems about the writing of poetry, Dickinson proclaimed:

> I dwell in Possibility –
> A fairer House than Prose –
> More numerous of Windows –
> Superior – for Doors –

For Dickinson (who in the same poem longs for chambers "Impregnable of eye"), those windows and doors are as much for exclusion, for maintaining privacy, as for inclusion. Benfey's essay on Liebling's photographs—the richest visual record we are ever likely to have of the chambers and windows and doors of Emily Dickinson's existence—extends this basic idea of the private and public valences of Dickinson's life and work. Benfey's recent research on cultural ties between Meiji Japan and Gilded Age America has again brought him into the Dickinson world, through Mabel

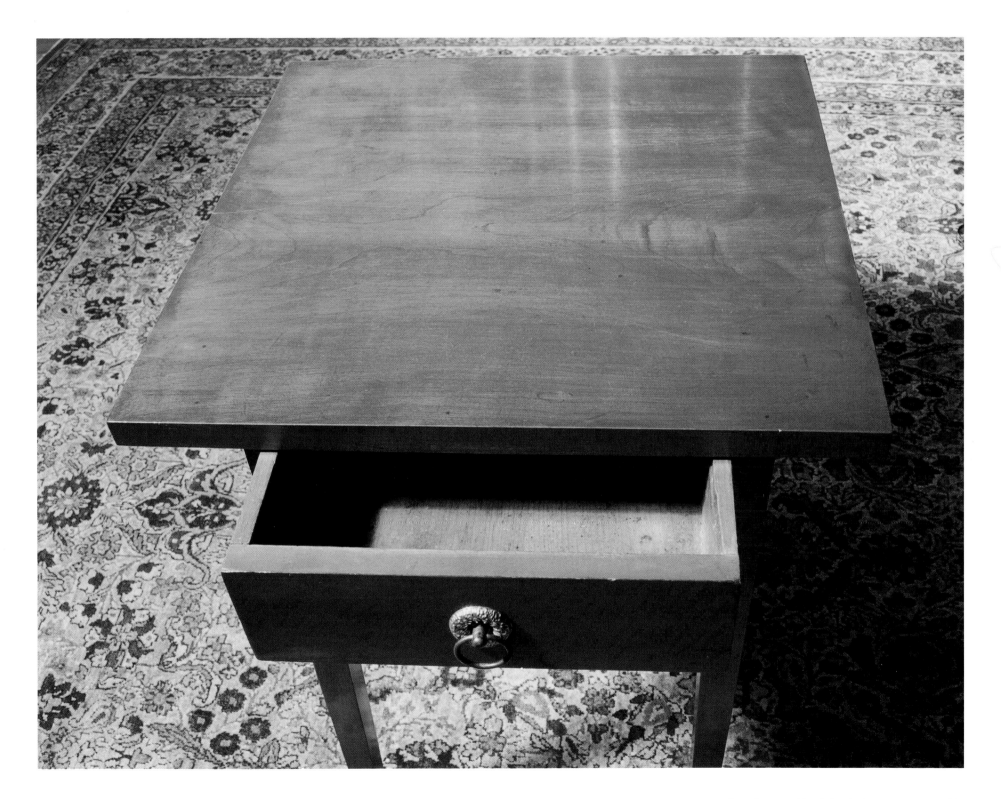

Emily Dickinson's writing desk: "This is my letter to the World."

A shadow across the curatorial white walls of the Homestead; the guest bedroom of the Evergreens, its Japanese chrysanthemum paper peeling.

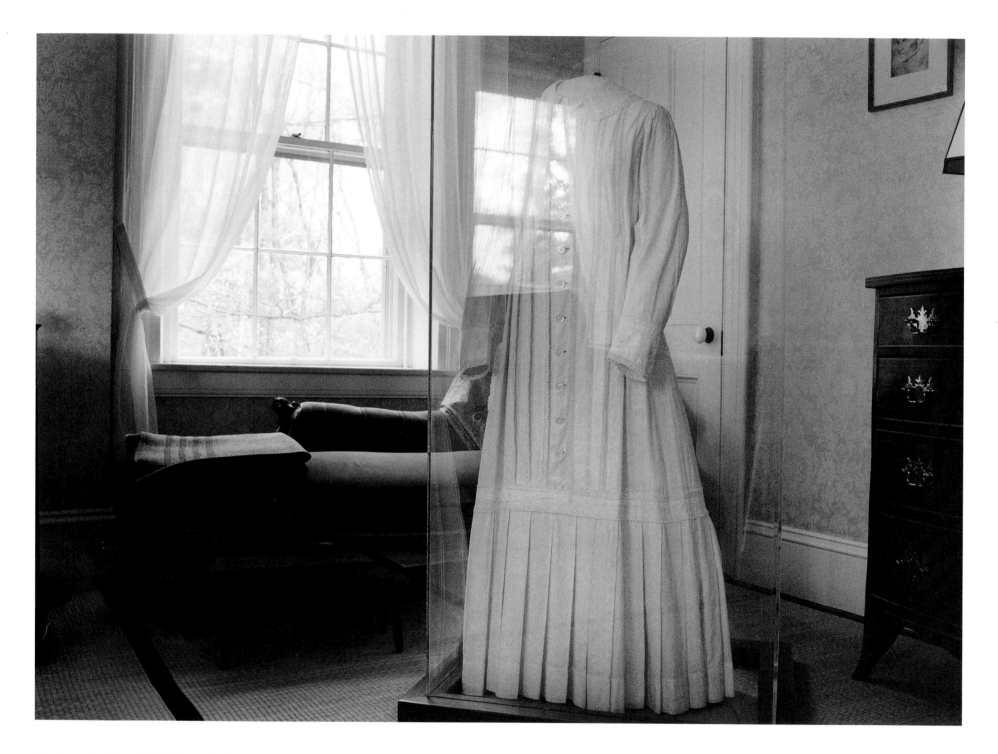

The only surviving dress of Emily Dickinson, dissolving in the reflections of her bedroom.

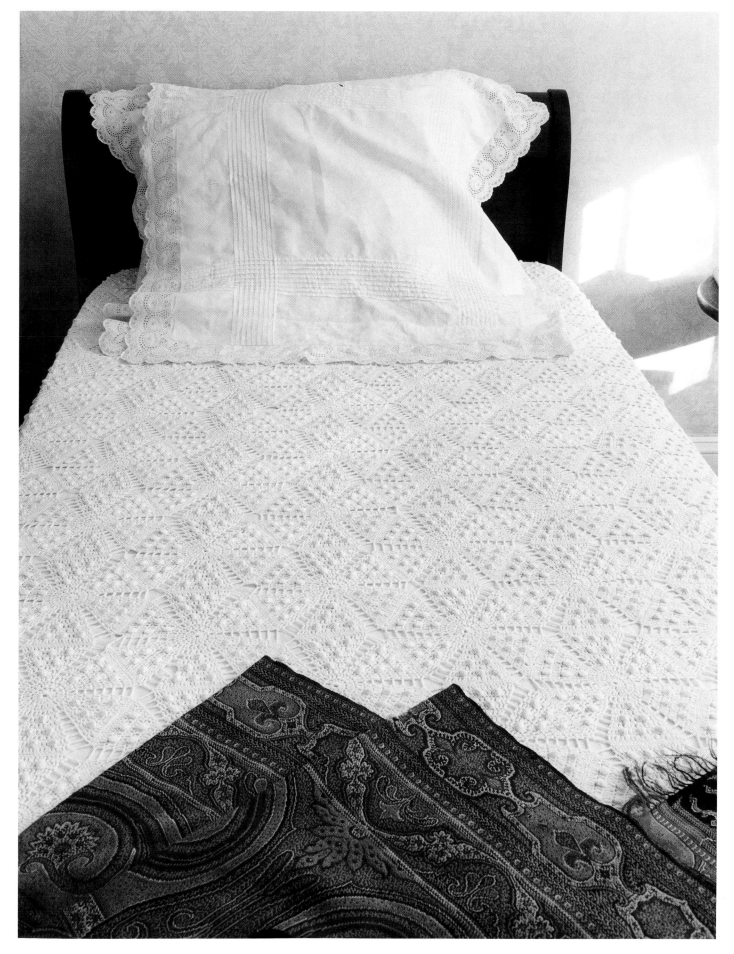

Emily's narrow bed.
"Be it's Mattrass straight –
Be it's Pillow round –
Let no Sunrise' Yellow noise
Interrupt this ground –"

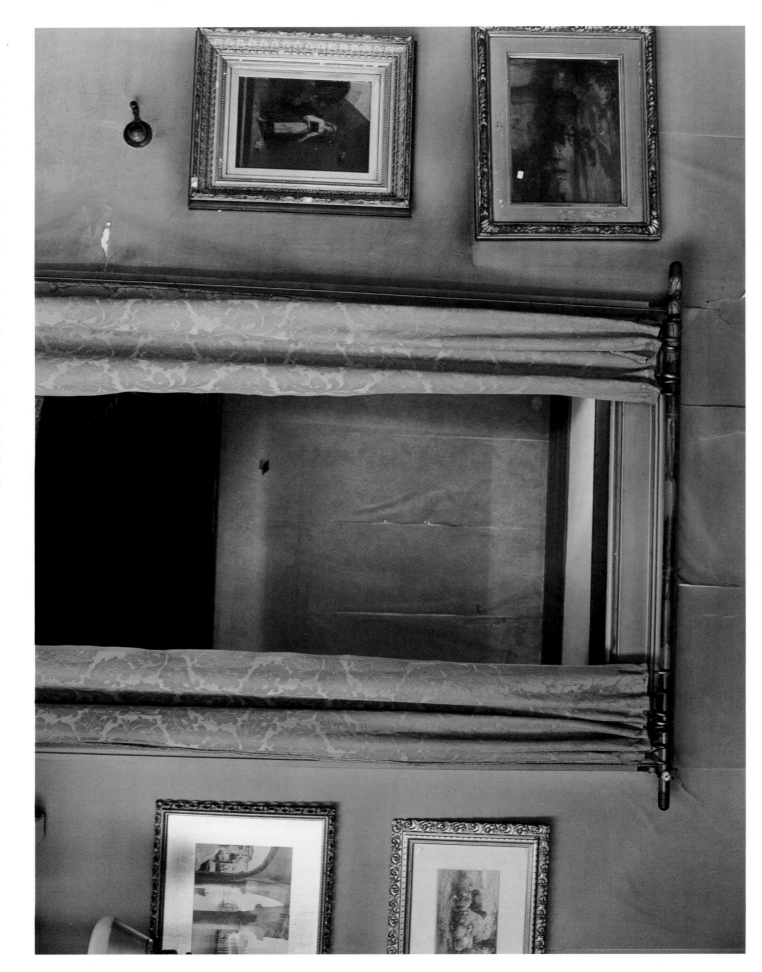

Evergreens parlor, looking into hallway. A gold curtain, drawn, reveals red wallpaper above a velvet sofa: a Rothko effect.

Loomis Todd's journeys to Japan and through the extraordinary popularity of Dickinson's work in Japan.

How should *The Dickinsons of Amherst* be read? The book began with the photographs, which are therefore in no way "illustrations" of the text. It would be more accurate to say that the text illustrates, augments, embroiders the photographs. You might say that the three essays are extended captions, taking their prompting and provocation from the images. The contributors have tried to make a single book, in which the sequence of photographs has its own logic and rhythm, functioning as the spine of the work as a whole.

The aim is to bring the Dickinsons to light.

Poems appearing in this book are from Ralph Franklin, ed., *The Poems of Emily Dickinson, Variorum Edition* (Cambridge, Mass.: The Belknap Press of Harvard University Press, 1998). Letters quoted in this book are from Thomas H. Johnson and Theodora Ward, eds., *The Letters of Emily Dickinson* (Cambridge, Mass.: The Belknap Press of Harvard University Press, 1958).

The "Latitude of Home":
Life in the Homestead and the Evergreens

Polly Longsworth

Because I see – New Englandly –

—*Poems*, P. 256

The year 1855 was a defining one in the life of Edward Dickinson, prominent lawyer and man of affairs in Amherst, Massachusetts. It was the year he repurchased, renovated, and reoccupied the Dickinson family homestead on Main Street, built in 1813 by his father, Samuel Fowler Dickinson, but forfeited a dozen years later through financial reverses. It was also the year that Edward's only son, William Austin Dickinson, became his law partner, out of gratitude for which Edward began building a fine new house for Austin and his fiancée, Susan Gilbert, next door to the Homestead. Then, too, 1855 was the year that Edward finished his first term in the U.S. Congress and ran for a second one.

Although the bid for Congress was unsuccessful, establishment of two side-by-side Dickinson homes on Main Street—the one an elegant Federal mansion of ochre brick, the other a fawn-colored Italianate villa—created a setting for remarkable dramas that transpired over the next half century. Even as Edward Dickinson vindicated his father's earlier losses by refurbishing the Homestead and its grounds, he began his own slow, nearly imperceptible slide into financial difficulties. And even as he looked fondly to his son in building the close professional relationship he had been denied with his own father, Edward was oblivious to that fact that his mansion housed a poet, that it was his brilliant, reclusive eldest daughter, Emily, who would

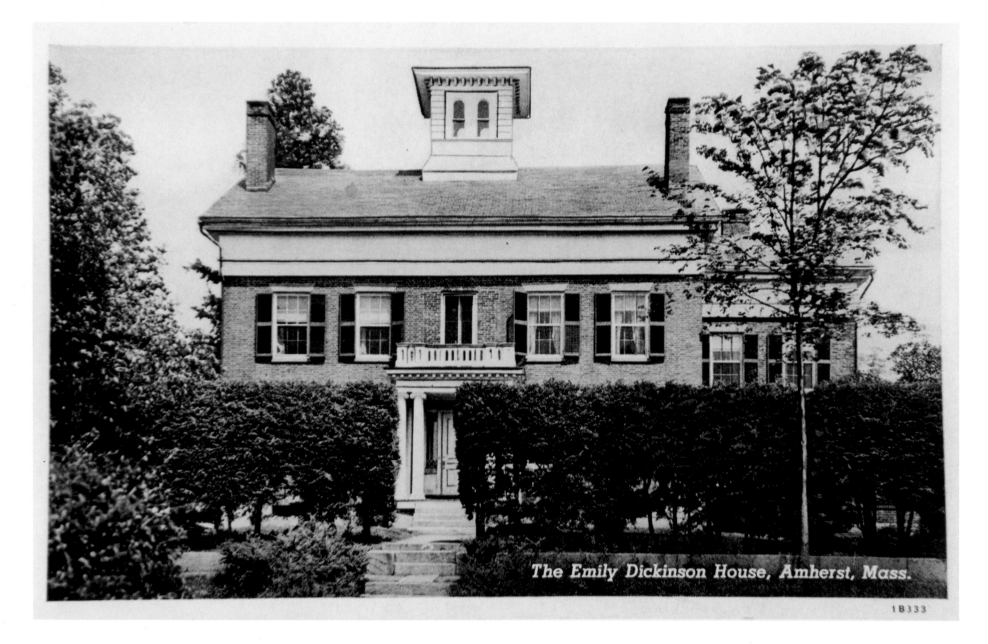

The Emily Dickinson House, Amherst, Mass.

1B333

Early-twentieth-century view of the Dickinson Homestead.

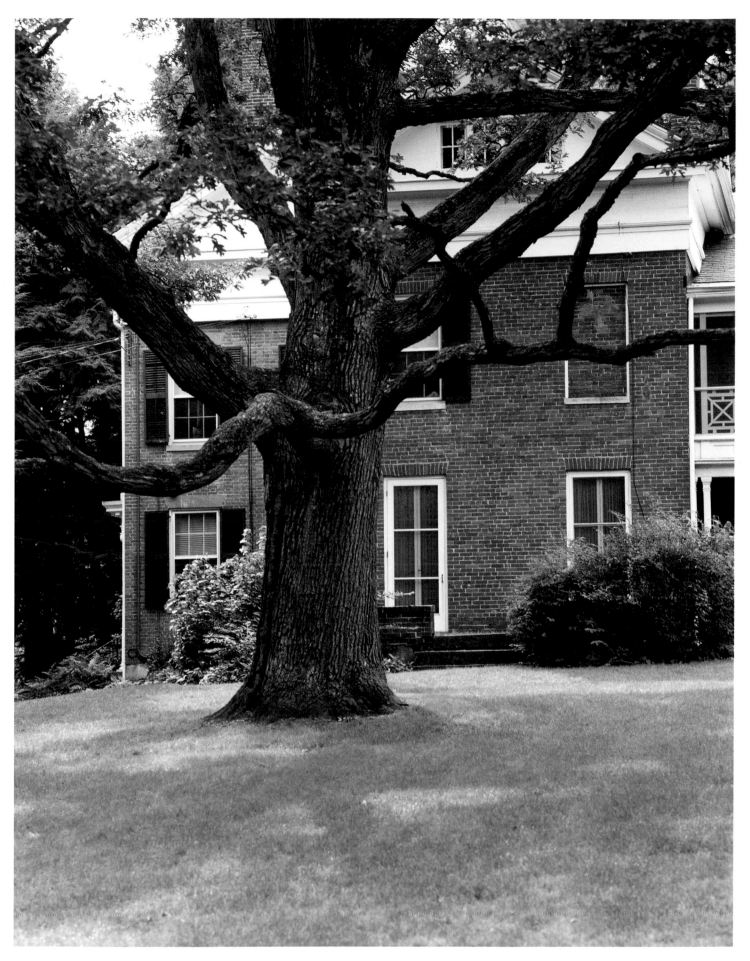

The Homestead's east
lawn and big oak.

secure the family name and reputation beyond his wildest imagining.

Next to the Homestead, in the Mediterranean-style cottage Austin and Sue named the Evergreens, Emily's adored brother and her cherished girlhood friend raised a family of three within a social setting so convivial that it long disguised deep tensions in their marriage. Some of their later strife arose from incongeniality, but much stemmed from the sacrifice of spirit both made by staying in Amherst under the parental Dickinson thumb.

In 1855, Sue had been dreaming of starting married life in a western city such as Chicago or Detroit, as her older brothers and a brother-in-law had done. By 1855, Austin knew how his romantic, exuberant nature chafed in harness with his disciplined, relentlessly rational father. But offers of a home and legal partnership were powerfully persuasive, and when a dowry of $5,000 was given to the orphaned Susan by her brothers, enabling her to furnish that home to her heart's desire, the matter was settled. Sue and Austin married the following July in Geneva, New York, where she had grown up, and after a wedding journey to Niagara Falls they moved into the nearly finished Evergreens.

Another man might have beamed with pleasure over his accomplishments, but Edward Dickinson always kept elation under tight rein. Rather than delighting in ambitions that had come to fine fruition in his fifty-third year, Edward grew "*sober* from excessive satisfaction," to use his daughter Emily's phrase.[1] He was serious almost to the point of severity. Any hint of flamboyance suggested by his receding red hair was canceled by a stern countenance, fierce gaze, and the thin, downturned Dickinson mouth. One notable visitor to his home found him "thin dry & speechless,"[2] but the commentator mistook the dignified reserve, for Edward was opinionated and could be vigorously outspoken, with a sharp if infrequently displayed wit. It was just that, as Emily put it, he "never played."[3]

For six months of 1855, Edward kept carpenters, plasterers, and painters steadily at work on his new $6,000 purchase. They reconfigured interior spaces and transformed the Homestead's exterior by demolishing extensions on the west and back and building a new two-story ell at the rear. Open porches were added on the east and west facades, and a glass and wood conservatory newly graced the front of the Homestead's east wing to accommodate the love of plants the Dickinson women shared. Atop his roof, Edward set a handsome cupola to enhance air circulation within the house and provide a grand view across the big Dickinson meadow on the south side of Main Street. Visible beyond the meadow was Amherst College, which Samuel Fowler Dickinson had ruined himself helping to found. Edward had been the college treasurer for twenty years now and would be for seventeen more.

The squire's aggrandizement wasn't lost on Amherst citizens. "Edward Dickinson Esq has Bought General Macks place and has made great repares," reported a neighbor late in the year. "[I]t is now one of the most pleasant places in Amherst it Cost him I understood over five thousands to repair it it is a Splendid House and every thing about the House is the same."[4] In his own records, Edward placed a value of $10,000 ($200,000 in today's dollars) on the renovated Homestead.

"I cannot tell you how we moved. I had rather not remember," Emily Dickinson wrote of her family's November return to the Main Street Homestead where she and her siblings had been born. "I believe my 'effects' were brought in a bandbox, and the 'deathless me,' on foot, not many moments after."[5] For the Dickinson females, difficulty attended the uprooting from their Pleasant Street house, a sunny, white clapboard dwelling with orchards and big barn beside the village burying ground. It held fifteen years of happy memories for Mrs. Emily Norcross Dickinson, as well as for Austin, Emily, and their youngest sister, Lavinia, now all in their twenties. Recollections of an earlier, more stressful decade, when the family had shared the Homestead with Edward's parents and siblings, may have oppressed Mrs. Dickinson, for the move back in 1855 induced a severe depression that lasted two or three years and placed excessive burdens and constraints upon her daughters.

The Evergreens from the Homestead.

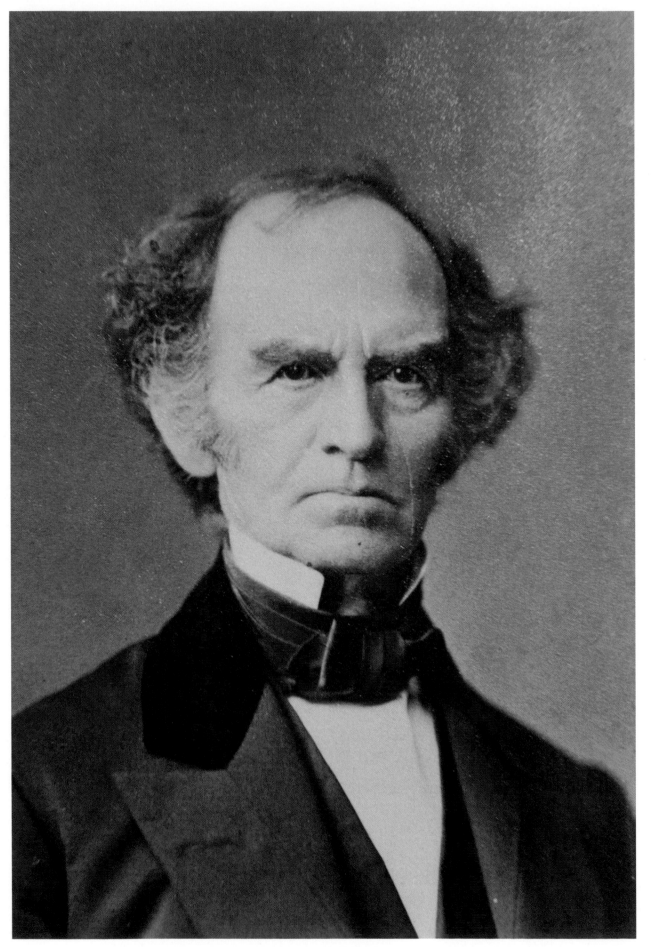

Edward Dickinson and Emily Norcross Dickinson in mid-marriage. "May we be virtuous, intelligent, industrious and by the exercise of every virtue, & the cultivation of every excellence, be esteemed & respected & beloved by all —" (from Edward Dickinson's courtship letters, Leyda, 1:4).

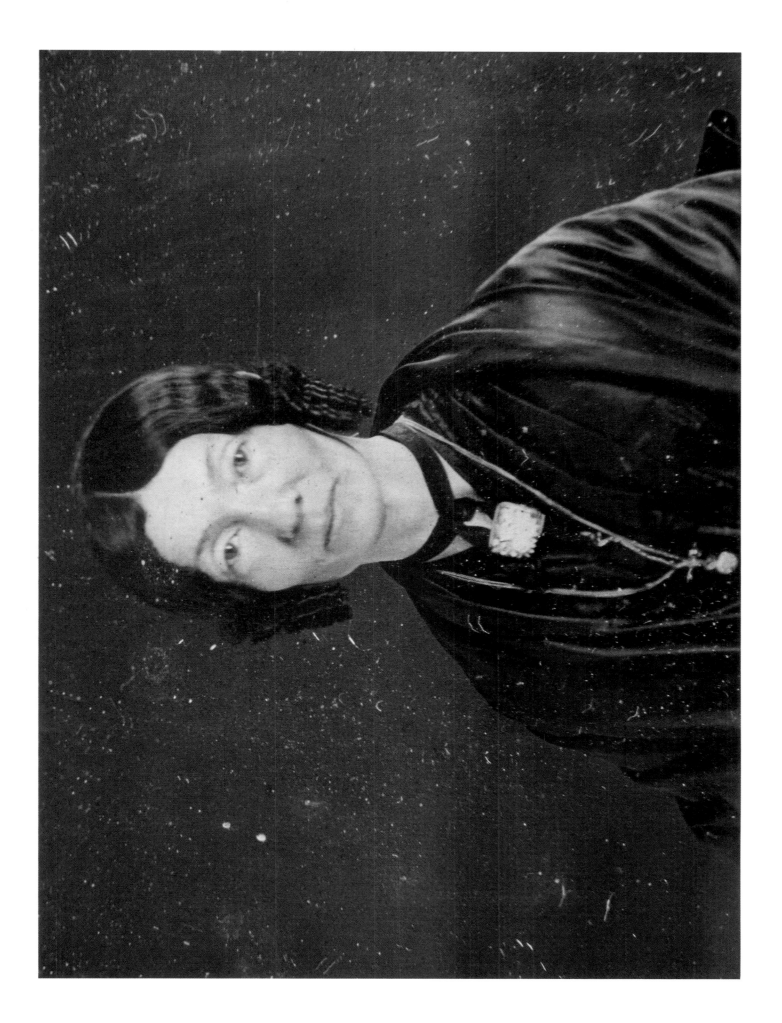

I like to see it lap the Miles –
And lick the Valleys up –
And stop to feed itself at Tanks –
And then – prodigious step

Around a Pile of Mountains –
And supercilious peer
In Shanties – by the sides of Roads –
And then a Quarry pare

To fit it's sides
And crawl between
Complaining all the while
In horrid – hooting stanza –
Then chase itself down Hill –

And neigh like Boanerges –
Then – prompter than a Star
Stop – docile and omnipotent
At it's own stable door –

Poems, P. 383

At age fifty-one, Mrs. Dickinson's youthful prettiness had deserted her, leaving her face strained and careworn. She was a timid, deferential woman, eager to escape public notice, and in most ways her husband's opposite. Yet she maintained her own unobtrusive point of view and possessed an affectionate, gentle sense of humor. She was a "guileless little being," her granddaughter Martha Dickinson Bianchi later noted, "a good and amiable housewife and mother."[6] In a time when domestic life entailed incessant labor, Emily Norcross Dickinson was an excellent housekeeper, a very good cook, and an accomplished gardener. Within her household she managed daily routine with quiet authority, and despite numerous deficiencies for which she has been cited (neighbors thought her plaintive, oversolicitous, oppressively neat), she passed on several skills and pleasures to her daughters—her household executive abilities to Vinnie, her talent for cooking to Emily, and her gift for gardening to both.

She may have passed to Emily, as well, a fearful, anxious temperament, possibly inherited from her own mother, Betsey Fay Norcross of Monson. Emily had grown up in Monson, twenty-five miles southeast of Amherst, where her father, Joel Norcross, was a prosperous farmer and enterprising businessman. Along with several siblings, Emily enjoyed the educational advantages of Monson Academy, a sound, progressive school her father helped to found. She herself seems not to have been a particularly strong student, for her writing skills were weak, so she rarely wrote letters and took little pleasure in philosophy ("My Mother does not care for thought," her eldest daughter once expained).[7]

Two brothers and a sister died during Emily Norcross's youth, and a year after she married, her eldest brother and her gentle, self-effacing mother both succumbed to tuberculosis. Like many brides of her era, Emily had a difficult time leaving her childhood home, which was dominated by her brusque, authoritative father and made loving by her sweet-tempered mother. Transference of her feelings of reverence, honor, and not a little fear from father to husband was accomplished only after two and a half years of

courtship, during which Edward Dickinson experienced enormous frustration in getting his unusually shy, evasive fiancée to answer his letters or visit in Amherst. At last they were married in May 1828 and set up housekeeping in Amherst, where Edward had opened his solo legal practice.

Edward's family line in Amherst went back to Nathan Dickinson, a farmer who settled about 1735 on the rolling, heavily wooded land then known as the east precinct of Hadley, Massachusetts, a Connecticut River settlement. Nathan was one of many great-grandsons of a certain Nathaniel Dickinson, emigrant from Ely, England, a century earlier, who lived first at Wethersfield, Connecticut, then moved up the Connecticut River to the fortification at Hadley. Once the dangers of the French and Indian War were over, Nathaniel's progeny spread out to farmland up and down the fertile river valley, creating a large population of Dickinsons in the region.

A grandson of the aforementioned Nathan Dickinson was Samuel Fowler Dickinson, who grew up with seven siblings on a farm at East Amherst. Fowler, like his oldest brother, was educated at Dartmouth College, graduating as salutatorian of his class in 1795 and becoming one of the earliest college-educated lawyers in western Massachusetts. A man of great physical vitality and wide-ranging intellectual interests, Fowler married Lucretia Gunn of Montague and early assumed a leadership role in his rural community of fewer than 1500 people. A deacon of the Congregational church, he stood at the heart of the village's religious life; clerk and treasurer of the town and frequent delegate to the state legislature, he was at its political center; his legal practice kept him engaged in local commerce, especially the buying and selling of land.

As he acquired substance and property, Fowler became concerned about providing his children with a good Christian education. Fellow citizens aided him in founding Amherst Academy, which opened in 1814 for male and female students from all over the region. Not long afterward, amid growing concern over the spread of rival religious denominations into the nation's expanding frontier settlements, the academy trustees, all good Calvinists, conceived a plan for a college at Amherst that would educate "indigent young men of piety and intellect" for the Congregational ministry.

Fowler Dickinson's contributions to winning the location, raising the money, building the buildings, and securing a charter for Amherst College are legendary.[8] Although the institution opened in 1821, its struggle to exist occupied several years; and Fowler's driving passion, which led him to underwrite too many pledges of support and to neglect his professional duties, eventually bankrupted him. By 1828 he had lost ownership of his fine brick homestead on Main Street and of numerous other properties. His practice was in a shambles when his eldest son, Edward, graduated from Yale College and began studying law. Finally, late in 1833, Fowler moved to Ohio to take up other employment, first at Lane Seminary in Cincinnati, subsequently at Western Reserve College in Hudson, where he died suddenly of cholera in 1838, aged sixty-three.

His father's humiliations rode hard on Edward, the only one of Fowler's five sons to remain in Amherst. Although he inherited nothing but his education and appetite for hard work, as he more than once reminded his bride-to-be, his strenuous exertions, strict attentiveness to duty, and will to succeed steadily advanced his career and reputation.[9] During the quarter century following his marriage he plied his trade with diligence and probity, attending the court circuits of Hampshire and Franklin Counties and involving himself in the affairs of the parish, town, and college. He was a leader in local and county organizations (the Temperance, Colonization, and Agricultural Societies), and during the 1830s and 1840s he served in the state legislature twice and the state senate once and also as a member of the Governor's Council for a two-year term. Active in Whig politics, a Daniel Webster man to the core, Edward plumped for his party's presidential candidates and attended state and national Whig conventions. Although antislavery in principle, his overriding concern, like Webster's, was preserving the Union. Webster's championing of the Missouri Compromise, however, demoralized the party, and passage of the

Nebraska bill (which Edward fought in Congress) weakened the Whigs beyond resurrection. Elected from the Tenth District only weeks after Webster's death in late 1852, the conservative Edward stood fast as his party disintegrated, its most vociferous antislavery element splitting off to form the Republican Party.

For Edward, a happier achievement of 1852 was the arrival of the railroad. After two hectic years of selling stock subscriptions and laying track, the Amherst and Belchertown Railroad Company, with Edward as incorporator, leading investor, and chief promoter, succeeded in linking Amherst to rail lines that crossed at Palmer and hence to the world. From the Homestead cupola Edward could look southeast beyond his big meadow to where the town's new passenger depot stood, fringed by the tenements of Irish laborers who had settled in town after the railroad was built.[10] Sitting at noonday dinner in the Homestead, he could hear the shrill whistle of the New London cars steaming in along nineteen miles of track from Palmer. Midcentury must have seemed to him a fine epoch indeed; perhaps he almost smiled.

I wish we were children now. I wish we were *always* children, how to grow up I dont know.

Letters, L.115 to Austin Dickinson

While Emily Norcross and Edward Dickinson both came from families of nine children born over twenty-year intervals, their own small family was completed in four years: Austin arrived on April 16, 1829; Emily on December 10, 1830; and Lavinia on February 28, 1833. A portrait of the young Dickinsons painted in 1840 by itinerant artist Otis A. Bullard shows them looking like three peas in a pod. But in fact, while Austin and Emily shared their father's auburn

hair and brown eyes, Vinnie possessed gray eyes like her mother, her brown hair holding just a glint of red.

Close in age, the three were united in their loyalty and dependence upon one another. For Emily, her handsome brother was a commanding presence, a chief source of fun and commotion in life. "There was always such a Hurrah wherever you was," her earliest letter informs him in the spring she was eleven and he was away at school. "I miss your big Hurrahs, and the famous stir you make," she told him at twenty-one when he taught school in Boston.[11] From early days, Austin and Emily shared a romantic sensibility and wide-ranging interest in books and ideas. They grew up freely discussing everything from favorite authors (Scott, Stowe, Dickens, Ik Marvel—the "modern Literati" their father scorned) to whether consciousness extended after death. Good friends when together, brother and sister competed when apart to write the wittiest letter, employ the aptest metaphor, or win Father's startled approbation with a phrase. A camaraderie established by constant letter writing in the early 1850s, when Austin was away, served them for life. Austin could be gruff, moody, and stubborn; he had a stiff pride and was ever frank (Dickinson diplomacy, it was called), but in a family that did not overtly credit feelings, he and Emily were extraordinarily sensitive to protecting one another's happiness.

As for Emily and Vinnie, two sisters could hardly have been more unlike. Emily was timid and plain ("the same old sixpence," she ruefully told a friend), while Vinnie was pretty and coquettish. Emily detested housework ("I prefer pestilence"), so she did the bread baking and pudding making while Vinnie dusted stairs.[12] Emily was witty and imaginative, an excellent student who loved her studies and her teachers and was heartbroken if illness prevented her from attending school. She loved a small circle of female friends intensely; and as she grew older, she developed platonic friendships among the Amherst College students and tutors who had connections to the family or were her brother's friends.

Vinnie was far more interested in people than in books.

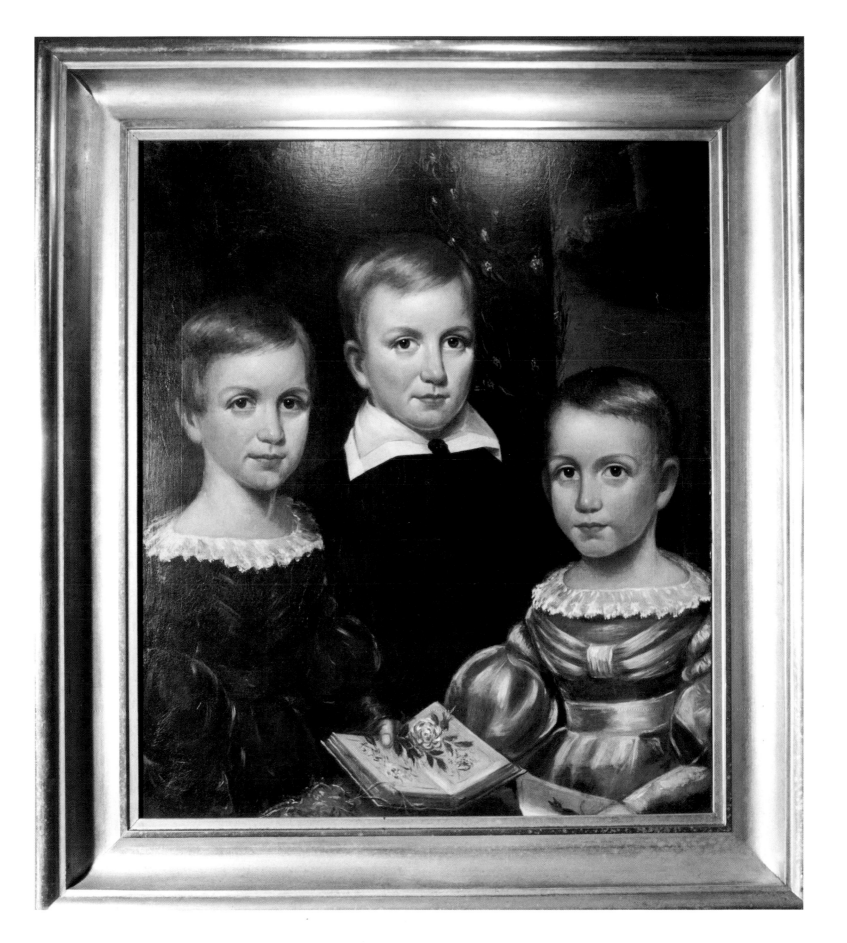

Emily, Austin, and Lavinia Dickinson in 1840. Painting by artist O. A. Bullard.

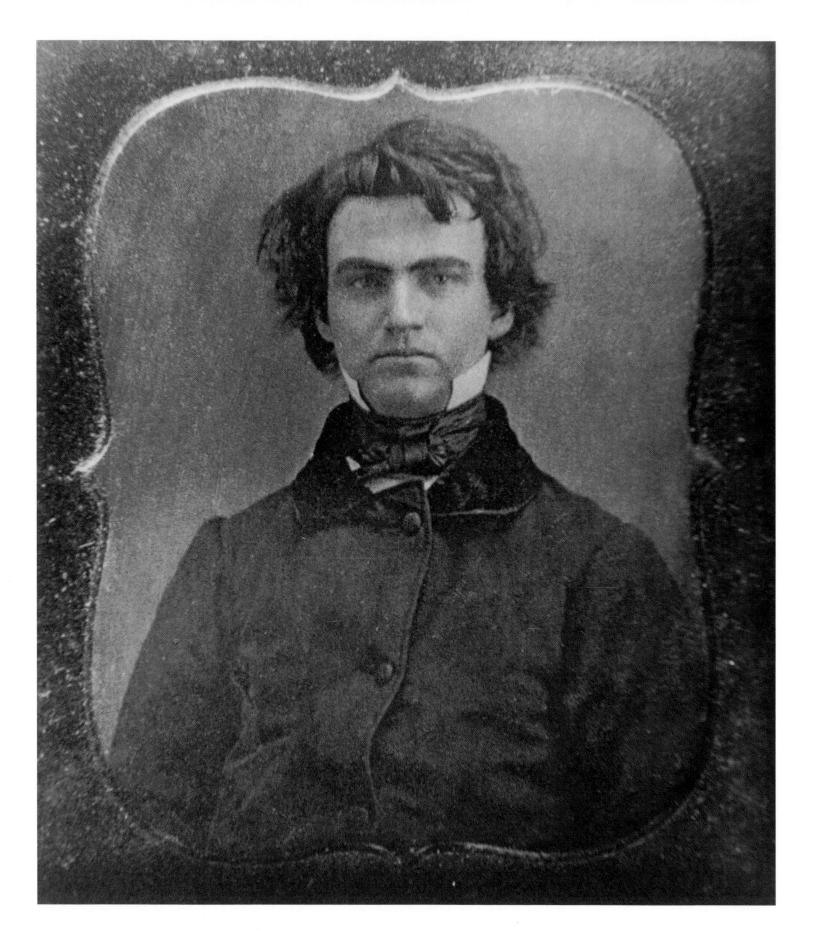

Austin's unruly red hair matched his flamboyance and zest. In late years he wore a red wig.

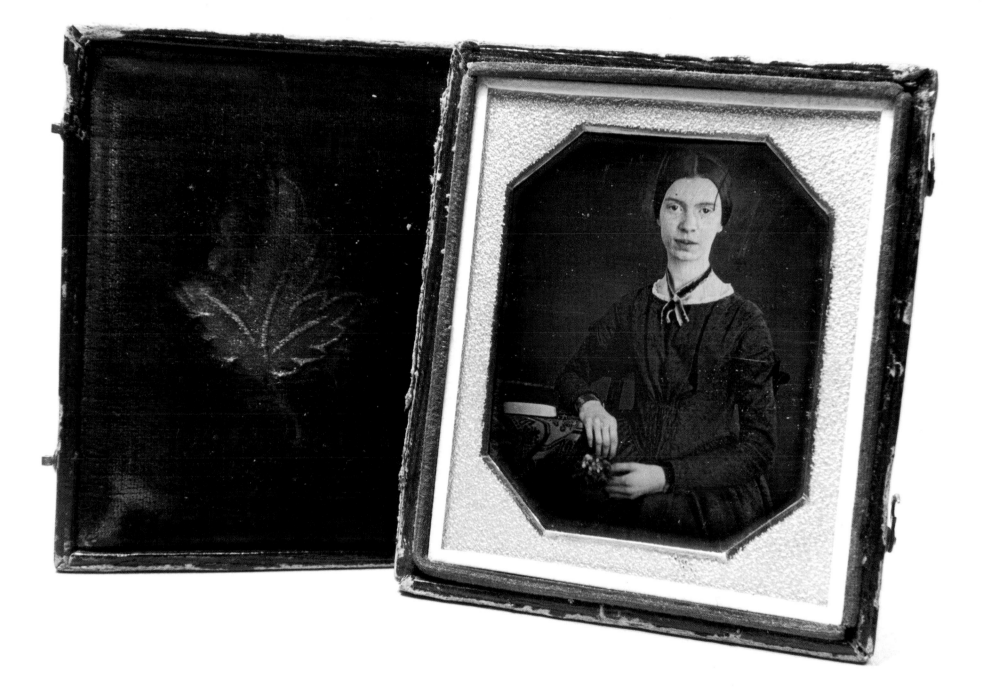

Daguerreotype of Emily at sixteen in 1847, the one incontrovertible photographic likeness of the poet.

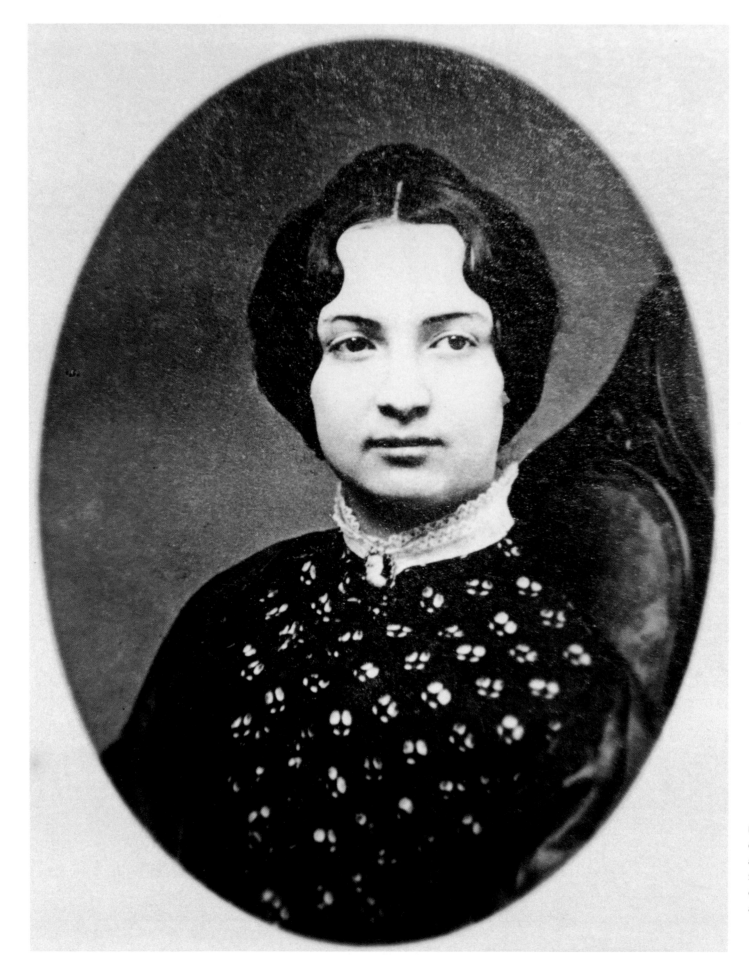

Lavinia Dickinson. Vinnie
could extract more
adventure from a trip to
Springfield than others
encountered in going
abroad.

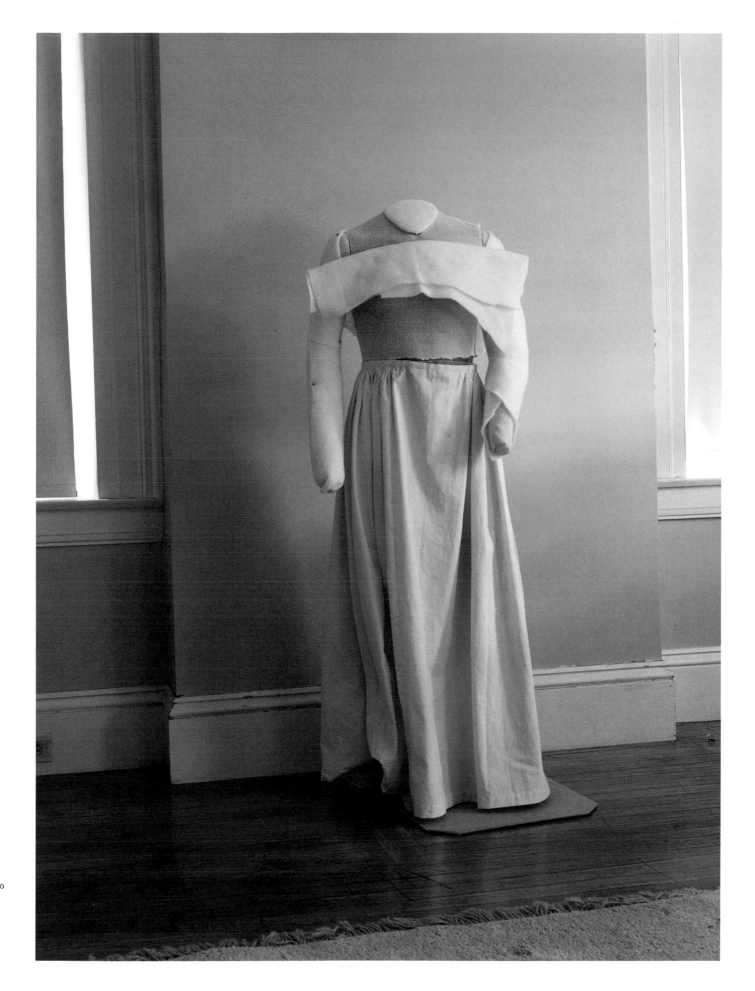

As the sisters neared their thirties, dressmakers fitted Emily's garments to Lavinia in deference to the poet's reclusiveness.

Outgoing, independent, and practical, she was also wickedly funny, with a gift for mimicry memorable to any who ever witnessed her impersonations. Her social life grew brisk as she matured. A diary kept at age eighteen in 1851 records her lively round of activities with friends and suitors and indicates two proposals of marriage. One of them was a serious understanding with Joseph Lyman, Austin's boyhood friend, that eventually came to naught. Vinnie's chief fault was her sharp tongue, which could lead her into unpleasant "dust-ups." Occasionally, too, she had problems with prevarication, a trait that no amount of discipline during her childhood managed to erase.

Although Emily began attending school earlier than Vinnie did, entering the Amherst Female Seminary when she was five, the two little girls were shepherded through childhood almost as if they were twins. They received careful religious instruction from their mother, who also introduced them very early to domestic duties and oversaw their first stitching and knitting. Their father made the family's educational decisions (he was a trustee of Amherst Academy from 1835 until his death) and dominated all issues relating to family illness. After the Amherst Female Seminary burned in 1838, Emily and Vinnie probably joined Austin at the local district school until old enough to attend Amherst Academy, which the little girls entered together in the spring of 1841 (Emily was ten; Vinnie, eight). Their first teacher was Mrs. Caroline D. Hunt, who as Miss Caroline Dutch had been their mother's preceptress at Monson Academy twenty years earlier.

Organized on the quarterly term system, the academy was usually in the charge of a newly minted Amherst College graduate poised to go on to seminary. Over the course of a decade the three Dickinson children partook generously of the school's rigorous offerings, Emily's and Vinnie's attendance records being more intermittent than Austin's because of Father's vigilant watch over his daughters' health. In the fall of 1846, Austin entered Amherst College, from which he graduated in 1850. In 1847–48, when seventeen, Emily spent a rich academic year at Mount Holyoke Female Seminary,

founded ten years earlier by educator Mary Lyon; and two years later, Vinnie attended Ipswich Female Seminary for the winter and spring terms. Austin subsequently taught school for two years, first in Sunderland, then in Boston. After reading law in his father's office for several months he attended Harvard Law School and was admitted to the Massachusetts bar in June 1854.

The first half of the 1850s, before the family moved back to the Homestead, formed an island between childhood and adulthood for the Dickinson young people. For several years after returning from Mount Holyoke Seminary, Emily participated actively in the simple amusements of her rural college town, with its sleighing and sugaring parties and excursions up Mount Holyoke, its student levees and Shakespeare Reading Society, its rounds of calls on friends. Her notable intellectual precocity, which found outlet in extensive reading and the writing of clever valentines, attracted several literary friendships of great importance to her. Also in this period, she began to concentrate on a secret project of her own, the writing of poetry, encouraged by her father's law clerk, Benjamin Franklin Newton, until his early death from consumption in 1853. In her words he "became to me a gentle, yet grave Preceptor, teaching me what to read, what authors to admire, what was most grand or beautiful in nature, and that sublimer lesson, a faith in things unseen, and in a life again, nobler, and much more blessed –"[13]

While Ben Newton's death afflicted her greatly, Dickinson experienced other heartfelt losses during this time, including a friend who may have been an even earlier guide to her interest in poetry. Leonard Humphrey was an Amherst graduate who had been preceptor at the academy for the two years after Emily entered Mount Holyoke Seminary, when he died suddenly of "congestion of the brain" in late 1850. The next year four former schoolmates died, as did John Spencer, the academy preceptor who followed Humphrey and, like him, was Dickinson's friend. In 1852 her cousin and Mount Holyoke roomate, Emily Norcross, died of consumption, and in 1854 she lost her grandmother Norcross and her cousin William Norcross, Emily's brother.[14]

It is interesting that during a period of so many deaths Emily should have set aside her long preoccupation with becoming a Christian and formally joining the Congregational Church. For young people growing up at midcentury in Amherst and orthodox evangelical communities like it, the issue of embracing their Savior and accepting the tenets of Calvinism hovered over all their religious and academic training. Emily endured the subtle pressures of at least two revivals during her youth, as well as the persistent efforts of Mary Lyon, who worked hard to save her students' souls. Perhaps more difficult, she resisted ministerial pleas delivered as sermons over the bodies of contemporaries and withstood the urgings of good friends, themselves converted, to give herself up to Christ. Although far from unconcerned about matters of faith, Emily found Calvinist doctrine exceedingly harsh and intimidating.

Her mother had joined the church at Amherst shortly after Emily was born, in 1831, but it took her father twenty years longer to submit to conversion. Admonished by his minister for attempting to come to Christ as a lawyer, rather than as a sinner, on his knees, Edward Dickinson at last joined the First Church of Christ during the revival of 1850. Vinnie, who was under significant pressure to become a Christian while at Ipswich, joined a few months later; Austin was converted shortly before his marriage in 1856, in large measure to please Susan Gilbert, his bride-to-be. Emily alone among her family evaded the commitment, although not without great anguish of mind and spirit. A vitally religious person all her life, she was at home with the Bible and in the early 1850s attended church regularly, sometimes both Sabbath services; but she found it difficult to reconcile what she believed with the church's unsparing emphasis on total depravity, predestination, judgment, and damnation. "I wish the 'faith of the fathers' did'nt wear brogans, and carry blue umbrellas," as she phrased it mildly on one occasion, and on another: "I believe the love of God may be taught not to seem like bears."[15]

Susan Huntington Gilbert was one of four sisters who lived in Amherst as children but after their parents' deaths were brought up by relatives in Geneva, New York. When Sue returned to the village in the summer of 1847 to visit her sister Hattie, who married an Amherst merchant, she attended the academy during Emily Dickinson's last term in her beloved old school. The two girls had birthdays nine days apart, and their friendship, begun that summer and renewed in 1850 when Sue returned to Amherst, developed into one of the most important relationships of Emily Dickinson's life.

"Sister Sue," as Emily began to call her well before they were sisters-in-law, was a good-looking, spirited, dark-haired young woman who spoke her own mind. Her wit and charm drew Emily mightily. They became such fast friends that, in the parlance of the period, Emily's love grew idolatrous, and her letters written during 1851–52, a year Sue spent teaching school in Baltimore, are love letters, full of tender sentiment and excessive pining for "Susie's" attention and her return home. How much the letters were influenced by the romantic novels the two were reading and whether the feelings expressed strayed beyond the period's broad limits for female friendship have long been debated; with only Dickinson's side of the correspondence preserved it is difficult to determine the true nature of the relationship. But the fact that Emily played a go-between role in her brother's courtship of Sue suggests that she had no illusions about how her strong desire for Susan's presence in her life would play out. Dickinson's need of this captivating intimate friend, with whom she shared a passion for Brontë and Longfellow novels, for the poetry of the Brownings, and, in time, the works of George Eliot, had another urgent dimension. Sue was one of a few persons outside her immediate family aware that Emily was coping with increasing anxieties that made her social behavior mystifying and erratic.

She had always been nervous and shy, always anxious in the presence of strangers, and for that reason had dreaded the public oral examinations that ended each school term and always suffered "the dismay attendant upon entering august assemblies."[16] In her early twenties it began to be easier not to attend the Sewing Society, not to go places if

A Dickinson mirror suggests that even vision is susceptible to disease.

West Cemetery, Amherst.

Austin's and Sue's wedding portraits, taken in 1856 shortly before they moved into the Evergreens. Susan Dickinson's wit and social charms drew many admirers over the years.

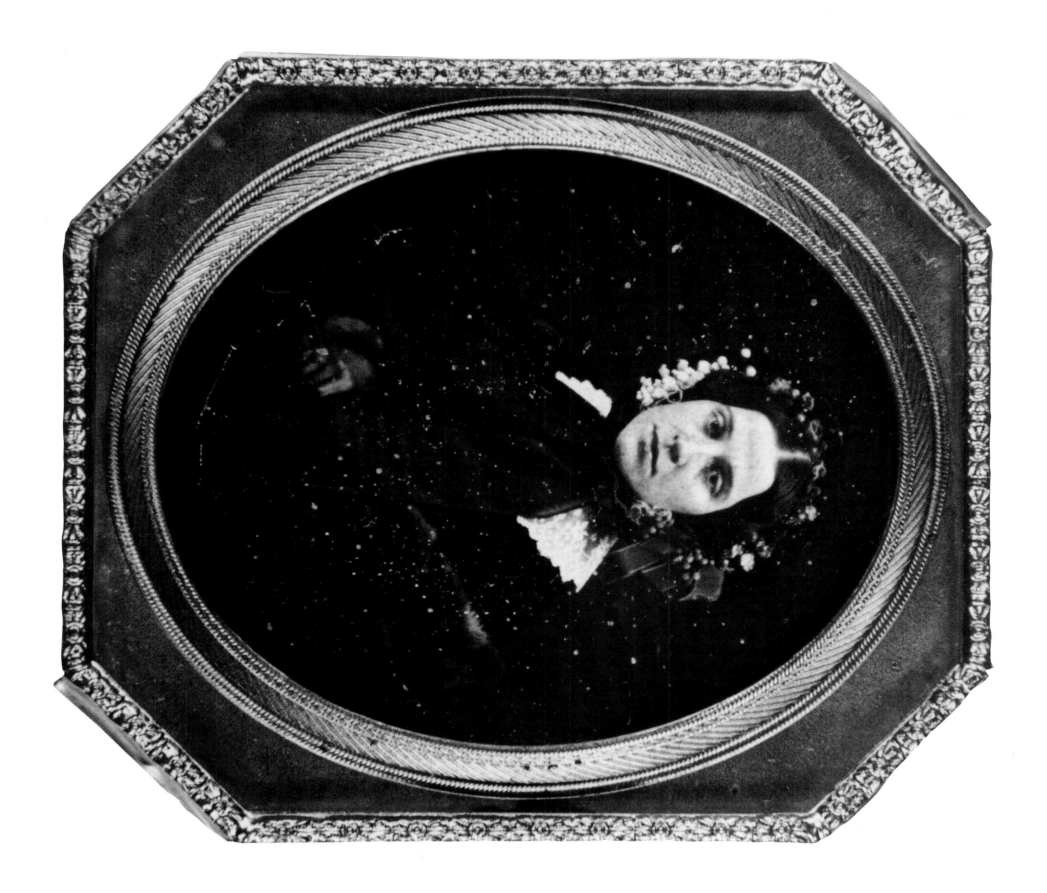

Polly Longsworth

Blazing in Gold – and
Quenching – in Purple!
Leaping – like Leopards in the sky –
Then – at the feet of the old Horizon –
Laying it's spotted face – to die!

Stooping as low as the kitchen window –
Touching the Roof –
And tinting the Barn –
Kissing it's Bonnet to the Meadow –
And the Juggler of Day – is gone!

Poems, P. 321

she wasn't with Vinnie or another trusted friend. Her father had even given her a huge, tawny dog—half Newfoundland, half Saint Bernard—whom she named Carlo and called "My Shaggy Ally."[17] Carlo began to accompany her when she paid calls or took the walks she enjoyed for exercise. To her brother and sister, asked in retrospect about Emily's increasing preference for staying home, it was a gradual happening, nothing extraordinary.

But in January 1854 a new complication arose, possibly triggered by the accumulated losses of friends that she was experiencing. A letter to Sue records a panic attack she suffered one Sunday when Father, Austin, Vinnie, and Sue were all away and Emily ventured to church alone. Whether more attacks followed is not known, although her behavior suggests she may have feared others and curtailed her activities accordingly.[18] That spring of 1854 she declined to go with the rest of the family to visit Father in Washington, D.C., instead staying at home with Sue and cousin John Graves, an Amherst junior, for companionship. A short while afterward she told her friend Abiah Root, "I dont go from home, unless emergency leads me by the hand, and then I do it obstinately, and draw back if I can."[19] The following year, however, during Edward's second year in Congress, she did go to the nation's capital, leaning on Vinnie's arm, and relishing in after years her sister's hilarious send-ups of the extraordinary people they met and the interesting sights they saw. On the way home they stopped at Philadelphia for over two weeks to visit their second cousin, Eliza Coleman, another person who "appreciated" Emily's bewildering problem.

Since childhood, Emily had shared not only a room but a bed with her sister. "It is so weird and so vastly mysterious," Emily wrote of Vinnie to their friend Joseph Lyman, "she sleeps by my side, her care is in some sort motherly. . . . [she] is in the matter of raiment greatly necessary to me; and the tie is quite vital; yet if we had come up for the first time from two wells where we had hitherto been bred her astonishment would not be greater at some things I say."[20] Emily's dependency, Vinnie's astonishment: it was to be the pattern of their lives in the Homestead for the next three decades.

Although they took separate rooms in the refurbished mansion, Vinnie's life gradually would be subsumed in her sister's, her own considerable wit discounted as she took charge of championing Emily's brilliance and audacity and protecting her privacy.

. . . if the anguish of others helped one with one's own, now would be many medicines.

—Letters, L.298 to Louise and Frances Norcross

The Evergreens was unlike any other house in Amherst. Its flat, projecting roofs, arched windows, wide verandas, and central tower stood out like a foreign accent among the Greek Revival facades and plain, pitched-roof farmhouses of the village. Had Edward Dickinson not roped the Tuscan villa to the Homestead by means of a long hemlock hedge fronting both properties, there would have seemed no tangible relationship between the dwellings.

The villa's structural features were lifted from A. J. Downing's recently published *Architecture of Country Homes* by Northampton architect William Fenno Pratt, whom Edward engaged to design the house after Austin picked the style "by whim," as family lore had it. Edward frugally insisted on incorporating at the rear a small rental cottage that had stood on the property for a decade, a New England element not visible from the street. Set back on its third of an acre, the Evergreens was approached by granite steps that drew a visitor into a naturalistic setting made lush by Austin's fondness for landscaping, which led him to scour the countryside for shrubs and trees to transplant to the grounds surrounding his new home and stretching east to the Homestead. First as an orphan, now as a dowered fiancée and wife, home was ever central to Sue's sense of worth, and she set about appointing the Evergreens handsomely. She chose

among colorful pastels and light floral designs of the early Victorian palette to brighten the compact central hallway and adorn the high-ceilinged rooms on either side, parlor to the left and library to the right. The library was established with "fifty books of your choice," from her brother Frank, who fulfilled a joking pledge of long ago to supply them if she ever married. Sue spent liberally but not extravagantly of her dowry, selecting "wedding band" French porcelain and a simple fiddle-thread silver pattern for tableware. In one heady day at Doe, Hazelton and Company in Boston she spent nearly $900 on an oak sideboard, a black walnut Gothic chair and whatnot, and other fashionable pieces of middle-range quality and eclectic style.[21]

Even shaving expenses as closely as he could, the Evergreens cost Edward $5,500 to build, and in order to finance it atop remodeling the Homestead, he indulged in some juggling among accounts he managed. Three years earlier his favorite sister, Mary Dickinson, and her husband, Mark Haskell Newman, a successful New York publisher, had died, leaving Edward the guardian of their four daughters, along with sufficient funds for their care and upbringing. Edward brought the girls to Amherst in 1853 and set them up in a rental house he owned on the common, with a relative as their caretaker. On January 1, 1857, in the annual accounting he made each year on his birthday from 1850 until near the end of his life, Edward for the first time indicated a charge against the Newman estate of $6,000, the same valuation he soon placed on the Evergreens.[22] Probably Edward anticipated that Austin would eventually purchase the Evergreens; meanwhile his investments in Michigan land, railroad stock, and other regional enterprises served as collateral for this "loan." Two years later, Edward made new arrangements for the Newman girls, increasing his debit to nearly $10,500 as he sold the house on the common and turned over responsibility for the two older Newman nieces, Catherine and Sara, to his brother William Dickinson, a banker in Worcester. The two younger girls, twelve-year-old Anna and fourteen-year-old Clara, he placed in Sue and Austin's childless home. Despite having benefited from

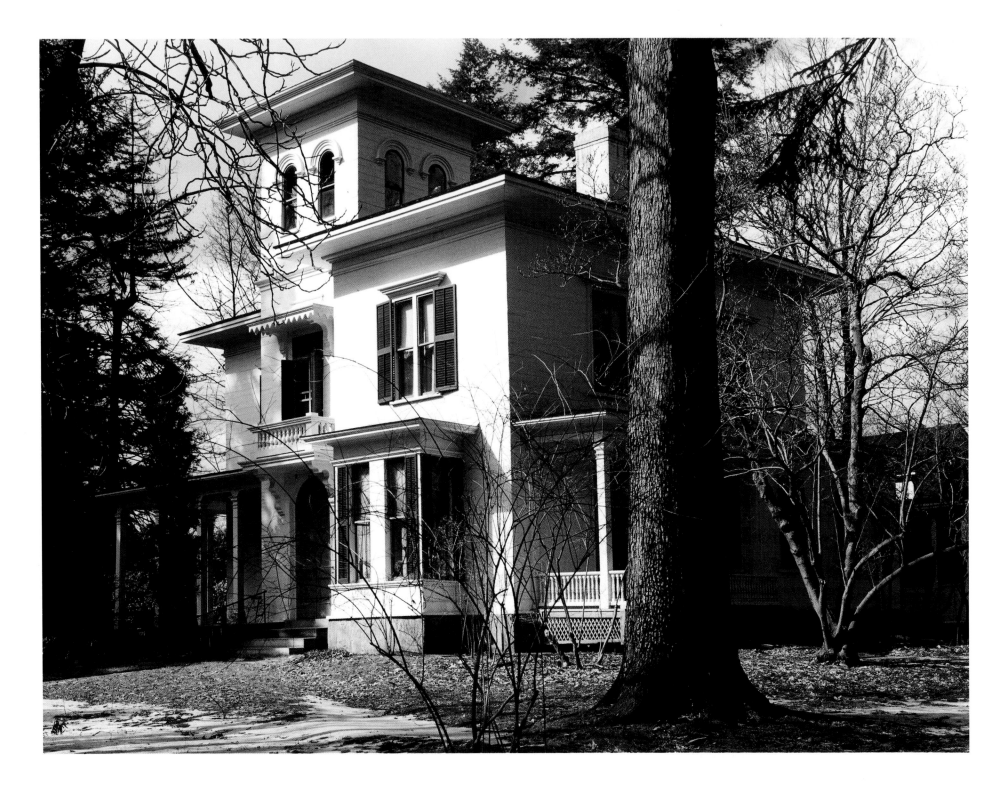

The Evergreens in 1982.

Sue's wedding band china.

such an arrangement herself while growing up, Susan was far from delighted.

The first Christmas in her new home Sue had hung evergreen wreaths in the windows, shocking many pious citizens of the village, perhaps even her father-in-law, who "frowned upon Santa Claus—and all such prowling gentlemen."[23] Mrs. Edward Dickinson's illness during the first years after she returned to the Homestead kept that house rather quiet, and Emily and Vinnie, despite domestic help, often were tired out by household routines. But Sue and Austin's home was notable for social whirl from the start, including, in the second winter of their marriage, a visit from the Sage of Concord, Ralph Waldo Emerson. "For years I had read him, in a measure understood him, revered him, cherished him as a hero in my girl's heart," Sue later wrote. "So that when I found he was to eat and sleep beneath our roof, there was a suggestion of meeting a God face to face"[24]

Far livelier hijinks occurred whenever Sue's former Utica Academy classmate, Kate Anthon, came as houseguest. "Those celestial evenings in the Library—" Kate wrote in later years. "The blazing *wood* fire—*Emily*—*Austin*,—The music—The rampant fun—" No one ever forgot an evening at the Evergreens when charming Mrs. Anthon and another close friend, the ebullient Samuel Bowles, editor of the *Springfield Republican*, played a rollicking game of badminton in the parlor and Emily, with Carlo in tow, had played her own weird compositions on the piano. That was the night Edward Dickinson suddenly appeared with his lantern near midnight to fetch his eldest daughter home.[25]

For Emily, such gaiety was a rarity, indulged in only among the trusted friends she termed "my Elect," for by the end of the decade she was extremely cautious about whom she saw, avoiding most social events outside the family. "You will forgive me, for I never visit," she wrote to a friend named "Susie" (most probably Susan Phelps of nearby Hadley, whom she counted as a bosom friend). "I am from the fields, you know, and while quite at home with the Dandelion, make but sorry figure in a Drawing-room."[26] She paid social calls if Vinnie could accompany her, or not at all. "Vinnie

has been all, so long, I feel the oddest fright at parting with her for an hour, lest a storm arise, and I go unsheltered," she explained when Vinnie was in Boston caring for Aunt Lavinia, their mother's sister, who was ill during the winter of 1859.[27]

While her deft evasion of invitations, avoidance of social situations, and startling habit of running from the doorbell seemed odd to others, a psychiatrist today would recognize her condition as the combination of anxiety disorders called social phobia, with avoidant personality disorder.[28] Dickinson herself had no such comfort. She was simply bewildered and embarrassed by her eccentricities, as were those who witnessed them. But her long aversion to being noticed (what she termed "a Cowardice of Strangers"), her sensitivity to potential criticism ("Odd, that I, who say 'no' so much, cannot bear to hear it from others"),[29] and her enormous social reluctance, despite the avid desire to interact with others that is apparent in her large correspondence, are behavioral markers that have been identified within the past two decades as belonging to this condition. Over time, Dickinson coped with her peculiarities by growing ever more reclusive, developing strategies that allowed her to function around her devastating symptoms.

By 1858, Dickinson had been writing poems for nearly a decade, at first with the encouragement of a friend or two, but after Ben Newton's death in 1853, alone, guided by experiment, by her wide reading, and by the metric, grammar, and vocabulary lessons available to her in her Watts hymnal and her two-volume Webster's dictionary. Often she sent finished poems across the path to Sue, whose critical judgment she trusted and relied upon. These were nature poems (perhaps a sunset) or a tribute to their loving friendship or something inspired by their mutual reading. Sometimes she sent a verse to Samuel Bowles or to her good friend Elizabeth Holland of Springfield, the wife of Josiah Holland, Sam Bowles's associate on the *Republican*. Although no scrap of their correspondence remains, she seems to have shared poems with the Reverend Charles Wadsworth, the Philadelphia minister who became vitally important to her

after she presumably heard him preach at his Arch Street Presbyterian Church back in the spring of 1855 when she visited Eliza Coleman. "My Shepherd from 'Little Girl'hood,'" she later called him, and "my dearest earthly friend."[30]

Mostly, however, Dickinson's poems were her own intense preoccupation, and only Sue had any true perception of her dedication to the art. Her family, accustomed to Emily spending time alone in her room, knowing she wrote letters late into the night, used to seeing her jot thoughts on scraps of paper and stuff them in her pocket, surely knew that she wrote poems. At the same time, they imagined neither the scale nor seriousness of her endeavor. In 1858 she had accumulated so many poems that she began the practice of copying finished ones in ink onto folded sheets of letter paper, arranging the four-page sheets atop one another and binding them with a length of string, thus creating the dainty booklets that have come to be called fascicles. Forty fascicles, containing over eight hundred poems, accumulated before she abandoned the practice about 1864, yet for another decade she continued to enter fair copies of her poems onto folded sheets, often grouping but no longer binding them. Another 350 poems occupy these loose "sets."[31]

It is not known why Dickinson created the fascicles. Simple housekeeping may account for it, for she destroyed drafts and worksheets of the poems she entered, or it may have provided a system of filing and retrieving poems more easily. Some believe she had a narrative purpose, while others theorize that she was creating what Emerson called "Poetry of the Portfolio," a form of self-publication in order to share poems privately with friends. Whatever her intention, the process occupied Dickinson for several years.

For the Dickinsons, the chaos of the Civil War seemed neatly bracketed by the arrival of Sue and Austin's first child just as it started and the birth of their second shortly after it ended. The baby boy born June 19, 1861, was named for Edward Dickinson and called Ned. Having lost a sister to childbirth fever, Sue felt enormously relieved to have the whole experience over with no dire consequences. Unlike his robust sister Martha, who joined the family in November

1865, Ned was a sickly child. His frequent illnesses caused concern in both households, especially after he suffered rheumatic fever as a boy and developed epilepsy at age sixteen. His parents conspired to keep knowledge of this last condition from him. He also was slow at schoolwork and not allowed to overexert physically. Ned grew into a sweet-tempered youth with a fine sense of humor, who made up in good manners and grace for his lack of physical vigor.

The Evergreens was noted, now, for Sue's charm and skills as a hostess. Her home was her pride and joy, her touch visible in the flowers, good food, plethora of books, and stimulating conversation that had quite swiftly made her a social leader in Amherst. One college student of the war years described Sue as "a really brilliant and highly cultivated woman of great taste and refinement," adding that she was "perhaps a little too aggressive, a little too sharp in wit and repartee, and a little too ambitious for social prestige, but, withal, a woman of the world in the best sense." A faculty member who came to call in much later years, after Susan's death, found the booklined walls of her library still familiar but missed "the wit and the searching ideas of the much-debated Susan."[32]

Yet it was Austin's passion for collecting art that truly distinguished the Evergreens. The walls began to fill with his eclectic collection of Pre-Raphaelite paintings, mostly atmospheric landscapes bought at the New York galleries he frequented whenever he could get away from Amherst. Austin was every bit a sensualist, and Sue was well read in Ruskin; both were enamored of the haunting vistas and mountains of the Hudson River school, which led them to acquire *Autumn Evening in the White Hills* by Sanford Gifford and *Sunset with Cows* by John Kensett, among others. By the early 1860s their tastes embraced depictions of the Alps and wild scenery of northern Europe. "Austin came home [from New York] in a feverish excitement over pictures—utterly worn out with his passion," Susan wrote to Samuel Bowles on Christmas night 1861. "The real fact of the matter is his desire and half plan for three of the Dusseldorf collection." By Christmas a year later he owned the

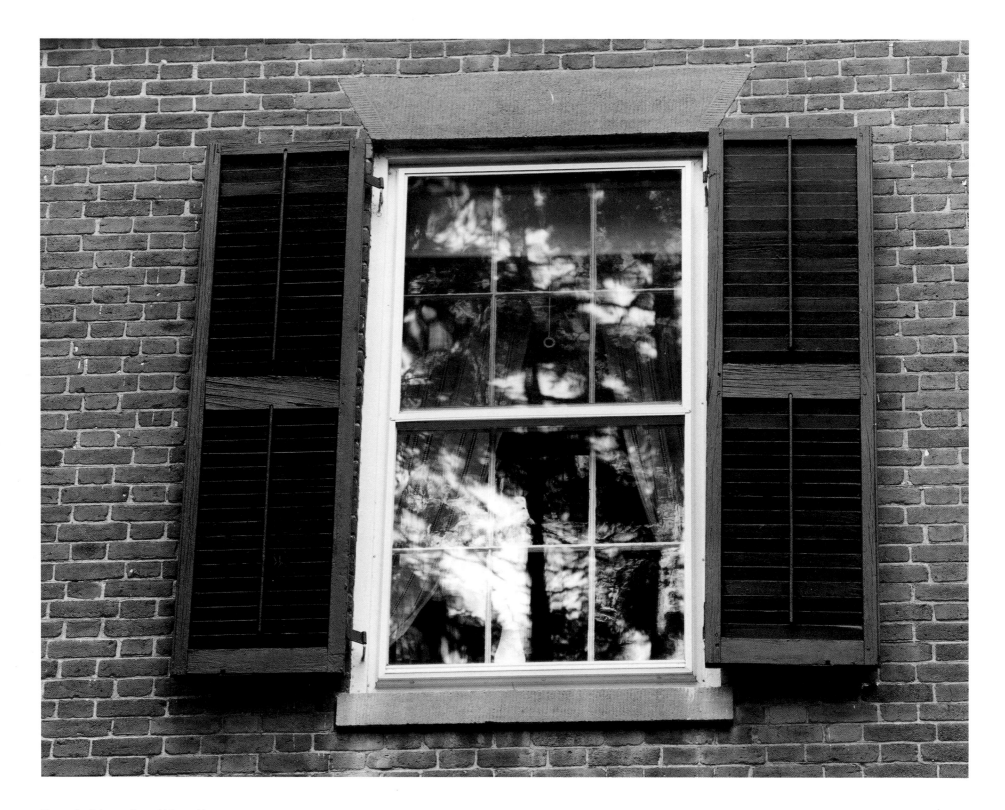

The poet's window on the world, from without.

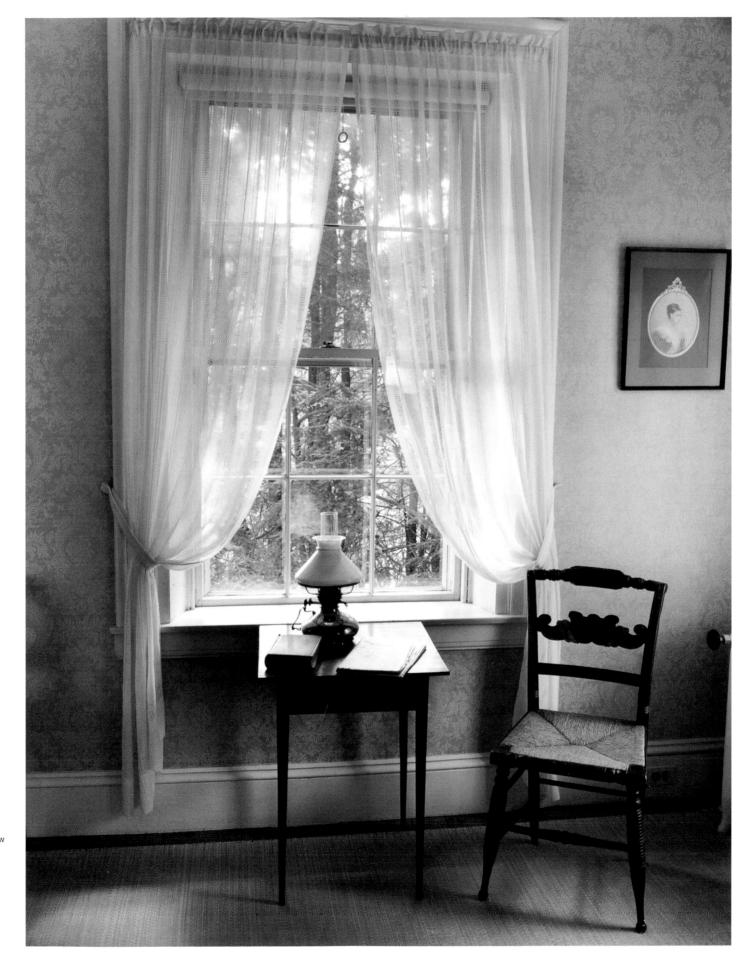

The southwest window
of Emily Dickinson's
bed chamber, where
she wrote poems and
letters.

They dropped like Flakes –
They dropped like stars –
Like Petals from a Rose –
When suddenly across the June
A Wind with fingers – goes –

They perished in the seamless Grass
No eye could find the place –
But God can summon every face
On his Repealless – List.

Poems, P. 545

three, adding *Landscape: Norwegian Scenery, with Bears* by Hans Frederik Gude and two scenes by Gottfried Johann Pulian to his walls, then bemoaning the chronic bankruptcy his obsession assured.[33]

Once the Civil War erupted, it was the central concern of life in Amherst. As Edward Dickinson neared sixty, his yen for public office diminished (he had twice turned down state nominations for attorney general), yet little in the village of three thousand souls took place without his endorsement. He raised money to outfit local soldiers, gave farewell speeches to departing troops at the depot, sparked patriotic rallies, and, in the second year of the strife, led victory celebrations. Austin supported his father's efforts. When what was supposed to be a swift and holy war grew long and loathsome and volunteers dwindled, Austin helped raise bounties to buy conscripts for local military quotas. He himself paid $500 for a substitute, disqualified from serving by his own rheumatic heart.

Father's and Austin's activities kept Emily and Vinnie well attuned to the national tumult and the local fray, and they prayed daily for the dozens of Amherst men and students who answered Mr. Lincoln's calls for troops, some to return all too soon as corpses or cripples. The death of Frazar Stearns, the brave, perhaps too brave son of the college's president, William Stearns, at the battle of New Bern in March 1862 devastated almost everyone in town and touched the hearts of people over a wide region. Murder, Emily called it, both in a poem and a letter: "Austin is chilled – by Frazer's [*sic*] murder – He says – his Brain keeps saying over 'Frazer is killed' – 'Frazer is killed,' just as Father told it – to Him. Two or three words of lead – that dropped so deep, they keep weighing –"[34]

Those who find Dickinson oblivious to the Civil War because she never named it in a poem haven't looked closely at the tropes and images and themes of combat that entered her work once the conflict began. Perhaps it was inevitable, for she read the *Daily Springfield Republican* as avidly as anyone, consuming details of the military campaigns and scanning the battle lists with dread. Now in her

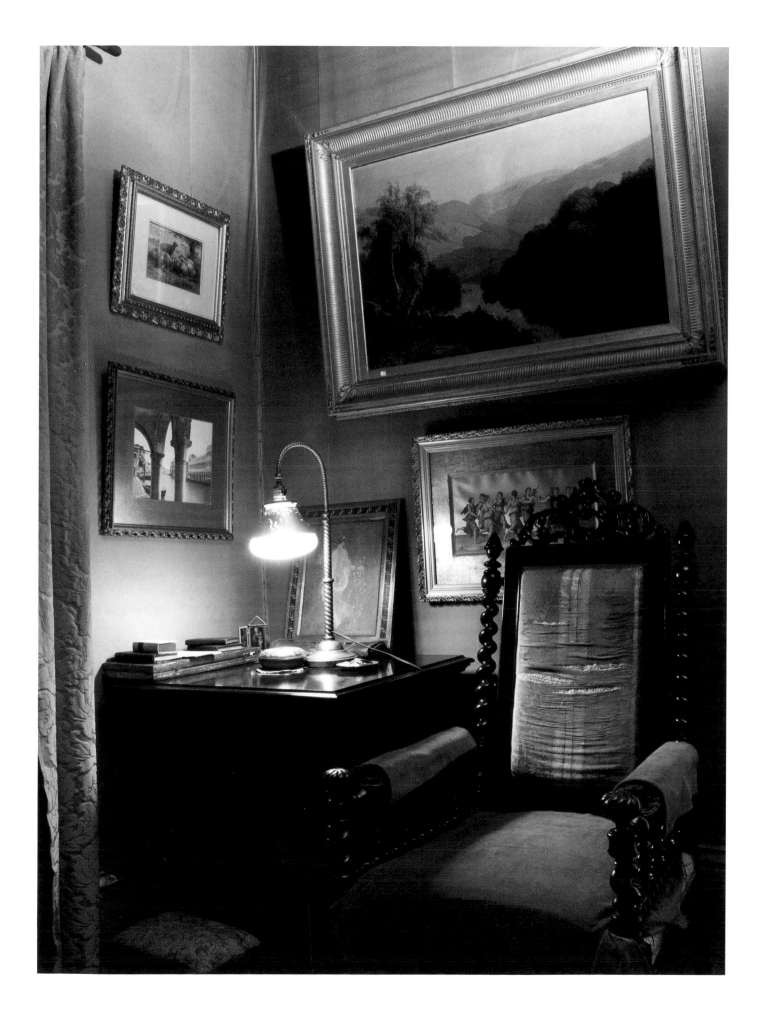

A corner of the
Evergreens parlor.

early thirties, she was finding the war years a time of enormous personal turmoil, a period of private anguish so intense it had spawned a great surge of poems. At the same time, her distress was so private that only its outlines can be traced. Her single reference came in April 1862: "I had a terror – since September – I could tell to none – and so I sing, as the Boy does by the Burying Ground – because I am afraid –"[35] Any number of possible interpretations of her unspecified terror have been put forward by those convinced she feared blindness or verged on madness or was rejected by a lover or suffered a crisis in her poetic vocation. Indeed, so much was happening in Dickinson's life in 1861 and 1862, events breaking thick and fast for one who lived in semi-reclusion, it would seem as if her trouble was nearly all of these.

The September of the terror, Emily lost to consumption her special friend Lucy Dwight, wife of the Amherst church's Reverend Edward S. Dwight. While Lucy's death unnerved her, Emily probably learned about that time of another impending loss, for in the fall of 1861 her friend the Reverend Charles Wadsworth was considering leaving his Philadelphia pulpit for Calvary Church in San Francisco, a move that would put him beyond reach of easy correspondence. We know little of Dickinson's relationship with Wadsworth, a married man then at the height of his preaching prowess, a sometime poet with reclusive tendencies himself. It seems probable that Emily looked to him for religious guidance and exchanged poems on the great themes that so preoccupied her—death, faith, and immortality. It is very likely that Dickinson loved him. Her niece, Martha Dickinson Bianchi, unequivocally claims that she did, citing confirming conversations with Sue and Austin and Lavinia to stress that Emily loved without expectation of an earthly liaison.[36] Such a possibility is supported by the existence among Dickinson's papers of three mysterious, possibly unsent draft letters written to a person identified only as "Master" but linked by internal clues to Wadsworth. It is further supported by what we know of two calls Wadsworth made on Dickinson at the Homestead at twenty-year intervals, in March 1860 and August 1880, and by what she wrote concerning her "fathomless" friend after his death.

By December 1861, Wadsworth's intention to move to California was certain. That Dickinson entered a period of enormous distress about this time is evident in the spate of powerful poems, many of them love poems and cris de coeur, that began to pour out, filling fascicle after fascicle. In her extremity she reached out to the magnetic Samuel Bowles, leaning on his great capacity for friendship by entrusting him with her secret (conveyed in some extraordinary poems) and relying on him to address and forward her letters to Wadsworth, for Dickinson sent much of her correspondence under guise of another's handwriting. Bowles was willing to serve as her confidant, but in addition to being an extremely busy journalist and editor, he was not a well man, having been in treatment for some months with a painful sciatic condition. When, in late winter of 1862, his doctor prevailed on him to travel abroad, the news that she would lose a second friend and advisor—Bowles in early April, Wadsworth in early May—was devastating to Dickinson.

There was another trouble on her mind through this period, one exacerbated by the many poems she was writing. She knew her verse was of publishable quality, but her phobic disorder prevented her from being able to publish, so fearful was she of the attention and critical response such an activity would elicit. Twice that winter she evaded requests from (unidentified) journal editors who asked her for poems. Deferral seems to have been her chosen strategy: "Could I make you and Austin – proud – sometime – a great way off – 'twould give me taller feet –" she told Sue a summer earlier during an exchange over the poem, "Safe in their Alabaster Chambers." Her comment may have been pointed, for Sue was probably the culprit who had sent one of Emily's poems, "I taste a liquor never brewed," to the *Springfield Republican*, where it appeared on May 4, 1861, under the title "The May-Wine." But if Emily hoped to deter Sue from further larceny, she failed, for "Safe in their Alabaster Chambers" appeared in the same newspaper on March 1, 1862, under the title "The Sleeping."[37]

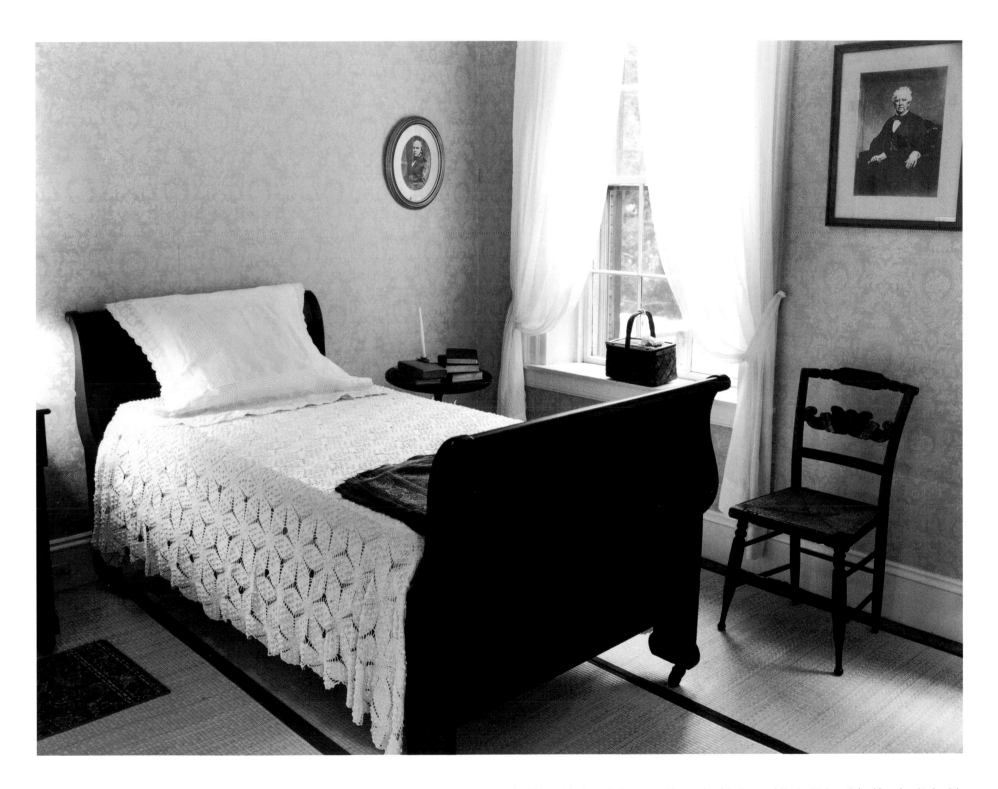

Emily Dickinson's bedroom in the 1980s, with portraits of the Reverend Charles Wadsworth (oval frame) and Judge Otis Phillips Lord (rectangular frame). The original bedroom furniture is displayed at the Houghton Library, Harvard University.

Emily would not have confronted Sue, but she did reduce the poems she shared with her sister-in-law during 1861 and 1862, a drop not evident in numbers but in proportion to her dramatic acceleration in production and most especially noticeable during the phenomenal year of 1862, when Dickinson apparently composed close to a poem a day. As her extraordinary crisis reached a peak during the month of March 1862, the month her poem appeared in print, the month Frazar Stearns died, and the month Sam Bowles announced his plans to sail to Europe, Dickinson turned for help to a stranger. After reading in the April issue of the *Atlantic Monthly* an article entitled "Letter to a Young Contributor," she composed a letter to its author, Rev. Thomas Wentworth Higginson, a Boston man of letters whose essays were familiar and whose advice that would-be authors not be precipitous about breaking into print she seized upon. Emily enclosed her calling card and four poems, inquiring, "Mr. Higginson, Are you too deeply occupied to say if my Verse is alive?"[38]

Twice in later years, Dickinson told Wentworth Higginson he had saved her life, and in 1870, despite the full reclusion in which she then lived, she invited this man whom she used as a shield to come to the Homestead so she could thank him. But at the start, when he agreed to become her "Preceptor," agreed to provide literary advice to this bewildering pupil (she called herself "your scholar"), he seemed befuddled about what Dickinson was asking him to do. For Dickinson was unable to say directly that she wanted him to tell her not to publish.

During the second half of the Civil War period, beginning in the fall of 1863, Emily suffered from a painful eye condition, probably a case of severe iritis.[39] Extreme sensitivity to light led to loss of her eyes for work, which greatly depressed her spirits. After consulting with Dr. Henry Willard Williams, a prominent, scientifically advanced Boston ophthalmologist, she spent two separate six-month periods during 1864 and 1865 in his care. Living in a Cambridge boardinghouse with cousins Lou and Fanny Norcross, she kept to darkened chambers, forbidden the use of her eyes and

pencil. "Prison" she called it, and "Siberia," but Dr. Williams's patient ministrations, which perhaps included some psychological assurances, at last succeeded in curing her.

the first Mystery of the House

—*Letters*, L.432 to Elizabeth Holland

Summer was the season when the skills of four superior Dickinson gardeners were apparent to the world. Edward and Austin might have their double hayings and their bountiful fruit crops in the big meadow across the road, and Dennis Scannell or other hired man might cultivate the big vegetable patch, but it was the Dickinson women, Sue, Emily, Vinnie, and Mrs. Edward Dickinson herself, who made the estate behind the hemlock hedge a veritable bower. The pansies, roses, foxgloves, heliotropes, geraniums, daphne, and lilies that populated Emily's poems and letters and found their way to neighbors as dainty bouquets attest to her love of plants, indoors and out. A gift of cape jasmine, even a winter spray of buttercups, from her glass conservatory off the library was considered a superior treat in Amherst. She could as easily, however, send a friend a hummingbird or butterfly or bumblebee in a poem that caught precisely the essence of the creature and attested to the hours of her life she had spent kneeling in the garden on an old red army blanket.

Just north of the Homestead stood the big family barn, which housed the horses, carriages, sleighs, and harness for both households, and protected swallows, pigeons, and doves that swooped and chortled in apertures of the hayloft above. The east wing of the barn sheltered the family cows, chickens, and pig, if one was being fattened; the west wing was the woodshed and toolhouse, with quarters for a hired man above. To the east of the barn stood grape trellises,

twined by red and white varieties for jellies and wine, and behind a protective fence stood Mrs. Dickinson's three prized fig trees. A line of flagstones led eastward through the honeysuckle, myrtle, lily-of-the-valley, and numerous fruit trees of the Homestead's upper yard to extensive rose beds and arbors in the lower yard. Here old-fashioned rose varieties had distinct territories (a Cinnamon rose, a Calico rose, and Mrs. Dickinson's tiny, clustering Greville rose from her girlhood garden in Monson). Beyond stretched more general beds, holding procesions of perennials. Off the western side of the Homestead, along the much trafficked path between the two houses, hollyhocks stood sentinel wherever Austin's trees permitted sun to shine. Sue's formal gardens at the Evergreens held prize-winning peonies and roses. She maintained a hotbed for early culinary delights and a sufficient cutting garden to keep her house freshly adorned with blooms from May to October.

But Vinnie's personality was perhaps most vividly apparent to visitors of the 1870s. Martha Dickinson Bianchi remembered her Aunt Vinnie as

> a passionate gardener who grudged daylight hours away from it on any terms. Her mignonette beds were yards square, whirring, whirring with bumble-bees. Her sweet peas marched in platoons. Her roses took on the more sophisticated hybrids. There was a riot in season of what the Irish gardener called "Excurtiums"—when nasturtiums ran wild over defenceless peony bushes, up the rose trees, across botanical decalogues at will. Aunt Lavinia liked some of everything: wild-sown Poppies, Gladioli, Snap Dragon, Sweet Sultans, Japanese and Tiger lilies, Madonna lilies. . . . All her flowers did as they liked: tyranized over her, hopped out of their own beds into each other's beds, were never reproved or removed as long as they bloomed; for a live flower to Aunt Lavinia was more than any dead horticultural principle."[40]

Little of this warmth and riot of the garden prevailed indoors at the Homestead. Unlike the Evergreens, where tall glass doors and windows and Sue's pastel decor kept the interior bright and airy, the Homestead, with its brown painted woodwork, was ever dark and cool. In all but the apple green kitchen, blinds were closed against the sunlight, so the dark mahogany furnishings stood in a perpetual dusk. "A parlor dark & cool & stiffish, a few books & engravings, & an open piano" was Higginson's description of the west parlors during his visit of August 1870. Martha Dickinson Bianchi called attention to the walls, "hung with heavily gold-framed engravings: 'The Forester's Family,' 'The Stag at Bay,' 'Arctic Night,' and other chastely cold subjects."[41] Indeed, engravings reigned at the Homestead, for elsewhere was a series portraying the Prodigal Son, and in Emily's own room, with its bed and bowed cherry bureau, its little writing table and Hitchcock chair, its wood stove and wide window sills crowded with hyacinths or geraniums, the poet placed engravings of favorite authors (Thomas Carlyle, Elizabeth Barrett Browning, and George Eliot) alongside a Currier & Ives print of Windsor Castle.

Amherst began to grow and change after the Civil War as the founding of the Massachusetts Agricultural College and northern extension of the railroad brought newcomers with unfamiliar ideas and needs to the quiet community. A Catholic and an Episcopal church arose where previously only a small Baptist congregation dared rival the Congregational stronghold. Amherst College was prospering, with a larger, more secular student body, new faculty members, and a need for improved facilities. Through his father's roles as treasurer of Amherst College and head of the Parish Committee of First Church, Austin found himself engaged in a series of projects he truly enjoyed. In 1867–68 he supervised the building of a handsome new Congregational church catercorner from the Evergreens. The following two years he took charge of constructing the college's new temple of science, Walker Hall; and before it was complete, he became a member of the trustee building committee for the college's new Stearns Chapel. He had found a way of setting his strong aesthetic imprint on the town and college he so loved; in the process he made many new friends.

"There came a Day – at Summer's full – / Entirely for me – " (*Poems*, P. 325).

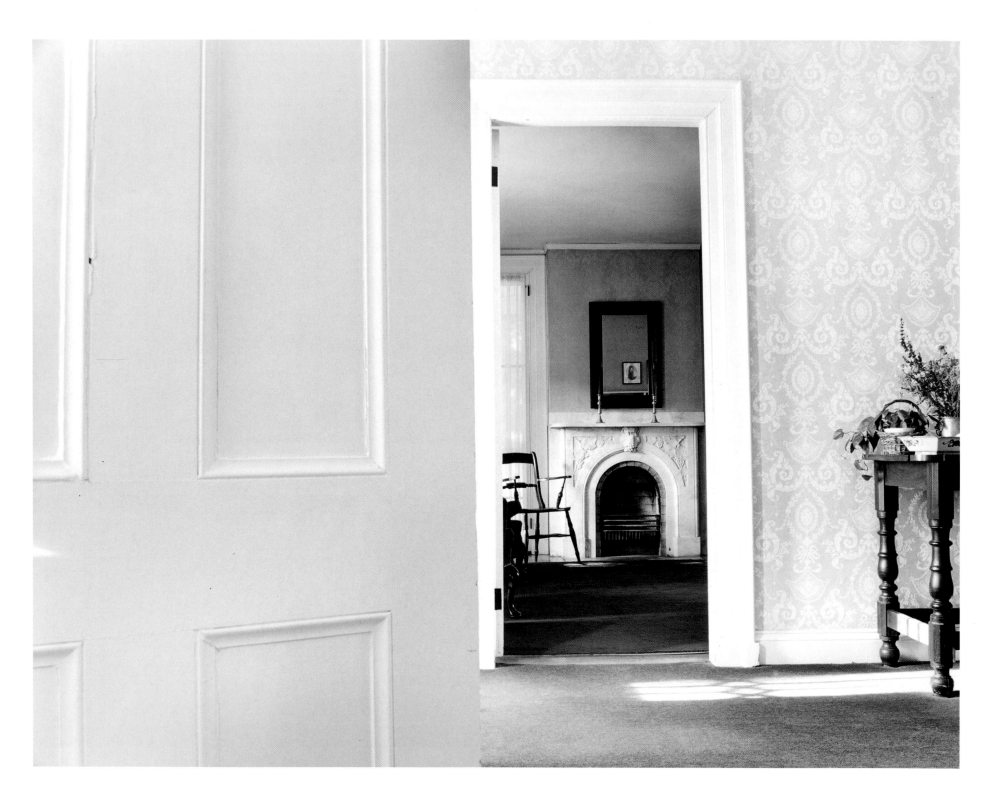

When the Dickinsons occupied the Homestead, its now-bright interior was made far duskier by dark woodwork and wallpapers.

Susan could not have been happier about the latter. Her essay "Annals of the Evergreens," composed in 1892 for the benefit of her children, speaks of the rare friendships she and Austin established among trustees, advisors, and visitors to the college. First and foremost, of course, was Samuel Bowles, with his rich experiences, irreverence, and wide-ranging connections to national politics. But she and Austin also entertained as houseguests such luminaries as landscape architects Frederick Law Olmsted and Calvert Vaux (Austin consulted them formally about the college grounds and town common and informally about the Evergreens). Then there was the emotive Reverend Henry Ward Beecher, the profound Bishop Frederic Dan Huntington, antic Governor Alexander Bullock, and stuffy, conservative Judge Otis Phillips Lord of the Massachusetts Supreme Court, a close friend of Edward Dickinson. Vaunted lecturers stayed more briefly—Wendell Phillips and Colonel Thomas Hart Benton, Harriet Beecher Stowe, and Frances Hodgson Burnett. Sue called them "high minded, earnest men and women" whose "informal talk about literature, affairs, religion, the supernatural, and of course other men and women" graced her elegant dinner table or provided deep and stimulating pleasure around the library's blazing fire.[42] Sue didn't mention the more constant round of social events she kept going with faculty and students, which led Austin to grumble occasionally in his diary about "my wife's tavern."

Austin was drawn into town affairs as completely as his father and grandfather had been. He had a strong, confident manner, and although outspoken like his father so that there was no doubt where he stood on any matter, he possessed an intensity of feeling to which people responded far more warmly than they ever did to Edward Dickinson. As Austin led efforts to improve the town by beautifying common and college, and by bringing in sidewalks, kerosene street lamps, then gas lamps, and a public water supply to counteract devastating fires, he grew indispensable to the civic life of Amherst. "I suppose," said a friend of his later years, "nobody in the town could be born or married or buried, or make an investment, or buy a house-lot, or a cemetery-lot, or sell a newspaper, or build a house, or choose a profession, without you close at hand."[43]

In 1874, Edward Dickinson, at seventy-one, agreed to go as representative to the legislature to try to induce action on the routing of the Massachusetts Central Rail Road, a major east-west line, through Amherst. One hot June morning, as he stood in the House speaking on the Hoosac Tunnel bill, involving another regional railroad, he felt suddenly faint and sat down. Returning to his room in the Tremont House, he suffered an apoplectic attack; and after being dosed with morphine, to which he was allergic, he died alone in his room.

"We were eating our supper the fifteenth of June," Emily wrote to Lou and Fanny Norcross, "and Austin came in. He had a despatch in his hand, and I saw by his face we were all lost, though I didn't know how. He said that father was very sick, and he and Vinnie must go. The train had already gone. While horses were dressing, news came he was dead." As shock spread through the town and beyond, the Dickinsons reeled in disbelief. Edward's body was brought to Amherst by train the next day, and the casket was placed in the center hall of the Homestead. Austin leaned to kiss his father's forehead, saying "There, father. I never dared do that while you were living."[44] But Austin was stunned, unable afterward to remember who had come to the service, who the pallbearers were. Emily kept to her room, thankful to have spent the previous Sunday in her father's company. It was Vinnie, with Sue's help, who saw to arrangements, greeted mourners, shielded her stricken mother, rose to the occasion for her father's sake.

On the day of the service (Ned's thirteenth birthday), all stores in Amherst closed. "I remember my grandfather's funeral by the odor of syringa," wrote Martha Dickinson Bianchi, who was eight at the time, "and the excitement of settees from College Hall placed in rows on the front lawn [for the overflow crowd] . . . but most of all by my terror at my father's grief. The world seemed coming to an end. And where was Aunt Emily? Why did she not sit in the library with the family if he could? She stayed upstairs in her own

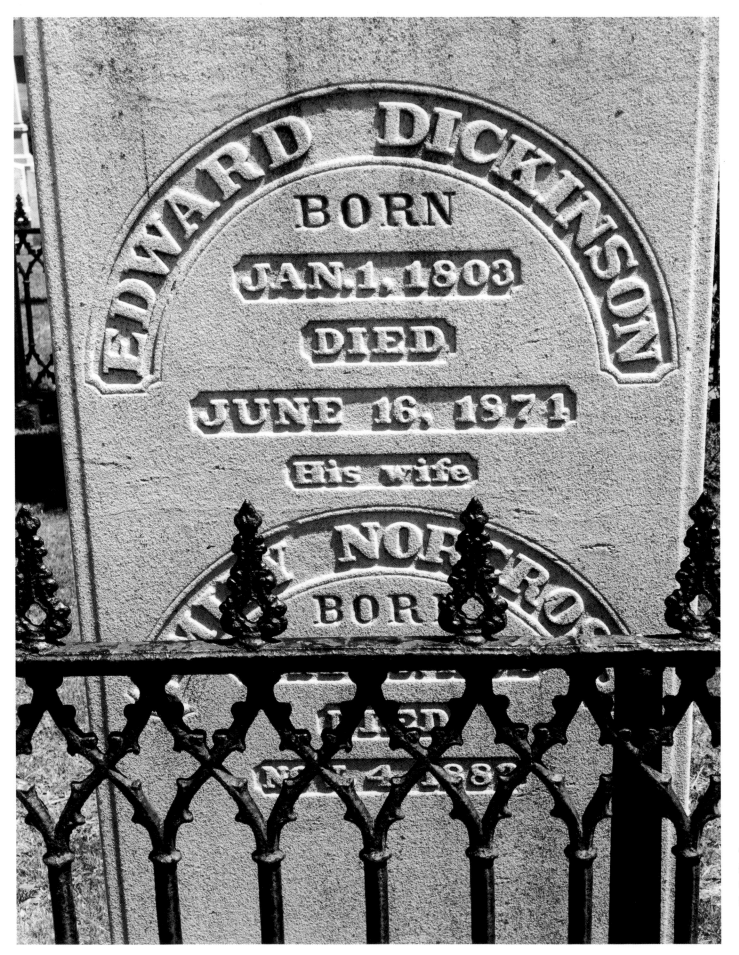

"Lay this Laurel on the
One / Too intrinsic for
Renown – "
(*Poems*, P. 1428).

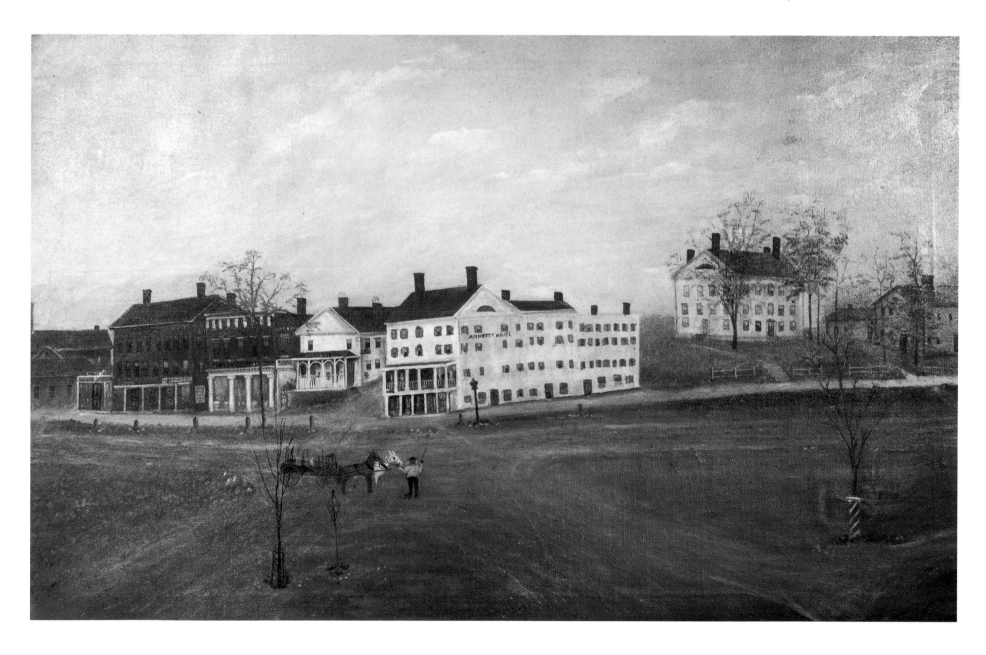

Center of Amherst ca. 1875, with Amherst Academy on rise to right. Painted by local sign and house painter George A. Thomas.

room with the door open just a crack, where she could hear without being seen."[45] Martha recalled her aunt's haunting voice in the months to come as "she went about always wondering where he could be, and even to her brother's children saying unforgettable things in her search for a clue to what, and where, he was, and 'what kind' he had become."[46]

Loss of Edward's authority had repercussions on all his family, suddenly rudderless in unfamiliar seas. For the poet, the loneliness of her father's death and of his lonelier life, made her ache. "His Heart was pure and terrible and I think no other like it exists," she told Higginson.[47] She had dressed almost exclusively in white, winter and summer, since her trauma of the early war years and didn't change that now, although Mrs. Dickinson, Vinnie, and Sue donned mourning. Nor did she visit her father's grave. Excepting the night that Austin had led her to the southwest corner of the Evergreens lawn to view the new church, she went nowhere. Her intensity by this time was extreme. "I never was with any one who drained my nerve power so much," Wentworth Higginson told his wife after his call on Miss Dickinson in mid-August 1870. "Without touching her, she drew from me. I am glad not to live near her."[48] Two years after her father's death, Emily still dreamed about him every night.

Now in her mid-forties, she continued writing poetry at a regular pace, sending occasional poems to Mr. Higginson for his "surgery," sending extravagant tributes to Sue's undiminished powers along the path to the sister-in-law she rarely saw. Her frantic production of the crisis years was over, however, ended by the enforced respite her eye condition imposed. The year after her father's death, with more than eleven hundred poems entered into fascicles and sets, she seems to have reached a pause or hiatus in which she reassessed her massive ouevre. She may have put completed work away, for she ceased working with fascicle sheets and began to live among single sheets and drafts, incorporating poems or parts of poems more often into her many letters.

Austin was staggered by his father's death. In early 1875, when Sue and the children left for a month, he moved into the Homestead. "It seemed peculiar – pathetic – and Ante-

diluvian," Emily told Mrs. Holland. "We missed him while he was with us and missed him when he was gone."[49] At least part of his dazed state can be attributed to the financial burdens he was bearing. In 1872, two years before he died, Edward had suddenly resigned as college treasurer after thirty-seven years, frightened by an inability to balance the books. His reputation as a scrupulous bookkeeper and manager of a greatly increased endowment was being undermined by accumulating debt he couldn't control. The treasurer's books indeed were in confusion; following months of hushed-up crisis and sharp debate among the trustees, Austin was chosen to succeed his father in 1873. He had just set about instituting a modern bookkeeping system and restructuring the treasurer's role in the college's financial decision-making process when Edward died, leaving his personal financial affairs in a still bigger mess.

Edward left no will. The last six years of his annual financial inventories are either missing (four) or incomplete (two). The January 1, 1868, inventory, the last that makes sense, lists his debt to the Newman estate as paid up at $13,600. How he managed it is not apparent, although the inventory lists significant increase in valuations for the Homestead and a tenement he owned and indicates that Austin was buying the Evergreens for $3,000, half its listed value. A deed for the Evergreens and its lot was drawn on the same date but never recorded, nor did Austin purchase the property from his father. Although Edward still had sound investments in 1868, notably shares in Joel Norcross's Monson cotton mill, which Mrs. Dickinson had inherited, his Michigan land and railroad bonds were badly depreciated.

What probably prompted the debt payment and inflated asset listings of the 1868 inventory was the departure from the Evergreens in 1867 of Clara and Anna Newman, who went to live with their recently married sister Catherine in Portland, Maine. In that year, then, Edward had had to provide the two young women their share of their father's estate, creating an indecipherable chaos in his financial records. The last of the Newman sisters to marry was Anna, and her wedding in Concord in early June 1874 was the final social

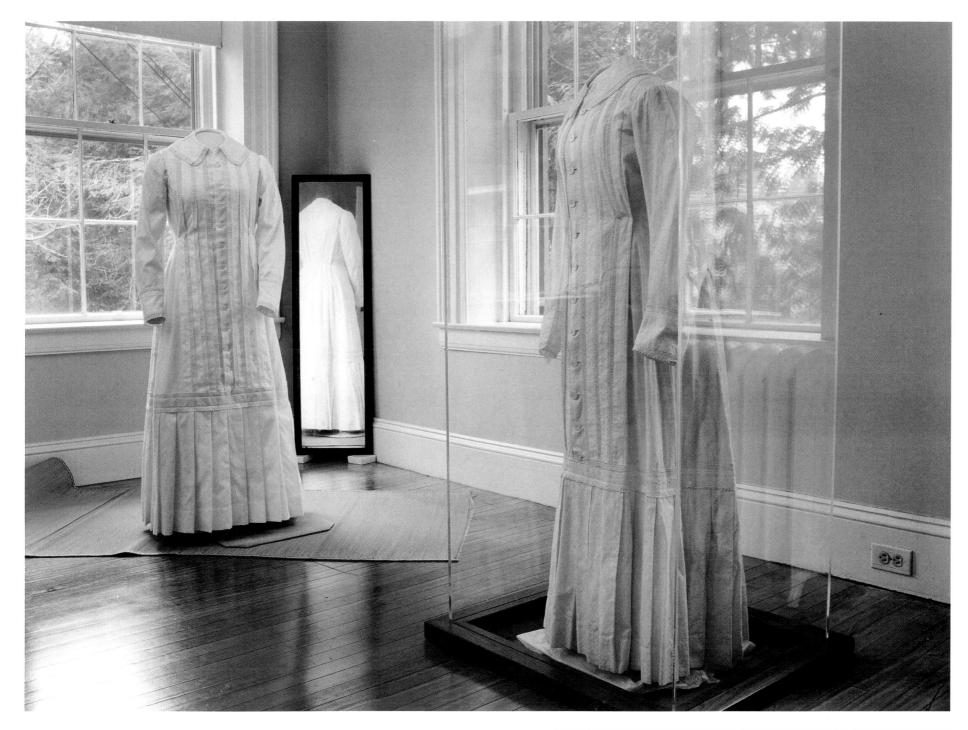

The significance of Emily Dickinson's preference for white garments, a habit of her later years, must be surmised. Her single extant white dress (in case) has been copied for museum display (on model).

These – saw Visions –
Latch them softly –
These – held Dimples –
Smooth them slow –
This – addressed departing accents –
Quick – Sweet Mouth – to miss thee so –

This – we stroked –
Unnumbered – Satin –
These – we held among our own –
Fingers of the Slim Aurora –
Not so arrogant – this Noon –

These – adjust – that ran to meet Us –
Pearl – for stocking – Pearl for Shoe –
Paradise – the only Palace
Fit for Her reception – now –

Poems, P. 769

event Edward attended before he died. By that time his state of mind may have been very close to what his father's had been forty years earlier.

Austin assumed an enormous burden in paying off his father's debts and beginning to manage both properties without letting any stigma fall on Edward's reputation. Perhaps he never told those who now depended on him how precarious their situation was. Was it to save Austin or to save her marriage or to bring a spot of joy to this traumatized family that Sue now bore another child, at age forty-four? A beautiful healthy boy, Thomas Gilbert Dickinson, named for Sue's father but always called Gib, was born in August 1875 and became the darling of both households. Six weeks before his arrival, however, on the first anniversary of Edward's death, Emily Norcross Dickinson suffered a stroke that changed life in the Homestead drastically. With the aid of the strong-armed Margaret Maher (Maggie), who had worked for the family since 1869, Vinnie and Emily assumed the care of their invalid mother for the next seven years.

Following the family patriarch's death, all three of his children indulged in affairs of the heart. Vinnie saw more openly her long-standing admirer, banker Melvin Copeland from Northampton, who had courted her out of Edward's view for over a dozen years. Sometime before or during 1878, Emily fell in love with widower Judge Otis Phillips Lord of Salem, her father's contemporary and friend. Evidence of their relationship survives in a group of love letters drafted by Emily and found after her death. There is no denying her feelings for a man whom Sue disparagingly described as "stiff" and "the embodiment of the law."[50] For Emily he was "My lovely Salem," possessor of a sense of humor as outrageous as her own. Into the early 1880s, Judge Lord visited Amherst regularly to court Emily, always hoping she would become his second wife; but by the time her responsibilities to her mother ended, Judge Lord was far too ill to remarry.

These were sedate relationships compared to Austin's love for Mabel Loomis Todd, which lasted fourteen years, made mockery of his marriage, created a virtual war between the two Dickinson households, enabled but also

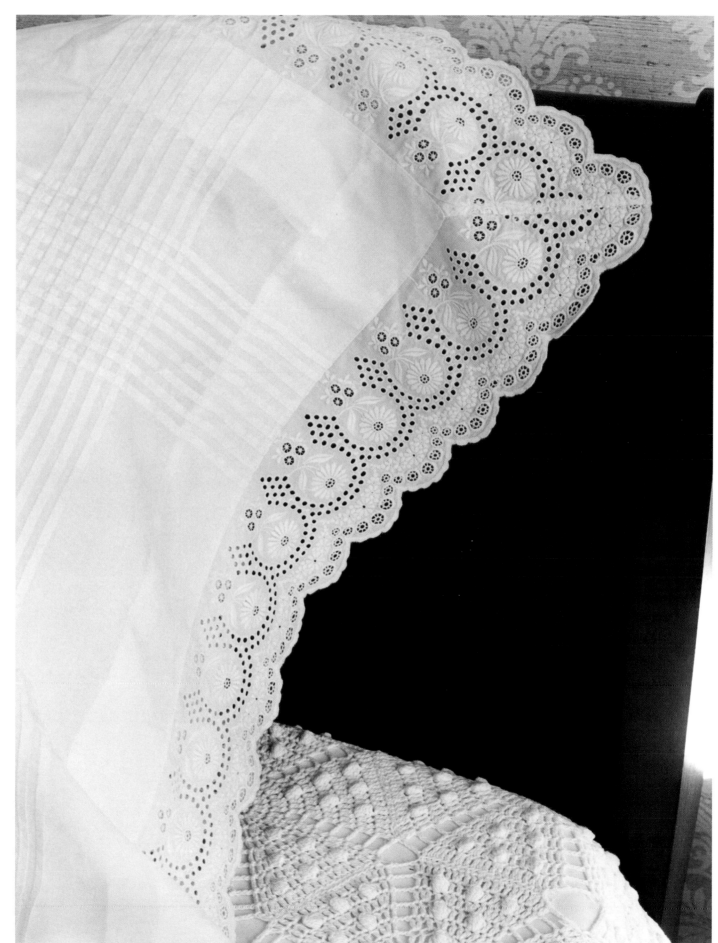

"Dont you know you are happiest while I withhold and not confer – dont you know that 'No' is the wildest word we consign to Language?

"You do, for you know all things – [words missing] to lie so near your longing – to touch it as I passed, for I am but a restive sleeper and often should journey from your Arms through the happy night, but you will lift me back, wont you, for only there I ask to be – I say, if I felt the longing nearer – than in our dear past, perhaps I could not resist to bless it, but must, because it would be right

"The 'Stile' is God's – My Sweet One – for your great sake – not mine – I will not let you cross – but it is all your's, and when it is right I will lift the Bars, and lay you in the Moss – You showed me the word.

"I hope it has no different guise when my fingers make it. It is Anguish I long conceal from you to let you leave me, hungry, but you ask the divine Crust and that would doom the Bread."

—*Letters*, L. 562, Emily Dickinson
to Judge Lord, ca. 1878

David. 18 XI/28 78. *Mabel.*

Prenuptial portrait of Mabel
Loomis and David Peck Todd,
1878.

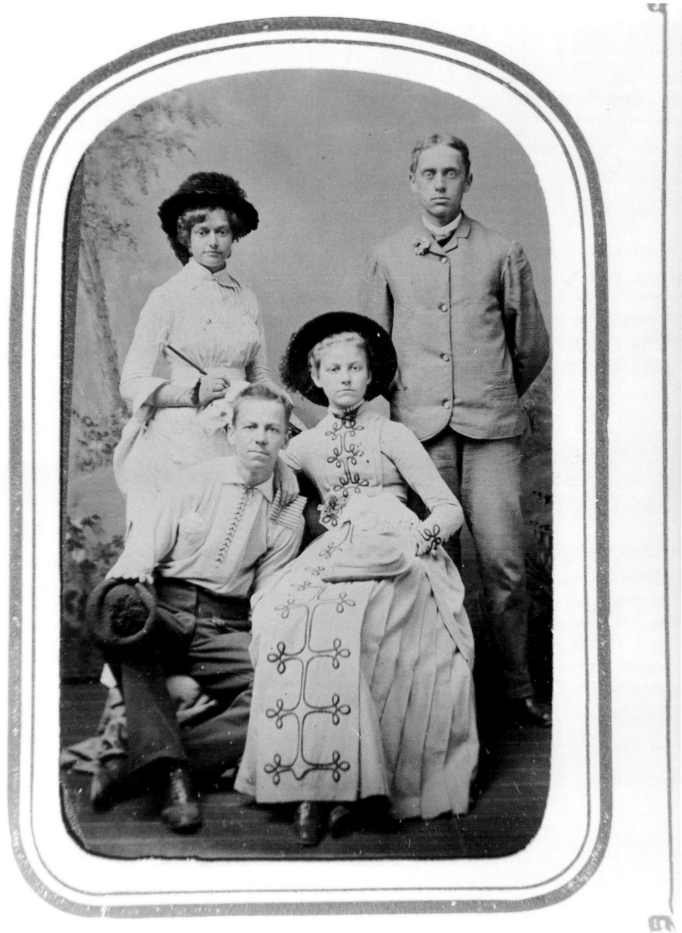

At first, Mabel Loomis Todd (back left) was friends with all the Dickinsons; here with Mattie, Ned (front row), and a friend, Brad Hitchcock, after an outing together.

In later years, Emily Dickinson loved to hear others play the Homestead piano she no longer touched, while she listened, unseen, at the top of the hall stairs. Her childhood piano with its short keyboard, pictured here, is now at Harvard University.

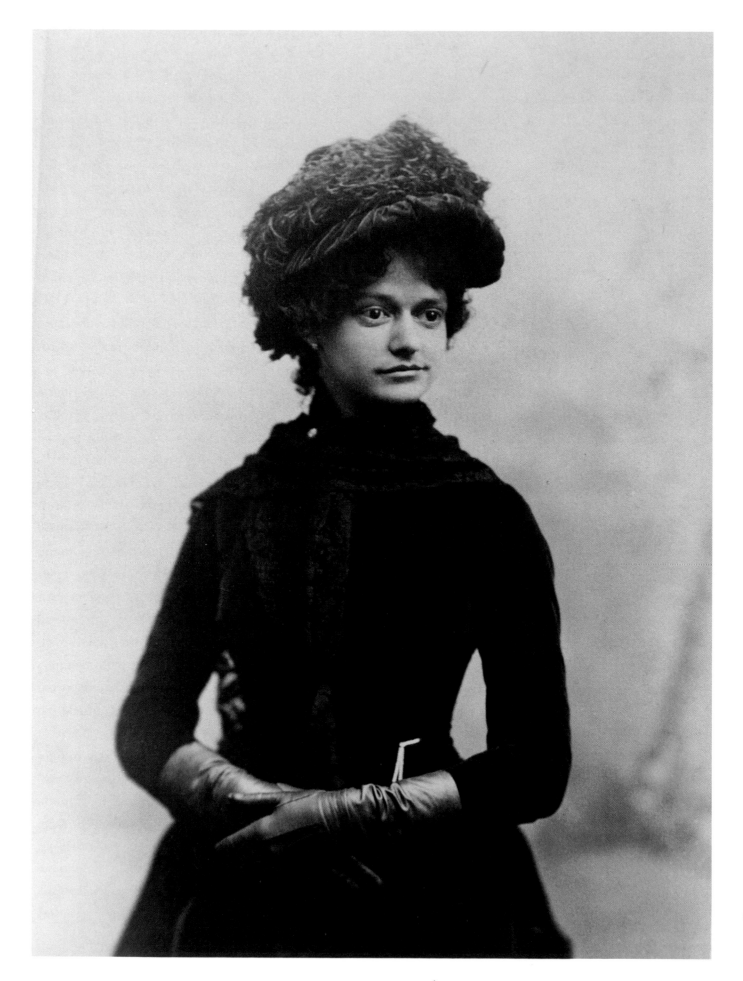

Mabel Loomis Todd.

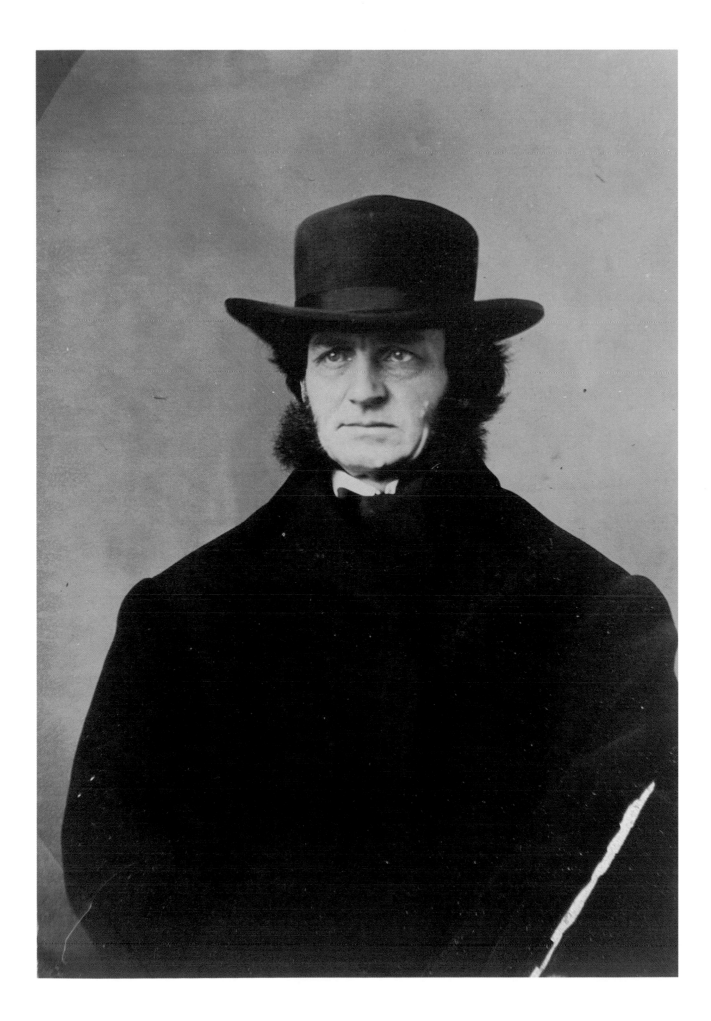

Austin Dickinson.

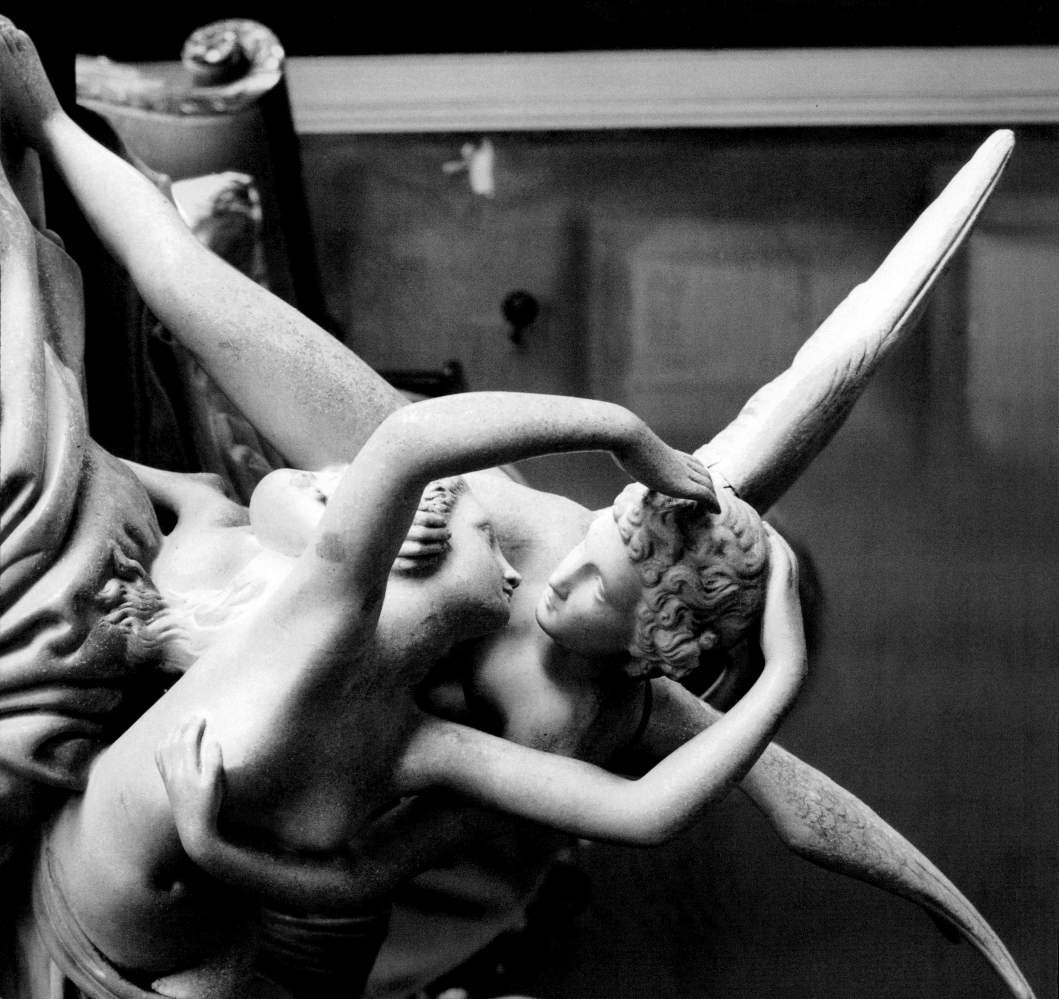

Canova's *Cupid and Psyche* has graced the parlor mantel of the Evergreens since Sue and
Austin married in 1856. It has become a symbol of the love affair of Austin and Mabel.

said he with inscrutable roguery –"[55] Wadsworth had solaced her large, disquieting questions; with him she had anticipated some form of union in heaven, nor did she cease to do so now.

In quick succession came other deaths. Elderly Mrs. Dickinson, who had been bed-ridden for so long, surprised her family by a quiet leave-taking in November 1882, just two months after Mabel Todd's concert in the Homestead parlor. "The dear Mother that could not walk, has *flown*," wrote Emily to Mrs. Holland in astonishment, equally amazed to discover how much her mother, whom she had often discounted over the years, had come to mean. "We were never intimate Mother and Children while she was our Mother –" Emily told her friend, "but Mines in the same Ground meet by tunneling and when she became our Child, the Affection came –"[56] While Emily and Vinnie adjusted lives that had long catered to the invalid's needs, they kept an eye on the Evergreens, well aware by now of their brother's unusual interest in Mrs. Todd and also aware that Susan had noticed it.

With her husband away for three months observing the 1882 transit of Venus, the vibrant Mabel, who thrived on social whirl, was in and out of the Evergreens like a star boarder until Ned, head over heels in love with her, complained to his mother that Mrs. Todd's early affection for him had attached itself instead to his father. Storm clouds began to gather, as Mabel and Sue had one or two frank talks, Mabel professing her sincere admiration for both Dickinsons but saying nothing about the passionate love notes she and Austin secretly exchanged inside books and newspapers when they "accidentally" met on the street. Sue was neither fooled nor unskilled at showing her displeasure in dozens of small ways. In February 1883, Mabel and Austin began trysting at the Homestead, meeting in the dining room, where a fireplace and the horsehair sofa, brought in from the hall to make of the room a winter parlor, allowed comfortable privacy. Lavinia and Emily, who had their own romances and their own quarrels with Sue, quietly accommodated their brother's newfound happiness. But Sue continued to make Mabel's life in Amherst so uncomfortable that in March she went home to Washington for six months until Mrs. Dickinson's temper could cool.

The children provided the brightest tie between the Evergreens and the Homestead in this period, their doings taking them between the houses several times a day. Ned, a junior at the college, on a partial course, kept his riding horse in the Homestead barn, saddling it up as often as health and the weather permitted. He and Emily were great comrades, for she enjoyed Ned's love of books and his gentle ironic wit. Mattie, at seventeen, was musical, had a talent for languages, and aspired to write poems and stories. She verged on prettiness and amused her aunts with her social tribulations. Little Gib, meanwhile, was eight the summer of 1883, a precocious child who attracted much attention with his wise ways and imaginative remarks. Everyone in the family doted on the youngster, even after his long locks were shorn at age six at his own request, so he could "become a man."

Emily wrote to Sue:

> "Were'nt you chasing Pussy," said Vinnie to Gilbert?
>
> "No – she was chasing herself –"
>
> "But was'nt she running pretty fast"? "Well, some slow and some fast" said the beguiling Villain – Pussy's Nemesis quailed –
>
> Talk of "hoary Reprobates"!
>
> Your Urchin is more antique in wiles than the Egyptian Sphinx –[57]

When Gib took sick at the end of September 1883, the family was not immediately alarmed, but the next day, September 29, the day that Mabel Todd returned to Amherst, he worsened, and Sue and Austin were up with him all night. The doctor diagnosed typhoid fever, and Gib was moved to Sue and Austin's downstairs bedchamber, ever afterward called the Dying Room. As hopes rose and fell over several days, the child suffered fevers and delirium while his frantic family, several doctors, and a nurse did all they could to save him. On his last night, at 3 A.M., Maggie Maher escorted a

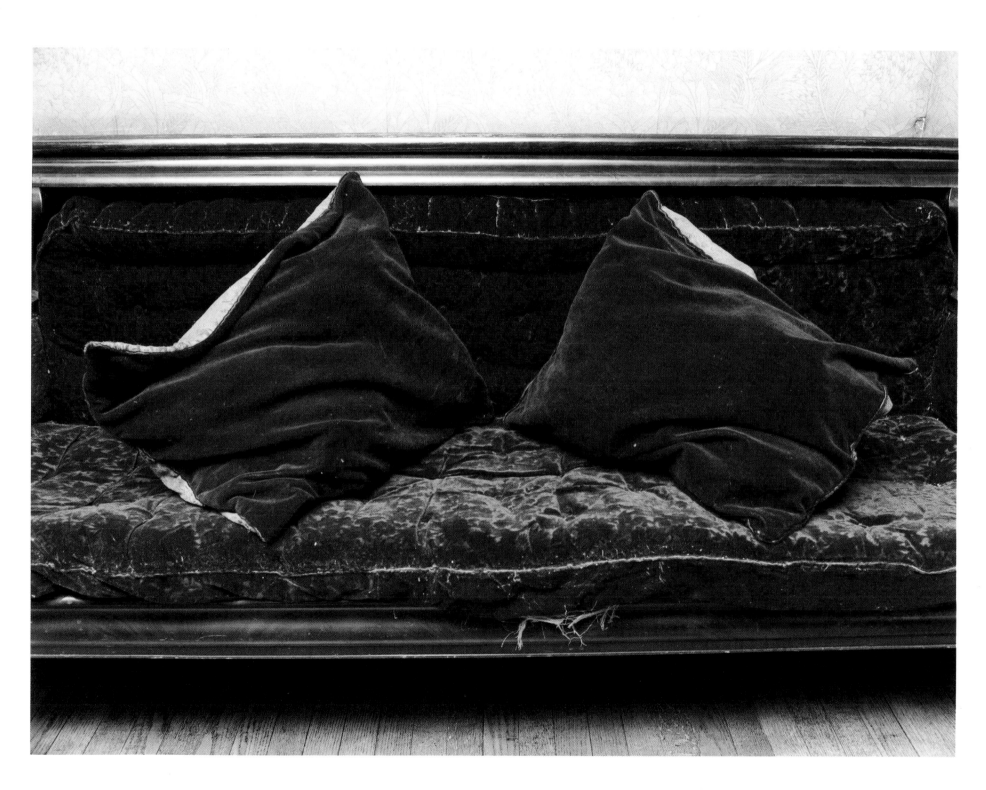

The Homestead hall sofa, covered in black horsehair in Mabel and Austin's time,
was later moved to the Evergreens and re-covered by Sue in red damask.

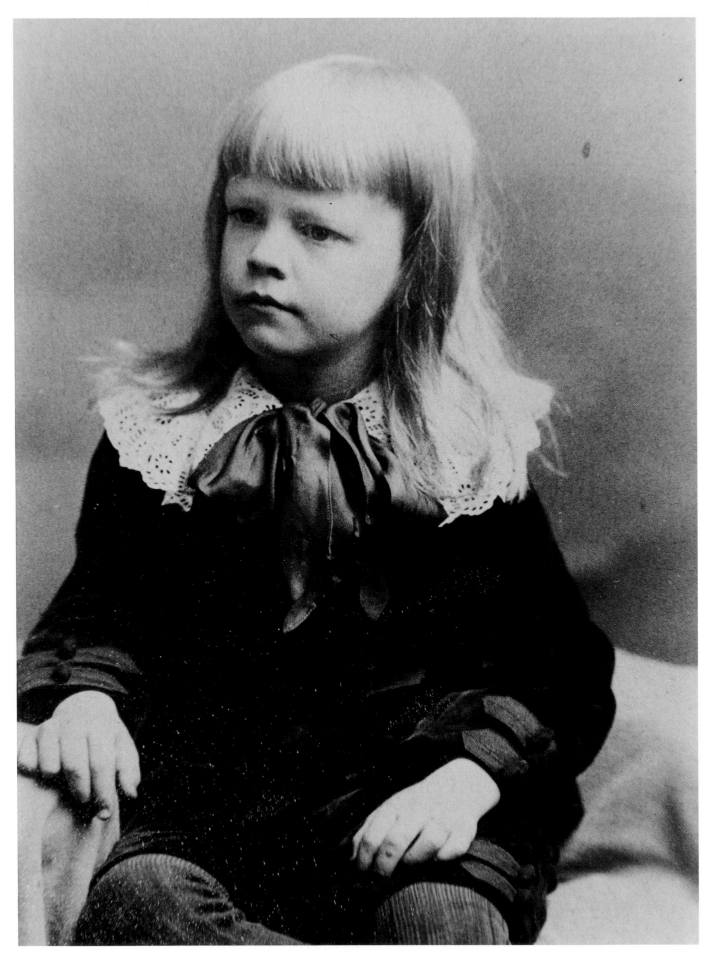

Gib Dickinson at six, shortly before his hair was cut.

Lock of Gib's hair at the Evergreens.

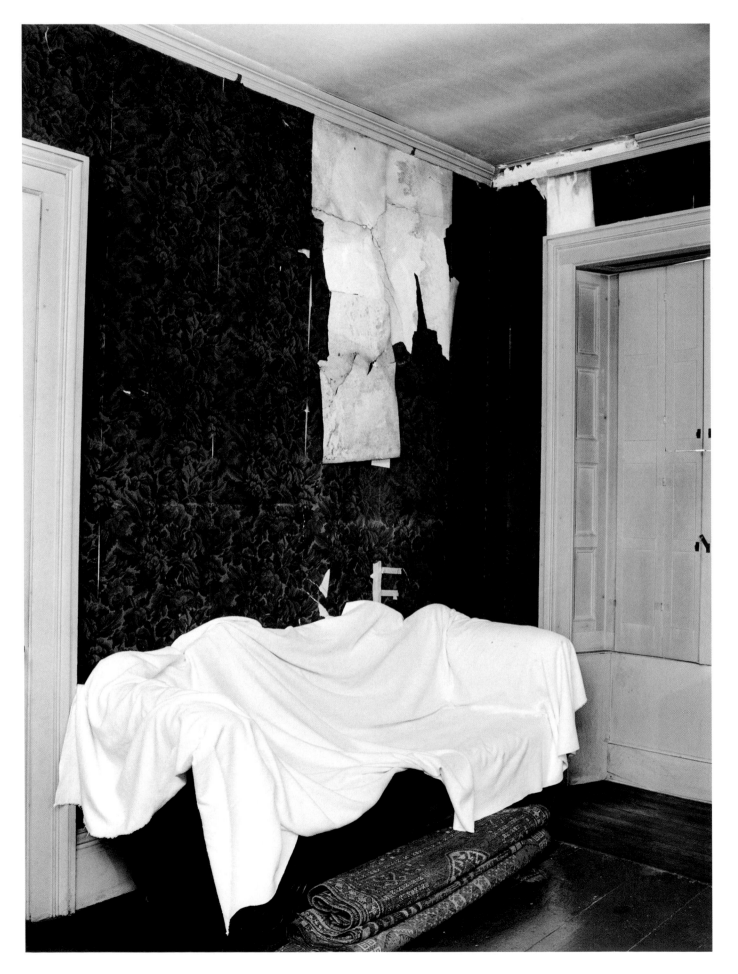

The Dying Room,
originally Susan and
Austin's bedroom.

Snow and leaf, Homestead garden.

Essential Oils – are wrung –
The Attar from the Rose
Be not expressed by Suns – alone –
It is the gift of Screws –

The General Rose – decay –
But this – in Lady's Drawer
Make Summer – When the Lady lie
In Ceaseless Rosemary –

Poems, P. 772

disraught Emily to the Evergreens for the first time in fifteen years; but her grief, the child's ravings, and the smell of disinfectants so sickened her that she returned home and collapsed, seriously ill herself. Gib died the following afternoon, October 5, and his funeral on the ninth was so unbearable that Sue could not accompany the casket to the cemetery. Nor could she, for long months, enter Gib's nursery chamber. The door was simply closed and remains so today; through its interior window one sees the room as Gib abandoned it.

"He was only eight years old, and yet we are astonished to find how many Gilbert interested," began an account titled "Death of a Promising Boy" in the following week's *Amherst Record*. For weeks a pall hung over both Dickinson houses, Emily continuing ill with what her physician called nervous prostration (although she sent several shards of poetry across the path to Sue), and Vinnie valiantly trying to raise the spirits of all around her, at expense to herself. At the Evergreens, the brokenhearted Sue, Ned, and Mattie were wrapt in desolation, while Austin's grief was too "terrible even to think of," Mrs. Todd told her parents. Toward the end of November, however, Mabel and Austin resumed their walks and drives together, David Todd encouraging his wife to help their friend in any way she could. When the consummation of the affair occurred in the Homestead the evening of December 13, 1883, it was with David's concurrence. "[Austin] has expressly told me over and over again that I kept him alive through the dreadful period of Gilbert's sickness and death," Mabel wrote in her journal three months later. "He could not bear the atmosphere of his own house, & used to go to his sisters', & then he or Lavinia would send for me— & it was on those oases from the prevailing gloom in his life that he caught breath & gathered strength to go on."[58]

There was no doubting the power of Austin's love, as he expressed it in letter after letter, all the passion of long pent up romanticism flowing now to this lovely young woman whose husband, the man of science, was willing to share her. (David's proclivity for attractive women, heretofore a burden to Mabel, found ways to right the balance.) For her part, Mabel believed, based on what Austin told her, that Sue had

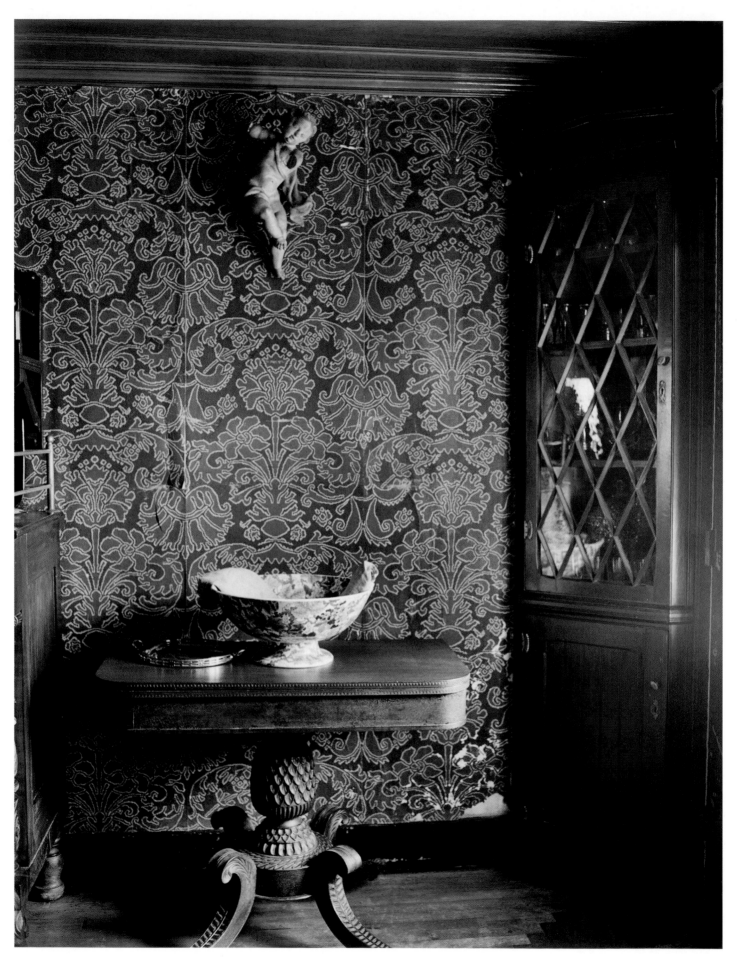

The dining room at the
Evergreens.

long caused her husband pain and disappointment, thus deserved to forfeit him. He "had a wretched life at home, in spite of the perfect house & grounds, the carriages & horses, pictures & luxuries generally," she told her journal at one point, and at another, "His life has been in all *home* things a terrible failure, and a sweet home has always been his greatest desire."[59] For the full year that Sue observed deep mourning, immuring herself within the Evergreens, Mabel enjoyed an active sex life with Sue's husband and her own. The relationship was kept deeply discreet, but the pair met often at Mabel's painting studio in David's college office, or at the Homestead, and they took long carriage rides into the countryside. The next year, when the Todds moved into a rented home, it too became a place of rendezvous, with David's acquiescence, and often with his presence.

By 1885 life within the Evergreens amounted to a heavily armed truce. Sue maintained a confrontational martyrdom, insisting that Austin keep up the outward semblance of their marriage, at the same time inhabiting an upstairs bedroom while he remained downstairs. As she began to move abroad once more, she slighted Mrs. Todd at every public opportunity. Her health suffered significantly from the strain she was under, so she was often in bed for short periods, dosing under the doctor's care with arsenic and other remedies. Her energies grew excessively focused on Ned and Mattie's activities, the latter being away at Miss Porter's School in Farmington, Connecticut, in 1884–85, where she received daily letters from a mother who offered minute advice on every experience. Ned, done with his college studies, remained at home, unable to seek employment with Sue so dependent upon him as escort and stay against loneliness.

As illustration of the dramatic tensions governing the family, in late January 1885, Sue decided to redecorate the Evergreens. Its original paints and papers, selected when she was a bride, were nearly three decades old, and Sue yearned for the dark-hued Eastlake tones that had become so popular. She planned to start with the central hallway, which stretched upward to the second floor, desiring a deep red

paper to replace the tired-looking blue with its floral pattern. "Father," however, in Ned's words, "positively forbid anything being done . . . Whereupon mother began to pull off the paper," and an expensive, disruptive operation began to transform all the formal rooms in the house.[60]

Emily's health, meanwhile, had been up and down since the attack that incapacitated her at Gilbert's death. In March 1884 her beloved Judge Lord died, his "steadfast Heart" stilled at age seventy-two, a cause for further grief. In June and again in October the fifty-three-year-old poet suffered alarming spells of unconsciousness, from which she slowly recovered each time. Dr. Bigelow determined that she had Bright's disease, a label then in use for a cluster of symptoms, some of which Dickinson appeared to have. Since she wouldn't allow the doctor to examine her, even take her pulse, much of his diagnosis was guesswork, arrived at by watching his patient walk past an open door. One of the symptoms included in the Bright's disease spectrum, severe hypertension, today is recognized as a primary illness, and it is this ailment that modern analysis, based on the documentary record, suggests the poet probably suffered from.[61] Emily's blackouts, vomiting, and the severe pain at the back of her head, mentioned periodically from the time of her mother's funeral in 1882, were exacerbated by the loss of one friend after another. The death of her childhood friend Helen Hunt Jackson, with whom she had enjoyed a lively correspondence, even entertaining some hope that the popular author might become her literary executor, surprised her in the summer of 1885, adding one more blow to the many befalling her.

Confined to bed between November 1885 and March 1886, and tended lovingly by Lavinia and Maggie, Emily at last lapsed into a coma on May 13 and died two days later, without awakening. Her funeral on May 19 was, by several accounts, both beautiful and unusual. On a warm, sunny spring afternoon, Emily's closed coffin, covered with violets and ground pine, lay in the Homestead's library. The Reverend Jonathan Jenkins, First Church's former minister, had come from Pittsfield to lead the simple service, and Thomas

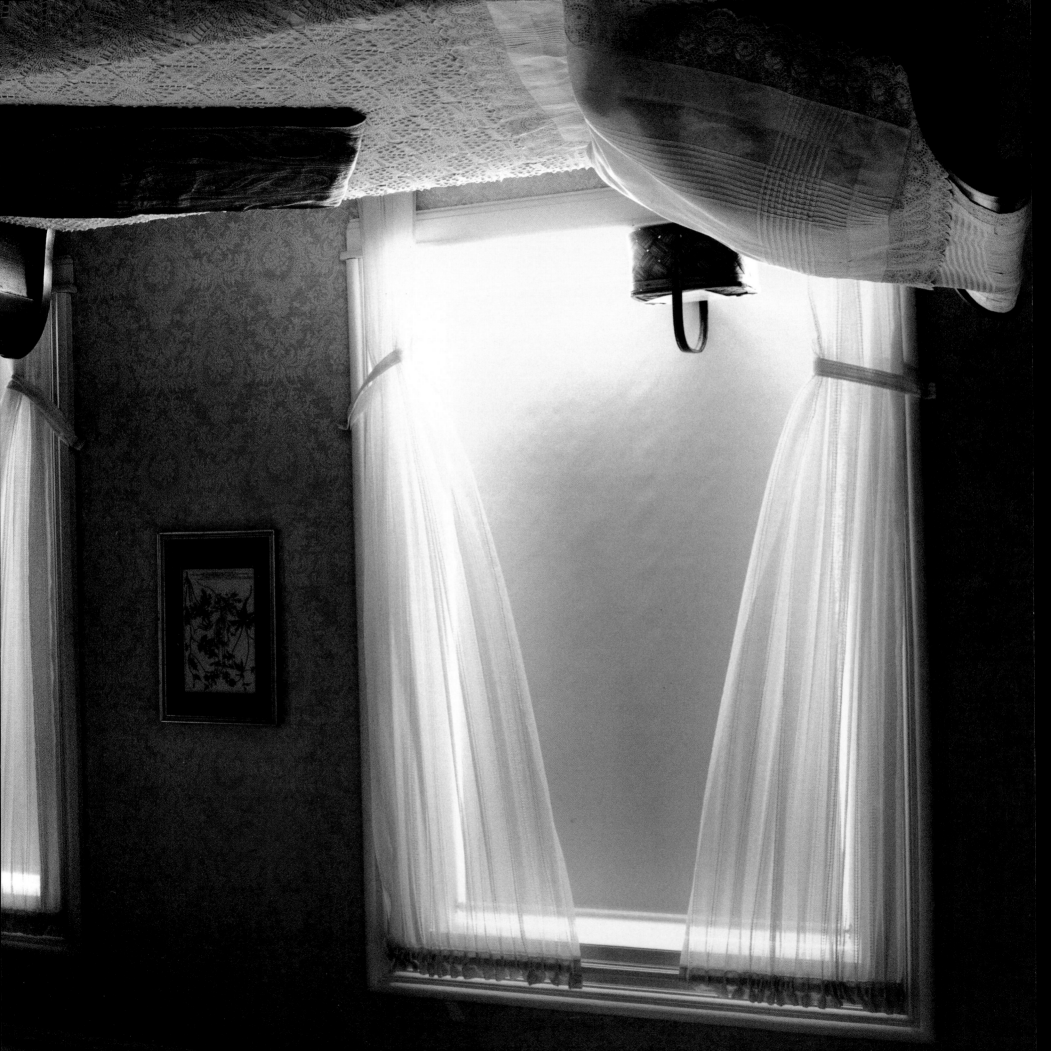

Emily Dickinson's bedroom.

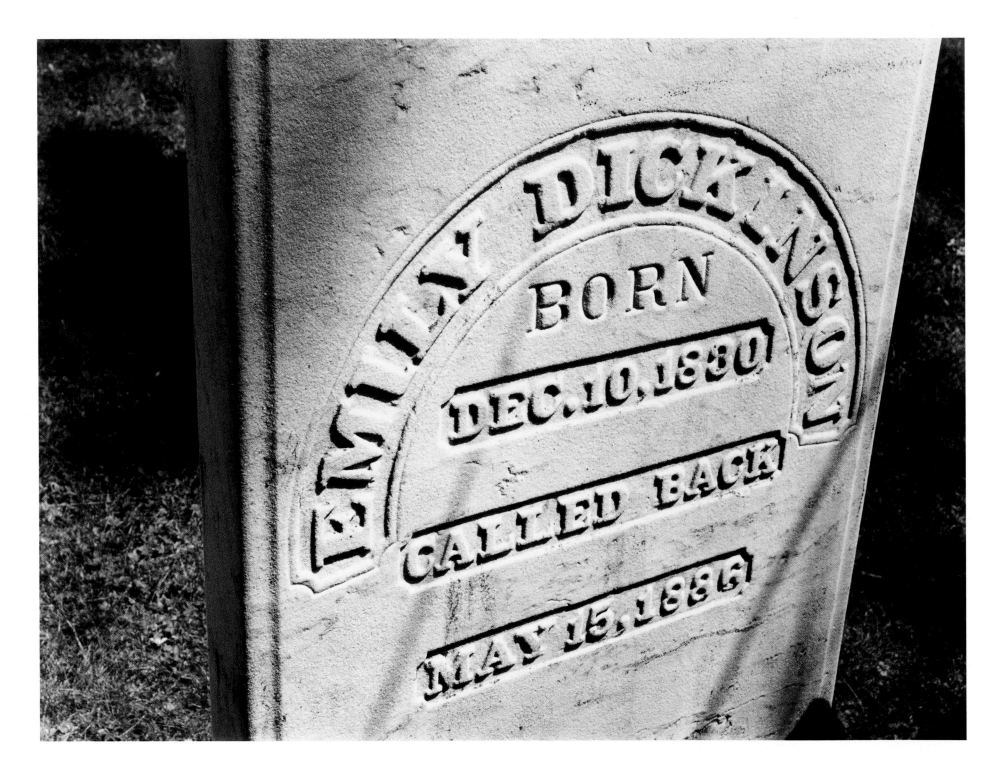

The poet's original gravestone, a small granite marker bearing only her initials, was replaced by Martha Dickinson Bianchi early in the twentieth century. "Called Back," Emily's last written message to beloved cousins, was the title of a popular book.

Wentworth Higginson came from Boston to read the poet's favorite poem, "Immortality" by Emily Brontë. Adhering to Dickinson's request, her coffin was taken out the Homestead's back door and borne by six Irish laborers, who had worked on the Dickinson premises, in a circle around the garden, through the barn from front door to back, then in procession across lots and over footpaths north to the cemetery. Mourners streamed behind, treading the new grass and buttercups.

Although Sue arranged the flowers for the the coffin and the grave, neither she nor Mattie attended the funeral because Mr. and Mrs. Todd were present. A day earlier, however, Sue's sensitive obituary tribute had appeared in the *Springfield Republican*, delineating the poet's life and nature and encapsulating her unique qualities: "Keen and eclectic in her literary tastes, she sifted libraries to Shakespeare and Browning; quick as the electric spark in her intuitions and analyses, she seized the kernel instantly, almost impatient of the fewest words, by which she must make her revelation."[62]

Emily had instructed Vinnie to burn all letters she had received over the years, a task Vinnie set about immediately, then later bitterly regretted. To her surprise, she came upon a bureau drawer full of hundreds of loose manuscript poems in her sister's hand. She consulted Maggie (for Emily apparently had left no instructions about poems), and the Irishwoman produced from the trunk in her room forty little booklets containing hundreds more that the poet had given her for safekeeping. What should Vinnie do? Her first impulse was to take them to Sue and beg her to publish them immediately. Sue, with some 250 poems of her own, began to read, copy, and loosely categorize them, but the enormity of the task grew apparent. Copying was essential, for Dickinson's hand was very difficult to read; also, many poems appeared unfinished, with variant words and even variant copies of the same poem. Sue knew that Higginson had advised Vinnie not to publish the poems, and her own attempt to send one or two to magazines met with rejection. What troubled Sue most, however, was Emily's lifelong proscription against exposing her thoughts to the world.

Vinnie grew annoyed when Sue began to read poems to callers at the Evergreens. Upset at her sister-in-law's apparent inaction, Vinnie retrieved her property in February 1887 and surreptitiously took the poems to Mabel Todd, who had had some success writing for magazines. Mabel acquiesced to Vinnie's entreaties out of respect for Emily and friendship for Vinnie. Love for Austin had little to do with it, since Emily's brother was unenthusiastic about publishing her verse. Before Mrs. Todd could begin, she and David were caught up in planning an expedition to Japan to photograph the solar eclipse of August 1887. The voyage that took place between June and October was unsuccessful in its mission (clouds obscured the eclipse) but resulted in remarkable photographs from the top of Mount Fuji, which Mabel had the signal honor of being the first Western woman to ascend.

The Todds now lived in a Queen Anne house they built on land that Austin gave them along the south edge of the Dickinson meadow. With many new expenses, Mabel sang, gave piano and art lessons, wrote about her travels for popular magazines, and reviewed books for *The Nation*, all to supplement David's salary. She began giving parlor talks about her experiences, a venue for which she had true genius. Through the next two years she worked steadily at transposing into her own legible handwriting hundreds of Dickinson's poems, finding solace in their beauty for her own unhappiness at not being Austin's wife, the circumstance both dreamed of. Their best times together came during Augusts, when Sue, Ned, and Martha vacationed in Maine, leaving Mabel and Austin to enjoy leisurely carriage rides far into the countryside. On more than one occasion Mabel spent the night at the Evergreens, but their regular trysting site was the Dell, as the Todds' Queen Anne cottage was called.

During the winter and spring of 1888–89, while David was absent on an eclipse expedition to Angola, Mabel organized Dickinson's best poems and persuaded Mr. Higginson to select candidates for a volume that Roberts Brothers of Boston subsequently agreed to publish. The chaste little white boxed volume with gold and silver stamping appeared

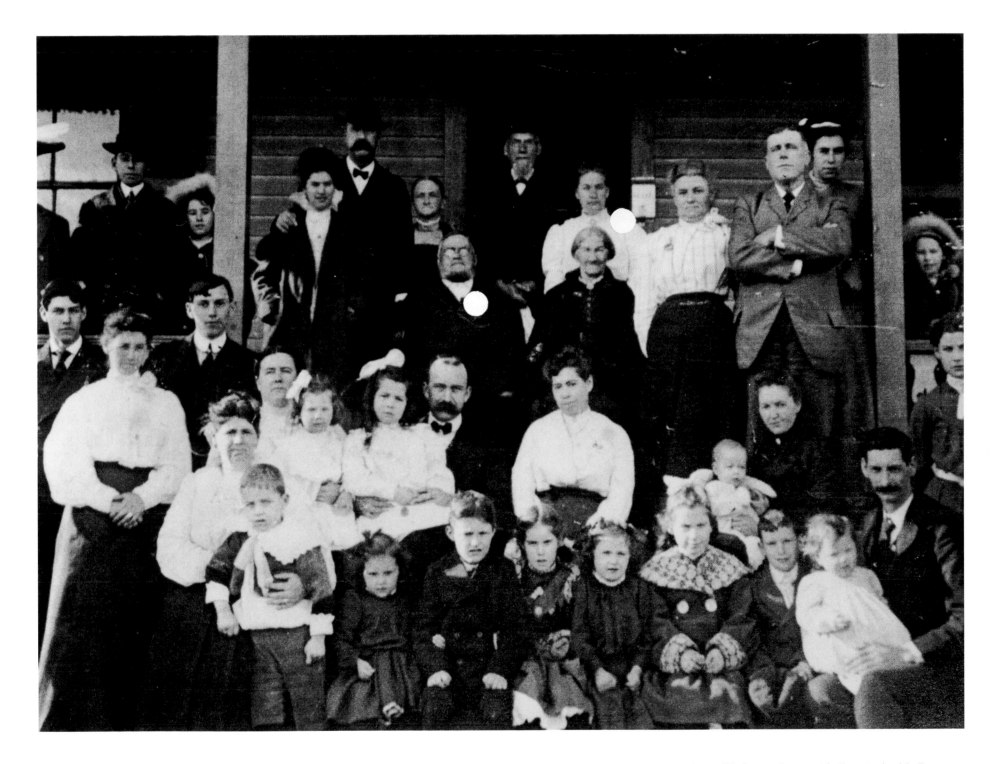

Amherst's Kelley family was the source of several hired men and women at the Homestead and the Evergreens. One-armed Tom Kelley (white dot), chief pallbearer at Emily Dickinson's funeral, is at the center back, and Margaret (Maggie) Maher (yellow dot), who worked at the Homestead for thirty years, is in the back row.

Mabel Loomis Todd
and Austin Dickinson,
ca. 1890.

With my heart all yours, dearie, immovably. Willingly. Gladly yours. With my head in

13 Sept. 1885

My Mabel.

of the future. Why should you care for me to lay one word about what is behind. At any rate so far as it may involve any other unpleasantly — Why do you care I have me put on paper

Letter from Austin
Dickinson to Mabel
Todd, transcription by
Millicent Todd
Bingham.

With my heart all yours, dearie, irrevocably, willingly, gladly yours.
With my soul in your keeping, holding my happiness in your hands, with
only you and my boy to redeem my existence from utter failure, having
learned through you what life means, and may be, sure of the present,
trustful of the future, why should you care for me to say one word
about what is behind, at any rate so far as it may involve any other
unpleasantly - why do you care to have me put on paper what, involun-
tarily, I have from time to time in varying moods, dropped from my lips!
You know it all, believe it all, and it is all True. Let the tragedy
of a wrecked, almost ruined life go. Let it suffice that I saw you and
lived. My earlier experience is the experience of thousands. My later
of how few!

Is it not enough, my darling, in the line (lieu?) of what you have
wished of me - this that I have called freshly to your mind! It is so
much better to suffer any amount of wrong, than to take the chances of
doing the slightest injustice. Believe me - Believe me. Always your
own Austin, as you are my own Mabel.

Sept 13, 1885.

The bottom drawer of the poet's bureau, now at Harvard University, once held hundreds of her poems.

Mabel Todd's picture of Indian pipe, painted for Emily Dickinson, later adorned the covers of the earliest editions of Dickinson's poems and letters. The poet called it her "preferred flower of life." The image recurs on Mabel's tombstone in Wildwood Cemetery, Amherst.

IN MEMORY OF

WILLIAM AUSTIN DICKINSON

APRIL 1829

SELF FORGETTING IN SERVICE FOR HIS TOWN AND COLLEGE
RESOLUTE IN HIS CONVICTIONS — AT ONE WITH NATURE
HE BELIEVED IN GOD AND HOPED FOR IMMORTALITY

AUGUST 1895

A commemorative boulder, found by Sue, stands next to Austin's grave in
Wildwood Cemetery. The message was supplied by his fellow townsmen.

Twentieth-century view of two of Austin's landscapes: Amherst College campus (foreground) and town common beyond.

on November 12, 1890, to mixed critical response, but individual readers so embraced the poems that the first edition sold out quickly. By March 1891 the book was in its sixth printing, and Mabel and Mr. Higginson were choosing poems for a second volume. Austin seemed mildly surprised by the acclaim, but Susan was furious and ceased speaking to Vinnie. After *Poems by Emily Dickinson, Second Series* appeared on November 9, 1891, Mrs. Todd turned to rounding up and editing Dickinson's letters. Their preparation took three years, even with Austin's help, for Mabel continued to write and to lecture before increasingly large audiences. Her most popular talk now focused on the poet, as the public clamored for information about the mysterious, brilliant woman dubbed by some the "New England Nun." No photograph of Dickinson could be found except an 1847 schoolgirl daguerreotype that Emily had hated, so Mrs. Todd used Emily's vignette from the oil portrait painted in childhood as the frontispiece for *The Letters of Emily Dickinson*, which appeared in November 1894.

The letters were less popular than the poems, but as Mabel began organizing a third volume of poems, her world fell in, for Austin's heart had begun to fail. He was ill off and on during 1894, then very ill through the spring and early summer of 1895, and died on August 16 at age sixty-six, "of overwork" said his obituaries. For thirteen years Mabel had prayed daily for the demise of Sue; now she herself nearly died of heartbreak. Her grief and David's ("I loved him more than any man I ever knew" David later said)[63] frightened their fifteen-year-old daughter, Millicent. Stores closed so that all Amherst (except the Todds) could attend the funeral at the Evergreens the afternoon of August 19; but Ned sent Mabel word that the French door in the library, where Austin's coffin lay, would be ajar at noon. While the Dickinsons ate in the dining room, Mabel slipped into the Evergreens to kiss the cheek and hold the hand she had been barred from visiting for many weeks and to hide a token of her love in the coffin.

The Evergreens family, exhausted by Austin's long illness, were left morose after his death. In the next six months,

Sue, Ned, and Mattie were often out of town, traveling or visiting happier places, leaving Vinnie alone with Maggie and a parade of cats in the Homestead. Through Austin's will, the house and great meadow opposite now were hers, but Vinnie's relations with Sue were at a low ebb, and she felt much at her sister-in-law's mercy without Austin's protection. Sue continued to be angry over the editing of the poems, for it had brought Mrs. Todd much acclaim that Sue felt was rightfully hers. Vinnie knew she would be even angrier when the third volume Mabel was working on was published.

Lavinia was further troubled by a promise made to Austin in November 1887, the day he wrote his will. If Vinnie outlived him, Austin had said, she was to deed the meadow Austin left her over to Mrs. Todd. Mabel knew about the plan, he told her, and would expect it. But Vinnie was far too frightened of Sue's wrath to carry out such an order. Furthermore, she was annoyed at Mabel for parading around town in mourning garb (Susan was galvanized) and for attracting undue attention to her own role in publishing Emily's poems and letters at the expense of Vinnie's role. By the time Mabel came to see her about Austin's promise, Vinnie had decided not to give Mabel the meadow but to do a partial thing that, with luck, Sue wouldn't notice. Vinnie would sign another deed that Austin had intended to sign before he got sick, which widened the Todd's house lot about eighteen yards. It was a narrow strip of land that filled out their property on the east side to a nearby line of trees and shrubs.

Sue was furious when her lawyer spotted a small legal announcement in a trade periodical the following April; it concerned conveyance of a parcel of the Dickinson meadow from Lavinia to Mabel Todd. The transaction had occurred at the Homestead in the presence of a Northampton lawyer just before the Todds left on another astronomical eclipse expedition to Japan, to be gone seven months. Frightened at alienating not only Sue but her own neighbor and business manager Dwight Hills (Vinnie had promised to consult him on matters relating to Austin's legacy to the Todds), Lavinia denied having signed any deed. She thought she was sign-

ing an agreement not to build on that strip of land, she told Sue. In that case, Sue responded, Vinnie must take the matter to court.

Not much later, Sue learned of the third volume of *Poems*, about to appear on September 1, 1896, and came down on Vinnie anew. From her resort hotel at South West Harbor, Maine, she had Ned type a chilling letter holding Vinnie responsible for further public outrage by "a woman who has brought nothing but a sword into the family."[64] When the Todds returned to Amherst in late October 1896, Mabel still grieving for Austin, they were shocked to find the town abuzz with slander about them. Vinnie's clever, sharp tongue, always enjoyed by callers at the Homestead, now told stories of Mrs. Todd, although the love affair, which would reflect so badly on both Dickinson houses, was not among her topics. Vinnie filed suit for fraud a few weeks later, but bills of complaint by both parties in the lawsuit, a countersuit, and two continuances delayed the case from reaching the state superior court at Northampton until the begining of March 1898. The intervening months gave everyone in town time to choose sides and gossip endlessly over the spicy Dickinson-Todd altercation.

None of the Amherst citizens who packed the Hampshire County Courthouse on March 1 and 2 in anticipation of fascinating local drama was disappointed. Together with the corpulent Maggie, Lavinia Dickinson appeared in her old blue flannel "best dress" with a black veil covering her face. Right behind them in the courtroom sat Ned and Mattie, while Susan, as if to test Emily's adage that "Absence is condensed presence," remained at home.[65] David and Mabel Todd, the defendants, sat with their lawyers some distance away, Mabel looking particularly stylish in a black hat with two white bird wings. Lavinia gallantly stood up to intense questioning through the morning, seeming to enjoy herself as she prevaricated with ease about what she told the court she thought was an unexpected social call by Mrs. Todd and a Northampton lawyer two springs earlier. Mabel took the stand in the afternoon to resolutely tell a different story about the signing of the deed, her lawyer taking time to draw

her out about her lack of compensation for long years of editorial work on Dickinson's poems and letters, trying to make the strip of land seem a form of compensation for her labors. But his effort collapsed when David Todd was asked to testify how much his $1,200 houselot had cost him. "Nothing," said David, ending the show for the day.

The following morning was given over to lawyers' summaries. Although no mention of the long love affair surfaced, both sides knew that Maggie Mahar had contributed a deposition describing incidents she had been privy to that, if used, would defame Mrs. Todd. Austin and Mabel's long, covert relationship hung like a palimpsest behind the whole event, for the suit turned on character: the Dickinsons' irreproachable integrity versus the Todds' worldly ways, with Mrs. Todd portrayed as having taken advantage of an inexperienced Miss Dickinson. The judge's verdict, announced six weeks later, favored Lavinia, and the state supreme court turned down the Todds' request for appeal.

The Todds were flabberghasted that truth and justice had so miscarried; they were humiliated as well. At the end of 1898, Mabel angrily placed into a camphorwood box the hundreds of Dickinson poems still in her possession (about half the canon), together with all the poet's letters she held and many Dickinson family papers and photographs that Austin and Vinnie had brought her to assist her work over the years. She locked the lid, put the box into storage, and didn't open it again for thirty years.

Although they had won the lawsuit, the occupants of the Dickinson Homestead and the Evergreens had little to celebrate. The day after the verdict was announced, in mid-April, Ned suffered a severe attack of angina, and two and a half weeks later he died, assumed by most observers to have been felled by the strains of the public fracas. The terrible strain on Lavinia was hardly less severe, although she lived until the end of August 1899. Her final, largely bedridden year was made exceedingly difficult by bad relations with the family members next door, who blamed her for Ned's death. Perhaps the greatest loss of all, however, was that of Dickinson's poetry, for in the new century it became

THE

ce Rawson's ad. on 3d page about
r ware at cost."

orge Lessey of Boston paid a visit
nds in Amherst one day last week.

business meeting of the Village
l church will be held to-morrow
g.

dime supper will be served in
estry of Baptist church Friday
g.

his week, the same as last, Raw-
ll sell "silver ware of all kinds at
ices."

he Prohibition club will hold a
g next Monday evening at eight
k in the hall in Kellogg's block.

he bill appropriating $28,000 for
e of the Agricultural college has
favorably reported to the Legis-
by the commi.tee.

large party from Amherst and
Deerfield paid a surprise visit to
d Mrs. Daniel McDonald at their
n North Hadley last Friday even-
d aad a most enjoyable time.

e Amherst college trustees have
l suit against the Amherst asses-
o recover the sum of $116.25 for
ent of taxes which the trustees
was assessed on property which
be exempt.

ne "Loud bill," which many have
ed as an assault on the preroga-
f country newspapers, has been
ed by Congress. Now will some
ent member of the national legis-
kindly draw up a bill that will
l the publishers of patent medi-
urnals to pay full rates for trans-
g the same through the mails?
bill would have the support of
espectable newspapers in the

ports continue to come in of the
e condition of the highways lead-
t of town. While sleighs are in
l use the snow is so full of cradle-
hat any attempt at fast time gives
ssenger the same sensation as if
'd a ship in a storm. There's a
dy of snow up back on the hills
hen rain and sunshine and wind
g begin to get in their fine work
will be old-time freshets in the

ws was received in Amherst yes-
of the death at his home in Phil-
a of C. H. Fisk, a former well-
resident of Amherst, where he
ted a restaurant on Main street.
k had lived in Philadelphia some
s but frequently visited Amherst,
visit occurring last summer.
an old-time subscriber to the
and when in town seldom failed
at this office. Mr. Fish's wife
r to Mrs. Horace Ward. The
will be brought to Amherst for

—The South Amherst Choral Society
will give the cantata of "Rebecca" in
the South Amherst church Wednesday
evening March 16th, commencing at
7-30.

PERSONATIONS.

Rebecca, Miss Carrie Thayer
Isaac, F. L. Pomeroy
Abraham, Isaac's father, H. D. Chapman
Eliezur, Abraham's eldest servant, E. B. Merrick
Seber, } Eliezur's com } T. J. Thurston
Obed, } panions on his } W. H. Sanderson
Joel, } journey, } Richard Pomeroy
Laban, Rebecca's brother, W. H. Smith
Bethuel, Rebecca's brother, Geo. O. Hannum
Acesa, Eliezur's wife, Miss Grace Sherman
Edna, Seba's affianced, Mrs. W. H. Sanderson
Chorus of 35 singers.
Pianist, Mrs. W. F. Joy
Director, F. L. Pomerey

The Dickinson-Todd Case.

A considerable number of Amherst
people attended the sessions of superior
court held in Northampton last week,
listening to the testimony and arguments
in the case in equity brought by Miss
Lavinia N. Dickinson against Mrs.
Mabel Loomis Todd. Sensation-loving
papers printed in this vicinity have
made much of this case, partly on
account of the prominence of the parties
involved and partly because it is a part
of their business to exploit anything
that may by any possibility aid them in
selling a few extra copies of their publi-
cations. The facts in the case are,
briefly, as follows: Soon after the death
of the late William A. Dickinson his
sister, Miss Lavinia Dickinson, gave to
Mrs. Todd a deed of a parcel of land
adjoining the Todd residence on the
east. This deed was signed by Miss
Dickinson in the presence of Mrs. Todd
and Lawyer Timothy G. Spalding of
Northampton. Its validity as a legal
document was not called in question,
but Miss Dickinson brought suit on the
ground that she had no knowledge of
its contents and supposed that in sign-
ing it she was merely signing an
agreement that no building should be
erected on the property in question, in
accordance with a request preferred by
Mrs. Todd. The answer made to the
complaint was that the deed was given
in full knowledge as to the nature of its
contents, and partially in consideration
of work done by Mrs. Todd in prepar-
ing for publication the poems of the
late Emily Dickinson, sister to Miss
Lavinia. The plaintiff was represented
at the trial by Messrs. Hammond & Field
and S. S. Taft, while Mrs. Todd's inter-
ests were cared for by Messrs. Hamlin
& Reilley and J. B. O'Donnell. The
case occupied two days in trial, the
pleas being presented Thursday after-
noon, and the judge has reserved his
decision.

CONCERNING WAR.

There is a possibility, by many con-
sidered an urgent probability, that with-
in the next few days or, at the utmost,
the next few weeks, war may be de-

A CHRISTIAN NATION?

A recent editorial in the Springfield
Republican contains the following re-
markable statement: "One of the speak-
ers before the Louisiana constitutional
convention, whose purpose is to dis-
franchise the negro voters, remarked
yesterday that such a convention in 1879
would have been dispersed by federal
troops if necessary. This was an over-
statement, perhaps, yet it reveals the
great change of sentiment in the North
on this subject which has undoubtedly
taken place." The Republican has no
word of condemnation, no word of crit-
icism even, for the convention "whose
purpose is to disfranchise the negro
voters," but closes its editorial with a
flippant allusion to the "bloody shirt."
Yet, so far as we have heard, the Four-
teenth Amendment to the United States
Constitution has never been repealed
and is yet a part of the law of the land.
A few days after this editorial was
printed the news columns of the Repub-
lican contained a report of the murder
of a negro family in South Carolina and
the burning of their bodies by an armed
mob. The murdered man was accused
of no crime; he was a peaceful, law-
abiding citizen; his offence rested in the
fact that he was a negro and that he
had dared accept an appointment as
post-master for the community in which
he lived. The Republican condemned
this outrage in its editorial columns,
yet the crime was not so grave as that
on which it commented so lightly. It
is folly to deny that the frequent mur-
der of negroes in the South is due in
large measure to the systematic sup-
pression by violence or fraud of the
negro vote in Southern states. De-
prived of the constitutional protection
afforded by the ballot, they suffer out-
rages as flagrant, though of different
kind, than fell to their lot in slavery's
days. With what grace can the United
States condemn the Turkish atrocities
in Armenia, denounce Spanish barbarity
in Cuba, so long as it openly counte-
nances the suppression of the ballot and
the reign of Judge Lynch in the South
It was as a safeguard against outrage:
such as these that the bill providing for
honest elections was introduced in the
national Congress, and the defeat of
that bill deprived the negro voter in
the South of rights that were necessary
not only to his happiness but his self-
preservation. Herein rests an element
of national weakness more threatening
than the lack of armies or navies or
coast defences, more menacing than
foreign complications. There is a prob-
lem involved that is at the very founda-
tion of our system of our government;
that problem has not been settled it
never can be settled until it is settled

Newspaper account of the sensational Dickinson-Todd lawsuit, 1898.

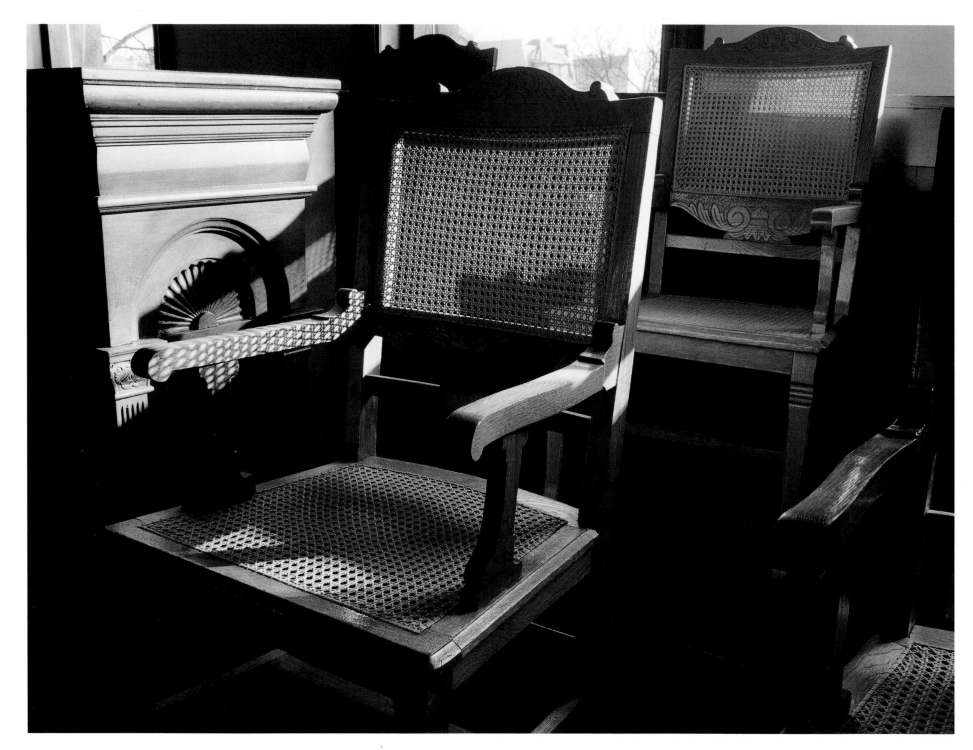

Old courthouse chairs. The case was heard in the 1886 Hampshire County Courthouse, which replaced the earlier
Northampton courthouse where Samuel Fowler Dickinson and Edward Dickinson had plied their trade.

A late picture of Vinnie with one of her beloved cats, perhaps Drummydoodles, on the east porch of the Homestead.

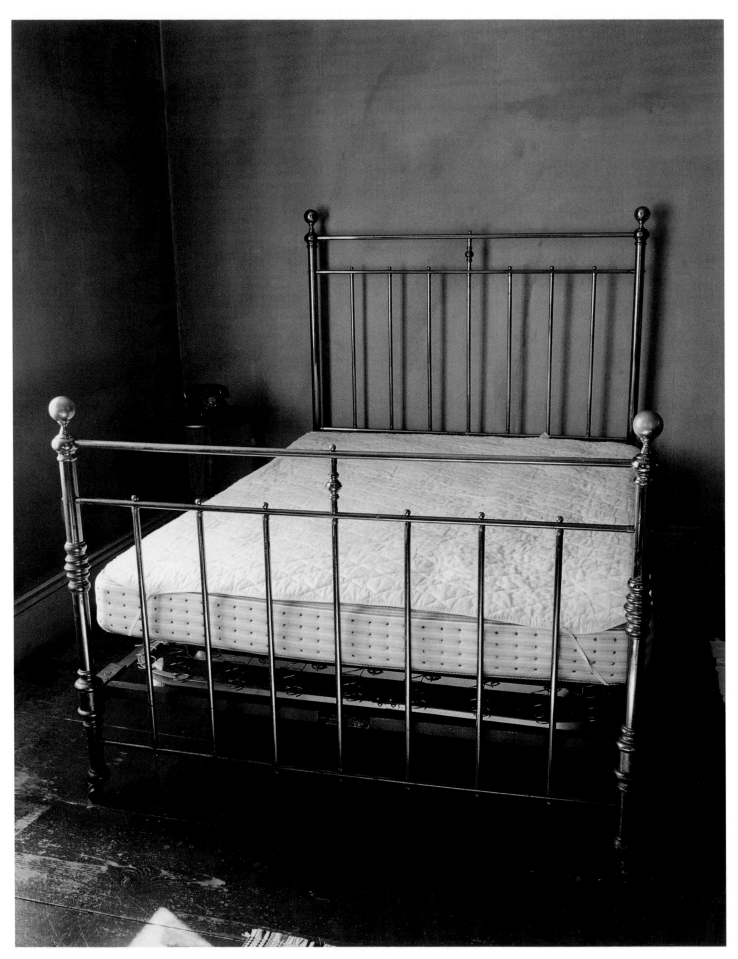

Ned's bedroom in the
Evergreens.

When he died (at thirty-six) in May 1898, Ned Dickinson was an assistant in the Amherst College Library and engaged to be married to Alix Hill.

Martha Dickinson.

the casualty of feuding parties as the Todds and the Dickinsons and their heirs contested the rights of ownership of her work, publishing her remaining poetry and her story piecemeal in dueling anthologies and biographies through the following sixty years. It would be 1955 before the complete poems appeared in a variorum edition under the auspices of Harvard University.

Notes

1. Thomas H. Johnson and Theodora Ward, eds., *The Letters of Emily Dickinson* [hereafter *Letters*] (Cambridge, Mass.: The Belknap Press of Harvard University Press, 1958), L.72 to Austin Dickinson.

2. Thomas Wentworth Higginson to his wife, 17 August 1870, *Letters*, p. 475.

3. *Letters*, L.360 to Louise Norcross.

4. Jay Leyda, *The Years and Hours of Emily Dickinson* (New Haven, Conn.: Yale University Press, 1960), 1:339.

5. *Letters*, L.182 to Elizabeth Holland.

6. Martha Dickinson Bianchi, *The Life and Letters of Emily Dickinson* (Boston: Houghton Mifflin Co., 1924), p. 93.

7. *Letters*, L.261 to T. W. Higginson.

8. See William S. Tyler, *History of Amherst College during Its First Half Century* (Springfield, Mass.: Clark W. Bryan and Co., 1873), and Edward Hitchcock, *Reminiscences of Amherst College* (Northampton, Mass.: Bridgman & Childs, 1863).

9. See Vivian R. Pollak, *A Poet's Parents: The Courtship Letters of Emily Norcross and Edward Dickinson* (Chapel Hill: University of North Carolina Press, 1988).

10. In 1855, Edward Dickinson built two houses for Irish tenants on land he leased from the Amherst and Belchertown Rail Road Company. Registry of Deeds for Hampshire County, Bk. 162, p. 209.

11. *Letters*, L.1 and 72, respectively.

12. Ibid., L.8 to Abiah Root and L.318 to Elizabeth Holland.

13. Ibid., L.153 to Rev. Edward Everett Hale.

14. In 1850, Leonard Humphrey, 26, d. November 30. In 1851, Abby Ann Haskell, 19, d. April 19; John L. Spencer, 33, d. October 12; Martha A. Kingman, 19, d. October 30; Jennie Grout, 19, d. October 27; Mary Ellen Kingman, 13, d. November 15. In 1852, Emily Lavinia Norcross, 24, d. July 2. In 1853, Benjamin F. Newton, 32, d. March 24. In 1854, William H. Norcross, 31, d. April 19; Sarah Vaill Norcross, ca. 65, d. April

25. These ten were among some two dozen deaths of personal significance to Emily Dickinson in the period 1850–55. From then until her Aunt Lavinia's death in 1860, there were none that touched her closely.

15. *Letters*, L.213 to Mary Bowles and L.230 to Louise and Frances Norcross, respectively.

16. Ibid., L.91 to Abiah Root.

17. Ibid., L.280 to T. W. Higginson.

18. For discussion of Emily Dickinson, panic disorder, and agoraphobia, see John F. McDermott, M.D., "Emily Dickinson's 'Nervous Prostration' and its Possible Relationship to Her Work," *Emily Dickinson Journal* 9 (Spring 2000), pp. 71–86.

19. *Letters*, L.166 to Abiah Root.

20. Richard B. Sewall, *The Lyman Letters: New Light on Emily Dickinson and Her Family* (Amherst: University of Massachusetts Press, 1965), p. 70.

21. Sue's generous gift of $5,000 from her brothers was the equivalent of $100,000 in dollars of the year 2000. Together with the book stipend from Frank Gilbert, she commanded sufficient funds not only to appoint the Evergreens in fine style (later she bought several of the paintings Austin hungered after) but to quite reverse any sense encountered in the village that in wedding Austin Dickinson she was marrying up. Records of many of her purchases, including those mentioned in this text, are among the inventories in the Martha Dickinson Bianchi Collection of the John Hay Library at Brown University, where the documentary contents of the Evergreens are archived.

22. Edward's financial records occur among his papers in the Martha Dickinson Bianchi Collection at Brown University.

23. *Letters*, L.425 to Clara Newman Turner.

24. Leyda, *Years and Hours*, 1:351.

25. Ibid. 1:366–67.

26. Friends of the Amherst College Library, *Emily Dickinson: A Letter* (written ca. 1858) (Amherst, Mass.: Amherst College, 1992).

27. *Letters*, L.200 to Mrs. Joseph Haven.

28. *Diagnostic and Statistical Manual of Mental Disorders*, 3rd ed., rev. (DSM-III-R) (Washington, D.C.: American Psychiatric Association, 1987). Also, in consultation with John McDermott, M.D., professor emeritus of psychiatry at the University of Hawaii School of Medicine.

29. *Letters*, L.735 to T. W. Higginson, L.245 to Louise Norcross, respectively.

30. *Letters*, L.766 and L.807, respectively, to James D. Clark.

31. Dickinson's complex poetry-writing history and habits can only be suggested in this essay. An authoritative, concise, and fascinating account of the intricate process occurs in Franklin, *Poems*, Introduction, pp. 1–43.

32. John W. Burgess, A.C. 1864, "Reminiscences of an American Scholar" (1934); see Leyda, *Years and Hours*, 2:124. See also John Erskine, *My Life as a Teacher* (Philadelphia: J. B. Lippincott, 1948), p. 73.

33. Leyda, *Years and Hours*, 2:41.

34. *Letters*, L.256 to Samuel Bowles.

35. Ibid., L.261 to T. W. Higginson.

36. Martha Dickinson Bianchi, *Emily Dickinson Face to Face: Unpublished Letters with Notes and Reminiscences* (Boston: Houghton Mifflin Co., 1932), pp. 51n–53n. See also her melodramatic account (without naming Wadsworth) in *Life and Letters*, p. 47. In an unpublished MS in the Martha Dickinson Bianchi Papers at Brown University, Bianchi combines these two published tellings in a third dramatic account. Her sensationalism and inaccuracies of dates and other facts have long kept Dickinson scholars skeptical of the central truth in her report.

37. *Letters*, L.238 to Susan Dickinson. "I taste a liquor never brewed" (*Poems*, P. 207) appeared in the *Springfield Daily Republican* on 4 May 1861 and was republished in the *Springfield Weekly Republican* on 11 May 1861. "Safe in their Alabaster Chambers" (*Poems*, P. 124) was printed only once, in the 1 March 1862 issue of the *Springfield Daily Republican*. Sue is suspected of being the source for the still earlier publication of Dickinson's poem "Nobody knows this little Rose –" (*Poems*, P. 11), which the *Springfield Daily Republican* published on 2 August 1858. For more information about the eleven poems published anonymously while the poet lived, see Franklin, *Poems*, Appendix 1.

38. *Letters*, L.260 to T. W. Higginson. Higginson would have been known to Dickinson not only through literary publications but because the Unitarian minister had been one of the eastern Abolitionists who supplied martyred zealot John Brown with "Kansas Bibles," the guns and ammunition that Brown and his band used in antislavery raids in that state in the mid-1850s.

39. See Norbert Hirschhorn and Polly Longsworth, "'Medicine Posthumous': A New Look at Emily Dickinson's Medical Conditions," *New England Quarterly* 69 (June 1996), pp. 299-316.

40. Barton St. Armand, ed., "Emily Dickinson's Garden," an unfinished essay by Martha Dickinson Bianchi, *Emily Dickinson International Society Bulletin* 2 (November/December 1990), p. 1.

41. *Letters*, L.342a, and Bianchi *Face to Face*, p. 34, respectively.

42. Susan Dickinson, "Annals of the Evergreeens," unpublished manuscript, Dickinson Family Papers, Houghton Library, Harvard University, also published in slightly condensed form as "Magnetic Visitors," in *Amherst* (the Amherst College Quarterly), spring 1981.

43. Polly Longsworth, *Austin and Mabel: The Amherst Affair and Love Letters of Austin Dickinson and Mabel Loomis Todd* (New York: Farrar, Straus, & Giroux, 1984; Amherst: University of Massachusetts Press, 1999), p. 356.

44. *Letters*, L.414 to Louise and Frances Norcross. Leyda, *Years and Hours*, 2:224.

45. Leyda, *Years and Hours*, 2:225. Samuel Bowles was the only person Emily Dickinson would see on the day of her father's funeral.

46. Bianchi, *Life and Letters*, p. 99.

47. *Letters*, L.418 to T. W. Higginson.

48. Ibid., L.342b to Mary Channing Higginson.

49. Ibid., L.432 to Elizabeth Holland.

50. S. Dickinson, "Annals of the Evergreens."

51. Longsworth, *Austin and Mabel*, p. 6.

52. Leyda, *Years and Hours*, 2:353.

53. Longsworth, *Austin and Mabel*, p. 62.

54. "the Flood subject," *Letters*, L.319 to T. W. Higginson; "keeps Believing nimble," L.750 to O. P. Lord.

55. *Letters*, L.1040 to Charles H. Clark.

56. Ibid., L.779 and L.792, respectively, to Elizabeth C. Holland.

57. Ibid., L.664 to Susan Dickinson.

58. Both quotations from Longsworth, *Austin and Mabel*, pp. 170 and 173, respectively.

59. Ibid., p. 116.

60. Ibid., p. 117.

61. Hirschhorn and Longsworth, "Medicine Posthumous," pp. 309–13.

62. Leyda, *Years and Hours*, 2:472-73.

63. Notes from an interview with her father (1931), by Millicent Todd Bingham, Millicent Todd Bingham Papers, Manuscripts and Archives, Yale University.

64. Longsworth, *Austin and Mabel*, p. 409.

65. *Letters*, L.587 to Susan Dickinson.

Keeper of the Keys:

Mary Hampson, the Evergreens, and the Art Within

Barton Levi St. Armand

To own the Art within the Soul

The Soul to entertain

With Silence as a Company

And Festival maintain

In an unfurnished Circumstance

Possession is to One

As an Estate perpetual

Or a reduceless Mine.

—Emily Dickinson, *Poems* P. 1091

My Story

When I was looking over my correspondence with Mary Landis Hampson, which dates from 1975 to 1983, I was startled to find at the bottom of the document box where the letters had been stored a set of keys I had long forgotten.* They were given to me by Mrs. Hampson, last heir of the Dickinson family and, until her hospitalization and eventual move to a nursing home in 1985, sole resident of a house on Amherst's Main Street that harbored as much drama, mystery, and romance as many a mansion that haunts the annals of American literature. Whether it be the real but legendary "House of the Seven Gables" that Nathaniel Hawthorne appropriated in his novel of the same name or the more generic and imaginary "Sutpen's Hundred" of William Faulkner's *Absalom, Absalom!* such archetypal dwellings are rooted in the material base of American dynastic possession, and it is wholly natural that the line between fact and fiction should become, through the capillary action of the human imagination, permeable and shifting. As early as May 1886, after visiting the residence adjacent to this one on the occasion of Emily Dickinson's funeral, her future editor and faithful lifelong correspondent, Thomas Wentworth Higginson, reflected that the Dickinson Homestead was like

* All original letters cited in this essay were given to the author by their owner, Mary Hampson, and remain in his possession.

"a more saintly & elevated 'House of Usher.'" If the darkness of Poe's particularly doleful mansion was destined to be gradually sublimed and transcendentalized by a poetic Woman in White who was properly and not prematurely buried, Mary Hampson's keys permitted entry to what was, almost a century later, still a house of strange shadows. In 1975, number 214 Main Street persisted in standing—withdrawn, silent, and stubbornly unexorcised—next door to the original family domain that was now, in season, open to the public by appointment every Tuesday at three.

One of Mary's keys is a small, brass, grooved implement, a fairly conventional device with which most of us would be familiar, a common "house key," although the name of its maker, the "E.S.P. Lock Corp.," might in some quarters conjure up certain uncommon psychic intimations. If the brass key is shiny, lightly cast, and diminutively intriguing, its mismatched mate is heavy, Gothic, squat, and somewhat clunky—a true old-fashioned steel "skeleton key" that already has a brown freckling of rust upon it. They are tied together by a piece of string attached to a round paper label, on one side of which is written my name in script and on the other the carefully printed words, "Keys to Evergreens." These are in fact duplicate keys to the two front doors, inner and outer, of the towered, ochre-colored Italianate villa built by Emily Dickinson's father in 1856 as a properly imposing and, in its time and place, distinctively palatial residence for his newly married son, Austin, and very social daughter-in-law, Susan Huntington Dickinson. The Evergreens was set on a terraced lot next door to the solidly Federal-style brick Homestead, which, before it was Higginson's transfigured "Usher" and Amherst's chief late-twentieth-century literary shrine, served as the sedate retreat for the retiring poet, her acerbic sister, Lavinia, her almost invisible mother, Emily Norcross Dickinson, and her formidable father, Edward.

The unique chemistry created by these two houses and their inhabitants produced a potent and lasting emotional charge, like the direct current of "Dynamical Electricity" given off by those "Voltaic Piles" that literally shocked so many fascinated nineteenth-century observers. This living galvanic battery, with its many human pairs of positive and negative plates, immersed in an increasingly acidic bath, sent forth a jolt of power that arced spectacularly and tragically beyond the confines of the town of Amherst itself, eventually illuminating—or "italicizing," to appropriate one of Emily Dickinson's own images for the effects of sudden light—a whole American Victorian cultural landscape. Her sister-in-law, Susan, wrote after Dickinson's death that she was "quick as the electric spark in her intuitions and analyses," and some of the tingling force that generated such storms of unconsummated passion, clandestine love affairs, corrosive lawsuits, and a coruscant literature to match seemed to cling to my own small set of metallic conductors, recalling Ben Franklin's original experiment with key, kite, string, and a random bolt of lightning There is a glaring and inevitable doubleness—a dark innerness and a bright outerness—to everything about the Dickinsons and their history, both individual and communal, and so it is only appropriate that there should also be two different keys to the front of the vaultlike house, looking almost as if it were carved out of blocks of solid sandstone, that became the final repository of what remained of their earthly possessions.

The rusty key, reminiscent of dank crypts and deep donjons, once opened the ponderous gray, round-arched outer or "winter" door of the Evergreens; its flouncy, more delicately scalloped brass companion fit the lock of the inner portal of the shadowy recess framed by the outer door. This genuinely Poe-like space of temporary claustrophobic confinement was illumined only by the dim light streaming through two oblong panels of pebbly frosted glass, for the ancient fixture that was set in the flaking roof of the narrow vestibule was empty of a bulb during the entire time I paid my visits to Mary. In spite of such obstacles and a few later minor jousts, tests, and chivalric trials, Mrs. Mary Landis Hampson, legendary Dragon at the Gate of the Golden Dickinson Horde, became for me "Mary"—sometimes even "Aunt Mary"—soon after I paid my first visit to the Evergreens, accompanied by my Brown English department colleague, Professor George Monteiro, on a misty June morning in 1975.

I also found, however, that the transformation of Mary's formal acquaintance into a warm friendship put me on a first-name basis not only with her but with a host of undeparted ghosts and transient living familiars. These regularly threaded their way through the hushed rooms with worn furniture upholstered in tasseled and faded gold Florentine brocades or traversed the lower hallways papered with raspberry-colored Morris era figures. Originally a rich burgundy incised with black outlines of palm leaves, the walls now seemed covered by a beautiful but spidery pattern increasingly subject to the subtle dilapidations wrought by extremes of temperature and a persistently leaky roof.

"Edward" had skillfully managed to paste most of this peeling red papyrus back up, while also studding the back hall ceiling with steel disks that, in spite of ominous cracks and crazings, somehow kept the plaster from falling down. Edward O'Neill was a kinetic member of this extended, semi-ectoplasmic household—Mary's unfailingly courteous, indispensable handyman, who had begun his custodial duties while a boy helping out his father, "Gene," who in turn had worked for "Martha." When I finally met him, in spite of persistent illness, the shy, quiet, slightly orotund Gene was still mobile enough to visit Mary and recall what the Evergreens was like before her own advent with her husband, Alfred, in 1947. It was Gene who knew where every vanished tree had grown and where every object in the house had stood. And after my first visit, it was Gene whom Mary consulted because I had noted that chestnut leaves made up the background of a striking pastel of blue jays that hung in the library and wondered if it could have been a study "from life" done on the property itself, perhaps paralleling some of Emily's own poems on this cheeky, colorful, and raucous New England bird. Excited about this prospect, Mary wrote me on June 9, 1975, five days after George and I had first met her:

> I must tell you about "Grandpa" who works here from time to time—his name is Eugene O'Neill—now 69. He had worked for Martha since about his 1st year in High School,

after which he went to Stockbridge, a part of what they called Mass. Aggie in those days—Now Un of Mass. There he studied about groundskeeping. The Sat. after your visit he was here with his son Edward (now 37—began at 9, and his son Tim now 9 began here 2 years ago). I happened to ask him about chestnuts on the grounds—the only one he could think of at The Evergreens was the deep pink chestnut. As he stood, you could "see" him think. "But, Mrs. Hampson, I used to work for the Rev. Parke, too, and one year I worked with a man who was cutting down two Chestnuts at the front." "What kind, Gene?" "The kind you eat." He thought the year was between 1921 and 1925. At that time there was no sidewalk on this side of Main Street, and the two chestnut trees were right in the middle of where the sidewalk was put in later. At that time the hedge was low— and the branches could easily have been near Emily's window—certainly easily seen from some of the front windows of the house. I have asked Gene to write down everything he can remember.

Surely there had been chestnuts in the vicinity of the Homestead, which Emily Dickinson's niece, Martha Dickinson Bianchi, had sold to the Parke family in 1916. Just as certainly they dated from the poet's time and had been cut down with Gene's help as a disastrous early-twentieth-century blight gradually felled nearly all of these majestically mature native specimens. Indeed, Martha herself confirms that there were chestnuts among the Olmsted-inspired plantings of the Evergreens in her unpublished autobiography, "Life Before Last." A small factual mystery had been solved, and Mary triumphantly concluded her letter by affirming that "the leaves in the drawing are not oak leaves," adding the fervent ejaculation: "I am so grateful for your work and perception—I shall die in peace!" This may seem to be something of an overreaction to a very minor incident, but as Mary later told me in a phone conversation, after I had promised I would send her a few "small things" I had written, "small things were important, *because they told the truth!*"

With her own remarkable gift for re-creating dramatic

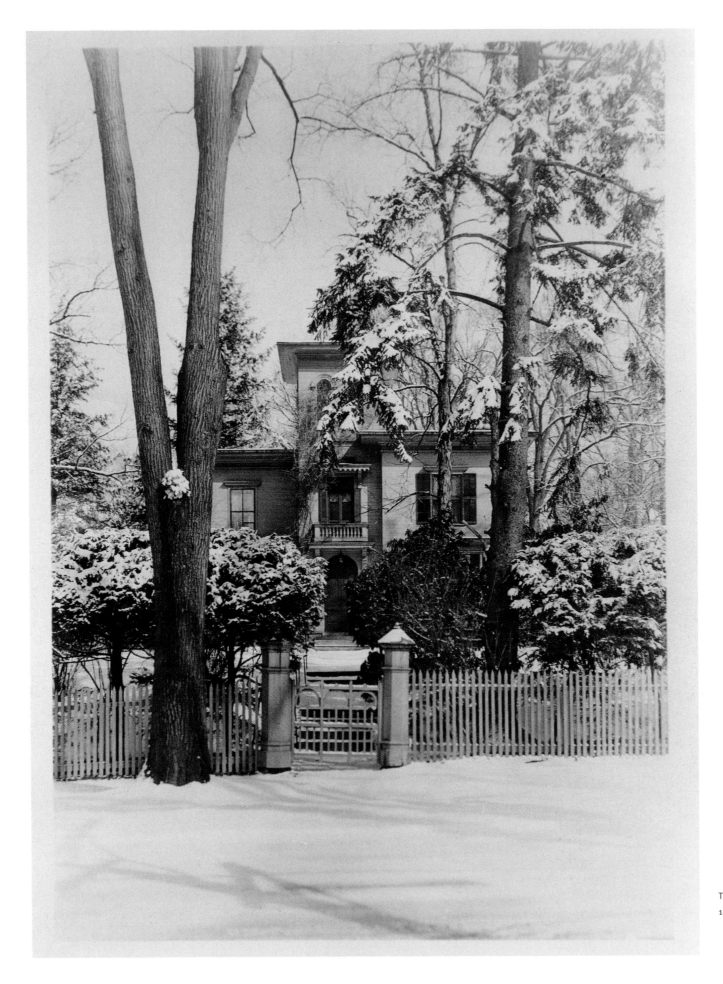

The Evergreens, winter
1890.

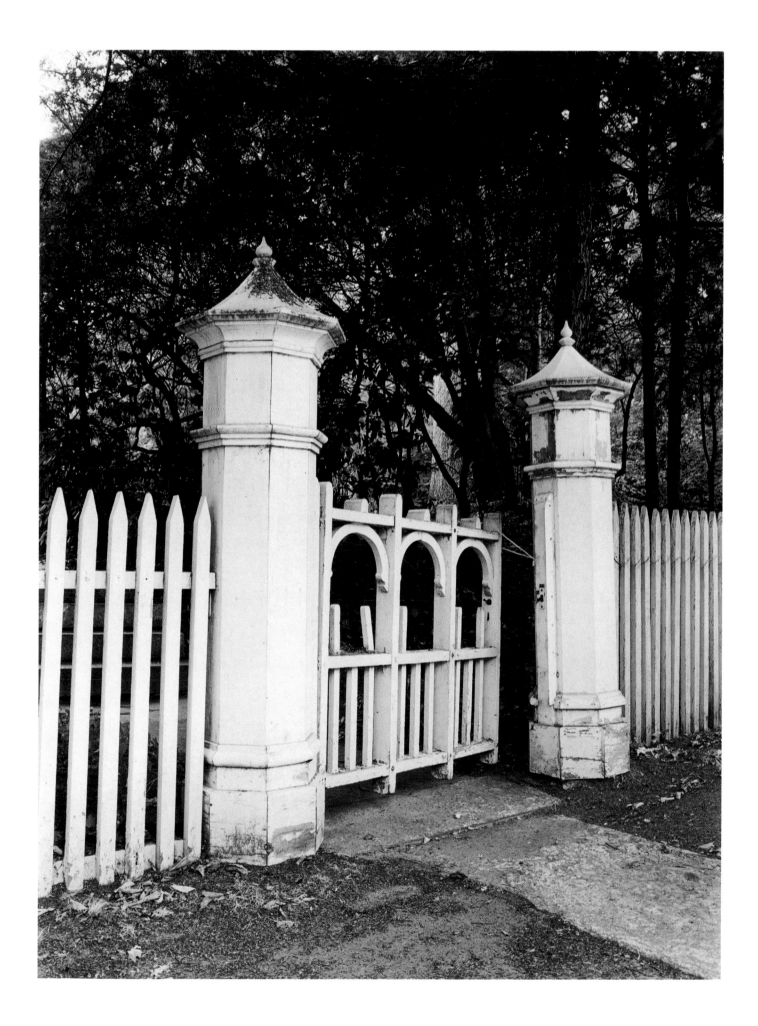

Entrance to the
Evergreens, 1982.

situations and mimicking dialogue. Mary Landis Hampson sought out the truth as she saw it and was ready to defend that truth to the death—and even after death, as it turned out. True to her own word, she asked Eugene O'Neill (with Edward's help) to make for me detailed plans of the interior of the house and of the exterior plantings as they were when he first knew them. At Mary's direction, he noted in particular where all the paintings hung, since I was then engaged in writing what would become my *Emily Dickinson and Her Culture: The Soul's Society* (Cambridge University Press, 1984), in which I attempted to reinsert the poetry into its original aesthetic and intellectual context and restore its lost American Victorian resonances. A study of the extraordinary collection of art still hanging in the Evergreens, which had been purchased by Susan and Austin Dickinson throughout the early days of their marriage, was indispensable for the completion of this project, and I was lucky enough to knock at the double entry of the Evergreens at just the right time, when Mary (as the urgency of her reply to me about the pastel of blue jays indicates) was looking for someone to share not only her deep knowledge but her growing burden as the lone custodian of the complex Dickinson family legacy. But there was also present a residue of that same electrical charge I mentioned earlier, that voltaic something that binds people together by ties of blood or sympathy, flaring beyond knowledge itself. For as Mary wrote at the beginning of the same letter I have quoted above, the initial one of over thirty I would receive from her, "First, I want to say this—when I opened the front door and saw you and Professor Monteiro standing there, it was the way it was when I turned the corner to Gramercy Park and waved to Martha—how could I not trust you!"

Trust in all of its many meanings, of which the two keys now in my possession became a tangible earnest, was to dominate my relationship with Mary and the Evergreens. Eventually, I would become the first chair of the Martha Dickinson Bianchi Trust, dedicated to preserving the Evergreens and its contents, as well as to celebrating and promoting the reputation of Mary's friend, the major American

woman of letters who dwelt there. My own first impression of the house and its occupant was equally magical and galvanic. After parking our car behind the gray stone Congregational church that stood diagonally across the street, we walked up to the gate with briefcases in hand, looking as professional and as professorial as we possibly could. George even joked that we looked a little like CIA agents, a quip that again had more truth to it than we then realized. We approached the gate with its intricate Gothic design and two round Romanesque candlesnuffer tops, learning later that one had been recently "yanked off" and stolen and so was in fact a replacement. As if it were an omen, the gate stuck a bit at first but then swung graciously open, leading us up a set of terraced granite steps into a beautiful overgrown yard full of ferns, blossoming rhododendrons, and the pink cloud of the horse chestnut that "Grandpa Gene" was to mention when searching his memory about the vanished older native plantings. The rarity of a June day was at its height, and the veil of morning fog had been tearing gradually away from the jumbled Pelham hills as we made our early morning drive up from Rhode Island, though the sky remained overcast. Bushes of yellow roses—the original Dickinson roses, we were told that same day, transplanted to the Evergreens by Martha herself before she vacated the Homestead—were complemented by lavender Persian lilacs, and these were towered over by a great, dark spruce. Mary later pointed out to us the location of a huge magnolia tree from the big arched windows of the third-story tower room, still furnished with a small bamboo table and fancy, rush-seated chairs, with stacks of magazines in the corner bearing Dickinson family names scribbled on their covers in pen and pencil. With its longish grass and forest atmosphere, the untrimmed and even luxurious landscaping of the Evergreens fully lived up to its verdant name, and I thought of runaway, old-fashioned gardens of grand, abandoned houses described by turn-of-the-century New England Local Colorists like Sarah Orne Jewett and Mary Wilkins Freeman. Peonies spilled over the steps to the half-open front winter door, and after pulling at the alarmingly loose, rickety, and wayward plunger that

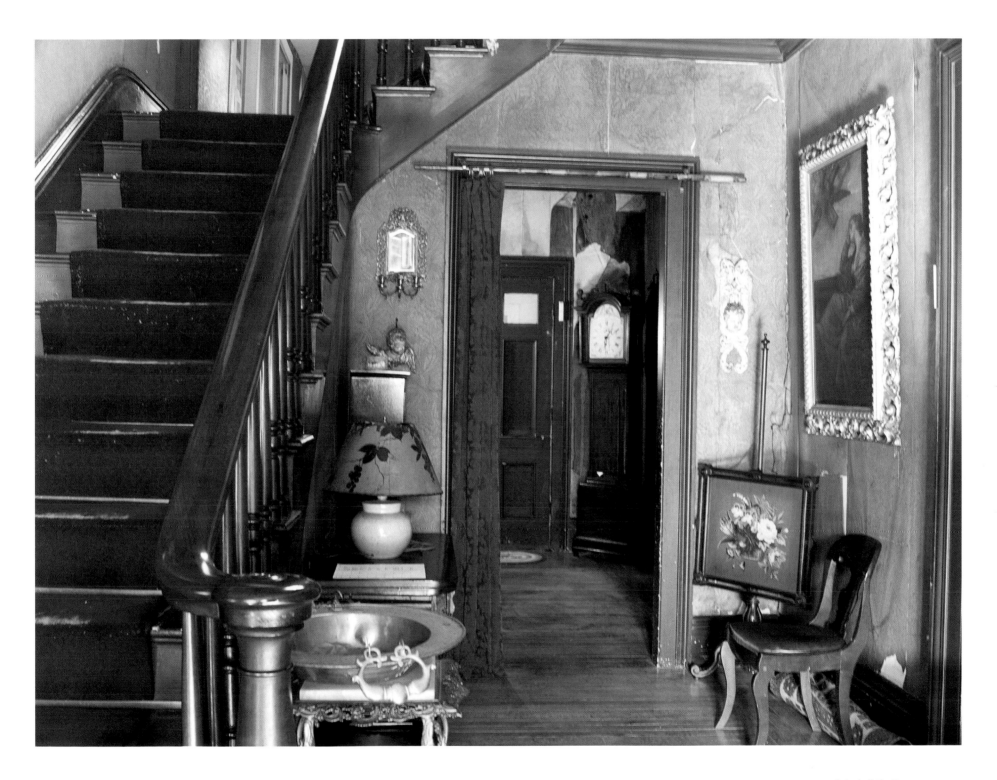

Entry hall, the Evergreens, 1993.

activated what sounded like a cow bell, we were suddenly in the narrrow entry with its missing bulb, small wooden "Evergreens" sign suspended from the ceiling, and dim (but hopeful!) interior light radiating from whatever lay behind the opaque oblongs of the final barrier. A small, handwritten card taped to this inner door said "knock."

If our approach was ceremonial, approximating more the entrance to a moated castle than to a country villa, our reception was that of expected visitors (I had written ahead, and Mary had called back, fixing the date) who fast became intimate friends. A rattling at the key hole greeted my knock, and I walked in, shook hands with Mrs. Hampson, introducing myself and George, and set my briefcase down in the big reception hall, dark with red paper and portieres, but brightened by a brass gas lantern hanging over the polished newel post. This fixture had long ago been converted to electricity, but originally it was an important amenity that Austin Dickinson himself had insisted upon, since he had long been embarrassed by his father's parsimonious habit of greeting evening visitors to the Homestead with an ordinary oil lamp in his hand. The old mahogany and red velvet Empire sofa in the hall, under the grand theatrical Egyptian scene *Sarah and Abraham at the Court of Pharaoh*, painted by the equally theatrically named Azzo Cavazza (Mary always chuckled wryly when she pronounced these slightly absurd syllables), was piled high with wide-brimmed ladies' hats and shawls, and I had the impression of a vaguely oriental, gloomily Victorian, and once very grand but now very worn stage set on which scenes from *Aida* had been rehearsed. Mrs. Hampson, then eighty-one years old and dressed in a white blouse tied with a cross-piece of lace at her throat and a blue serge skirt, seemed herself to be out of another era, and in fact she never really yielded to the age of modern media, except for her firm attachment to the radio. Pale, breathless, excited, and seemingly anxious to talk, she invited us into the library to the right of the hallway, with its dark fireplace mantel, big terrestrial globe, and an amazingly eclectic miscellany of chairs. The table in the center was overflowing with books, pamphlets, and folders,

and there George put the new tape recorder he had just bought, which we used for the first fragment of our interview. But Mary was far more comfortable and forthcoming when the recorder was switched off, establishing a free and easy rapport with us almost immediately, as she sat in a small black Windsor, George negotiated the slippery depths of an overstuffed walnut rocker, and I settled into the ornate tooled leather of a late Renaissance armchair.

We learned many things that day: that Mary had been compelled to have the library walls painted, leaving only a rococo frieze at the top, because the original paper was so moldy and peeling when she moved to Amherst in 1947; that Austin, great connoisseur of art that he was, would "throw himself down" before the fireplace in this very room and exclaim, "Here's my thousand-dollar painting," referring to the roaring fire itself; that the room had been broken into while the house had been shut up before she came—that she found candles everywhere and books scattered about, and that only a few years ago her porch furniture was stolen. The top of the fence was only the latest casualty in this line, and she would soon lose her last favorite remaining brown wicker porch chair. She allowed me to photograph the paintings, save for the *Habitant Winter Farm Scene* by the leading Canadian snow painter, Cornelius Krieghoff, because she had recently seen in a catalog that his works were now quite high-priced; as it turned out, there were just as valuable canvases hanging throughout the house. When George by chance mentioned the fact that the writer Hamlin Garland had mistaken Martha Dickinson Bianchi for her Aunt Emily, she at once volunteered that "I have a letter of his in my filing cabinet," whereupon we adjourned to a gloomy back office that Martha called the Dying Room, because both her brother Gib and her father, Austin, had died there. The Dying Room was on the ground floor and so more convenient for tending the sick, and it was this space that Martha had set up and furnished as a singular museum room honoring her aunt after moving what she could salvage of the vast array of ancestral furniture from "the mansion" when it was sold to the Parkes in 1916. In fact, Thornton Wilder had

Photograph of Mary Hampson on Dickinson sideboard.

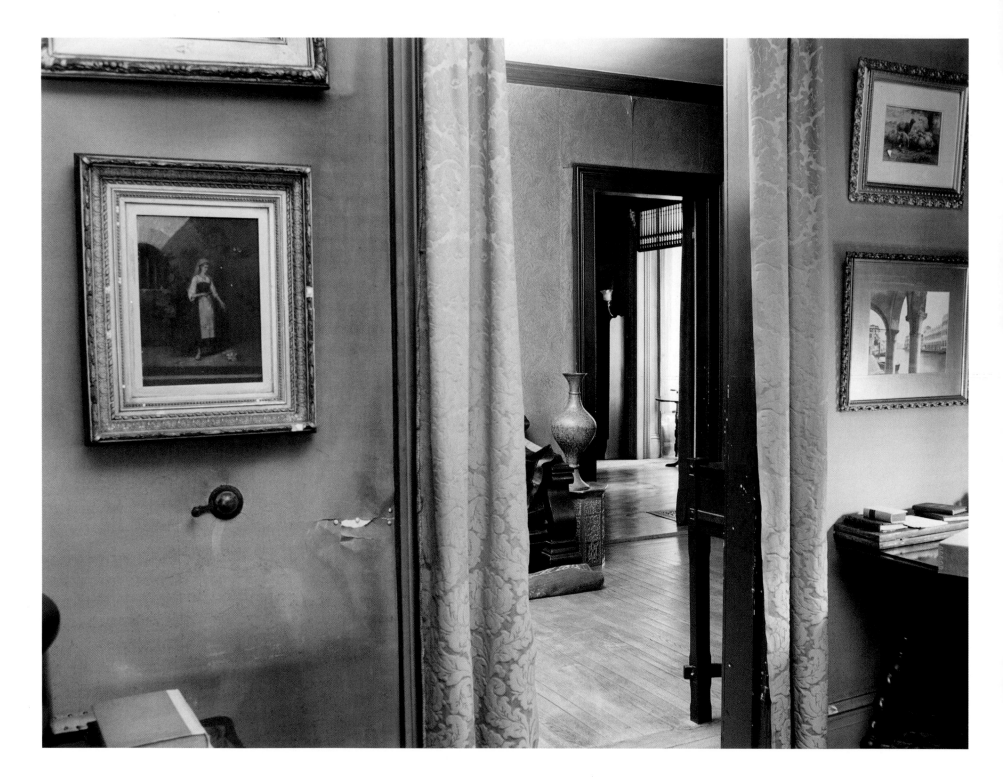

The Evergreens from the parlor across the hall to the library.

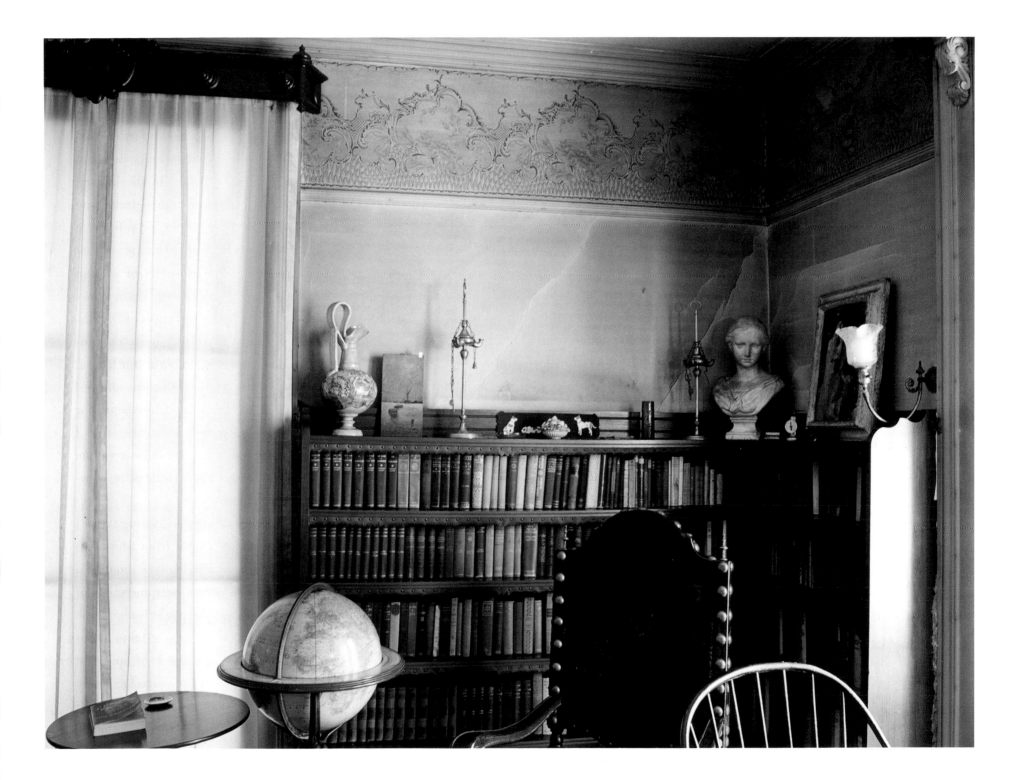

Library, the Evergreens.

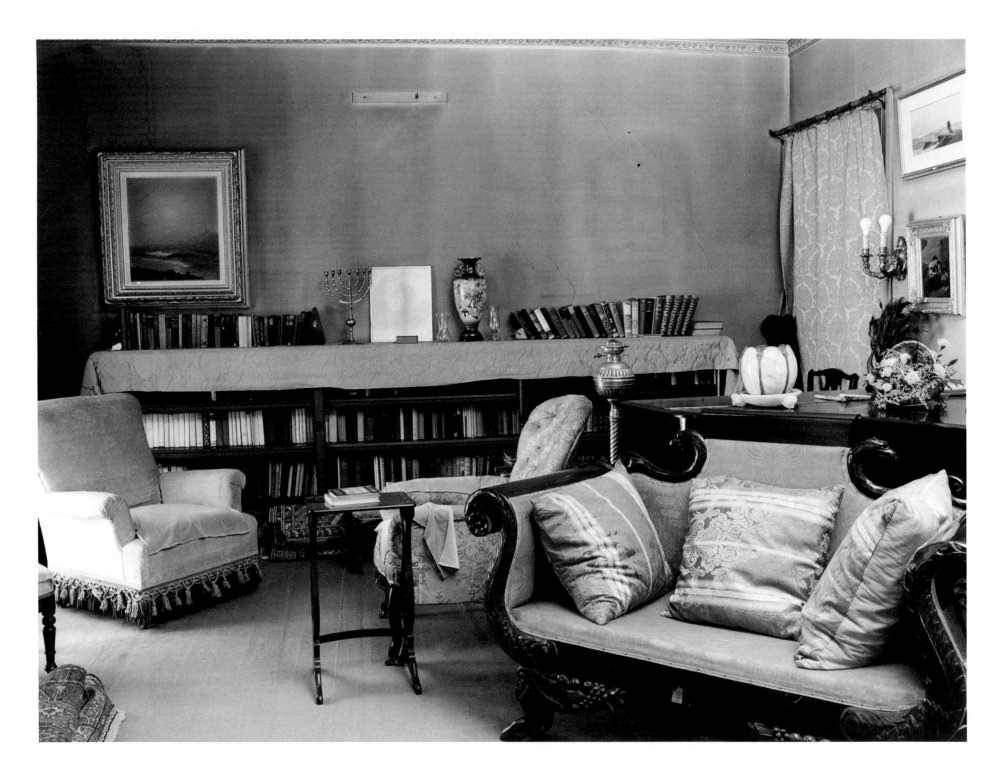

The Evergreens, parlor.

children, Kate, Stephen, and Emily (who *was* named for Dickinson and was a budding poet herself), to some of which I was a party. Kate took photographs of her own, and I noted on a visit by George, his son, and myself that we made on September 2, 1983, that Mary "was very pale and weak when we first arrived, but perked up considerably as the day wore on—We all went to the Lord Jeff and then to the Old Book Store in Northampton." And indeed it was true that Mary visibly revived when she saw us, as if she had been administered a shot of scholarly adrenalin. On my own, I dined with Mary most often at the Lord Jeff, always on the "Boltwood side" of the Inn, enjoying a ritual gin and tonic—"Gin clears the arteries," she declared; but we also sampled the fare of a short-lived vegetarian diner called the Equinox, the cafeteria at the University of Massachusetts, and, on very special occasions, the Smith College Faculty Club. Mary was a regular at the Lord Jeff until her growing fragility forced her to consider the option of subsidized home delivery of her food, although she later wrote me rather triumphantly that she had finally "kicked over meals on wheels." She dined there at least three times a week and was especially fond of the fresh turkey club sandwich. Here she seemed to unwind most of all, here were her true stomping grounds and, no doubt aided by a little gin, stomp she did.

What she stomped on and stumped against most fiercely were the depredations of Dickinsonians who had followed the "pseudo-scholarship" fostered by Mabel Loomis Todd and her daughter, Millicent Todd Bingham. As the keeper of the keys to the Evergreens, Mary Landis Hampson was a tireless crusader for the Dickinson family honor, and her pet peeve was Richard Sewall, whose two-volume biography of Emily, heavily influenced by his friendship with Mrs. Bingham, had just appeared. Accompanied by Priscilla Parke, daughter of the clerical purchaser of the Homestead, he had earlier called on Mary, but with her antennae sensitized to the "Todd-Bingham conspiracy," she felt he was somehow a spy for the other side, a "reporter" out looking for a "scoop," and now "I would not allow him in my house." How the Evergreens became "my house" is intimately interwoven with Mary's own story, which is also the story of Emily Dickinson's fate as a twentieth-century cultural icon, and that will very shortly be told. But for now, it is enough to say that, sitting at her round table set in the bay window of the library, Mary Hampson contemptuously used Sewall's book as a footstool, sometimes kicking it clear across the floor boards. "Think of the way Sewall has denigrated the Dickinsons of The Evergreens," she wrote me on November 22, 1976, "the ones I especially loved personally. Remember I knew Martha for over 12 years and I know what she suffered. And I am in their home." It seemed to her that the Dickinsons "were never to be allowed to stand by themselves" but "must . . . eternally be haunted by shadows of the Todd-Bingham thieves and liars." Now that both Mrs. Todd and Mrs. Bingham were dead, it was Mary's firm belief that Richard Sewall was the chief "heir" and promoter of that same tainted legacy.

On this point, she was not to be gainsaid, and when George and I were preparing a special issue of the periodical *Prairie Schooner*, featuring material we had retrieved from the file cabinets of the Evergreens that Mary had so freely opened to us, we made the mistake of merely citing Sewall's work in a footnote. "George's letter arrived Sat. and I have not slept the last two nights," she wrote. "He must understand about Sewall." Since George was responsible for writing up this particular section, she reiterated to him that "if Todd, Bingham or Sewall are in any way (foot note or other) brought into this supposedly all Dickinson issue," she "would feel I had betrayed the Dickinsons and my last promise to Martha and could have nothing belonging to me used in connection with it." Mary had given us formal legal "licenses" to use this material and any other publishable documents we might discover, and now she told us to read carefully the lawyer's letter accompanying them, which spelled out the limits of our privileges, which were always subject to her approval and review. Needless to say, the footnote was eliminated, the number duly appeared, and the licenses stood, but this incident demonstrates just how much what had been a small thing to us was to her a very large thing of burning truth and sacred honor, touching upon

Photograph of Martha Dickinson Bianchi.

Martha Dickinson Bianchi's hat and hatbox.

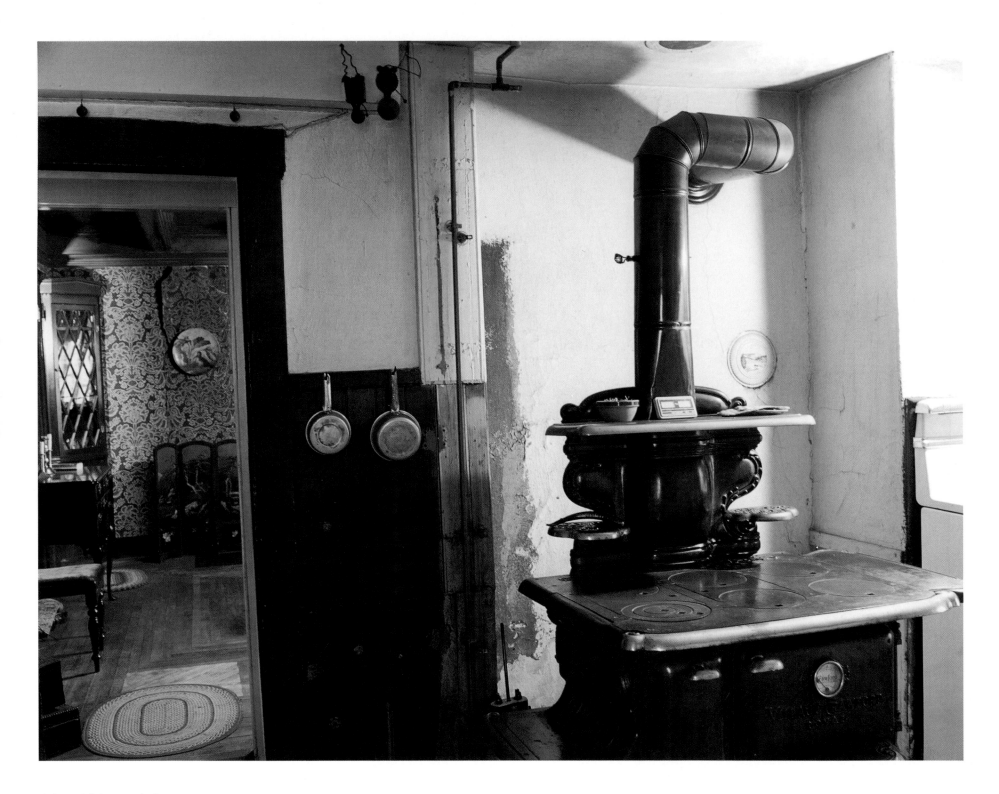

Kitchen and dining room, the Evergreens.

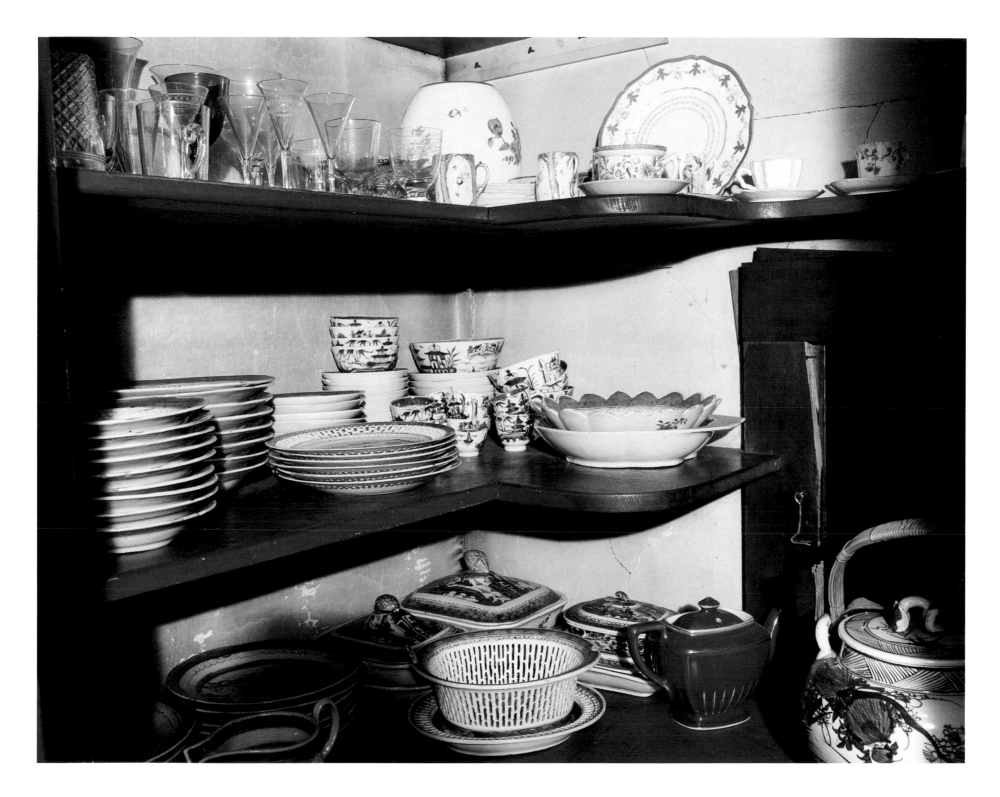

Remnants of Oriental china in the pantry, the Evergreens.

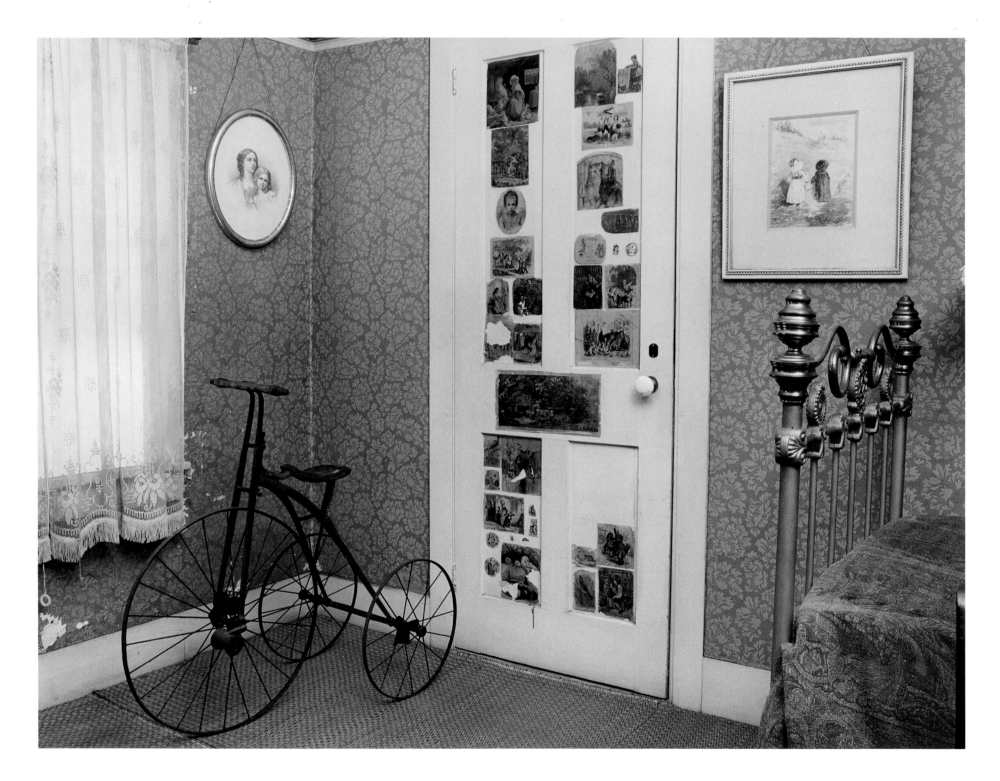

Gib's room.

Gib's toys.

he had mustered in favor of the photograph's being one of the poet were spurious. As for the pin, she herself remembered from her own childhood similar jewelry worn by "a grandmother or a great-aunt Matilda," and the supposed "slight tendency" toward exotropia in the right eye that might connect to Dickinson's well-known eye problem of the early 1860s was negated by the fact that "if strabismus is present, it usually is constantly evident," and there was no mention of Dickinson's having a squint in any extant description of her that has come down to us.

Mary's training as an ophthalmologist's assistant and her own expertise on diseases of the eye lent an authoritative and imperious grandeur to her frosty "This will never do," for it was even "questionable that there is any such thing" as "a slight tendency to strabismus," though Dickinson, in her own professional opinion, could have suffered from "an exophoria, perhaps alternating, which might have been apparent at times, according to the angle(s) of vision." Yet she also noted that various printed reproductions made from the 1847 daguerreotype "vary in the appearance of the exophoria," some showing "hardly any," while other "execrable" ones distort "the whole right side of Emily's face." Her ultimate judgment was that "a thing like this seems completely irrelevant to the mind, spirit, and work of genius." At the same time, devising her own physiological counterblast, Mary took Sewall severely to task because, in her view, all the photographs of the Dickinson family depicted them quite clearly as long-headed types, while the woman in his disputed image was obviously round-headed, perhaps someone with some Spanish blood in her. Making the old anatomical and anthropological cephalic index her bible, Mary thundered against Sewall's "wall-eyed thesis" and declared scornfully that "he doesn't know a dolichocephalic from a brachycephalic!"

After reiterating the fine points of this controversy on one occasion and giving the Sewall biography another kick, she handed me the framed portrait reproduced here, saying emphatically "That's *not* Emily! *This* is Emily!" She had found the image she gave me sometime soon after her husband's death in Paris in 1952 and her return to America, while rummaging in those incredibly cluttered and dusty upstairs lumber rooms and attics of stored, forgotten, or displaced Dickinson family memorabilia. Expert opinion hazards that it is "a weak photographic image" produced by a developing-out process that has been used as a base template and enhanced by hand, most probably using a mixed media of watercolors, crayon, pencil, and chalk. Increasingly popular from the 1860s to the early twentieth century, these kinds of pictorial hybrids, half print and half sketch, were produced in large numbers, along with a myriad of variously tinted and painted varieties of photographs on paper and on tin. Whether the face be dolichocephalic, mesocephalic, or brachycephalic is up to someone more expert than myself to decide, but certainly the image as a whole is symbolic once again of the ineluctable doubleness and abiding ambiguity of the Dickinson family legacy of truth slowly "developing out" into legend and fable. The faded ephemerality of this "Evergreens Portrait" of an "Emily Dickinson" with a haunted and haunting countenance turned three quarters to the viewer, escaping our direct gaze and perhaps fleeing from the very fame she knew she could not at last escape, can serve as a tangible emblem of the kind of "spirit photography" that Mary Hampson herself practiced in conjuring up cabinet-size pictures of living ghosts like Martha and Alfred. For as George Monteiro and I both remarked to one another after our first visit to her, she spoke of these long-dead people always in the present tense, as if they were still alive. And in the close but increasingly familiar shadows of that great shuttered mausoleum of a house, as long as Mary Hampson dwelled there, perhaps they were.

Mary's Story

As I have noted, my first visit to the Evergreens was on an initially cloudy but steadily brightening day of early summer overcast. Almost like a scene at the close of a romantic novel, at four o'clock, just an hour before George and I left,

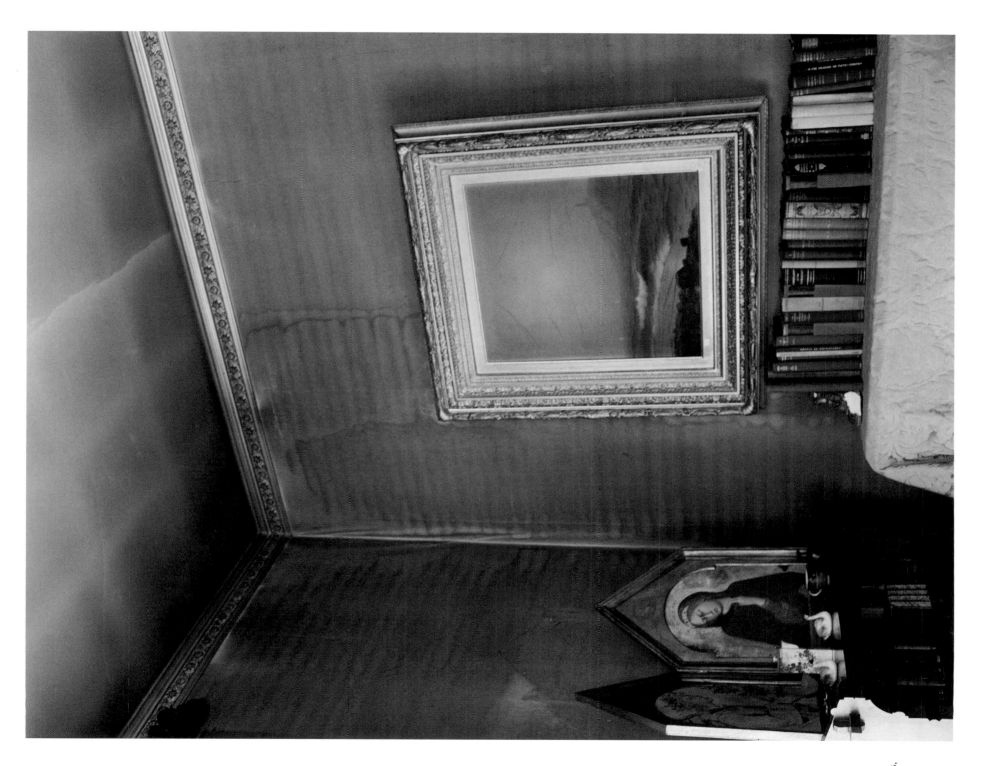

Parlor, the Evergreens,
1993.

the sun shone out in its warm, full glory, and Mary showed us, across the indented turf driveway, the famous "Path between the Houses" leading from her domain to that of the Homestead. Trodden by Emily Dickinson before her reclusive self-confinement, when she still visited her brother and sister-in-law, most probably entering through the big glass French doors of the library in order to remain as inconspicuous as possible, it had been kept open and passable by Edward on Mary's express orders. The path, too, remained symbolic of Mary's abiding connection with those first- and second-generation Main Street Dickinsons, in spite of the fact that her true affinity was with the third generation, represented by Martha Dickinson Bianchi. Again she was mightily frustrated with those who were soley interested in Emily alone; on February 17, 1981, she wrote me that "it has suddenly occurred to me that there could be another reason why Sue did not finish the work she had started on Emily. All these pseudoscholars never seem to realize that Susan and Martha had lives of their own" and so could not waste all their time "just sitting around here—a couple of Emily shadows." Mary Hampson was no Emily or Martha shadow herself, however much they may have figured as living shades in a polemical defense of the family that became fairly standardized, since she was to rehearse it so often for the random visitors who continued to knock at the portals of the Evergreens and were luckily granted leave to enter and be catechized. Although she told George that "I do not count, I am but a cipher in the chain," Mary never devoted all of her conversation to the Dickinsons, because she herself came from a distinguished and very interesting family, about whom she spoke freely, openly, and often.

Even on our first outing with her, the themes of Mary Hampson's table talk ranged wide, wild, and far afield, taking in contemporary as well as historically significant topics. There was her fear that Amherst College wanted to secure ownership of the Evergreens in order to knock it down and so make "a clean sweep" between the Frost Library and Valentine Hall, and that a "spy ray" that Russia had secreted in Finland was still causing the death of many innocent Finnish citizens. She also spoke of personally seeing such celebrities as Maude Adams, Joseph Jefferson, George M. Cohan, and John Philip Sousa on the stage and of her face-to-face exposure to exhibitions of the Post-Impressionists in Paris and the Blaue Reiter group in Munich. If there was an apocalyptic sense that "the world was going to smash" constantly edging this talk, her apprehensions about a Finnish catastrophe perpetrated by the Soviet Union were prophetic of Chernobyl, and her well-developed conspiracy theories on the part of Amherst were grounded in her acrimonious memory that the college, under President Plimpton, had seriously contemplated suing her and Little, Brown over copyrights to Emily's poems after the perfidious Millicent Todd Bingham had deposited her "stolen" cache of Dickinson papers in its special collections. Yet while the tossed salad of her conversation was laced with bitter herbs, we both felt that our gracious hostess, besides being the last representative of a lost age, was a high and stately lady in her own right, an individual of great culture, openness, and generosity, to whom her own oft-repeated word for the day's soft weather and its eventful, unfolding friendships—"lovely"—fully and aptly applied.

Obviously, Mary Landis Hampson had her own story to tell, though it was continually punctuated by references to other hovering presences like Martha and Alfred and Bill and Harriet and Stell, not all of whom were Dickinsons and not all of whom were definitively dead, for I was eventually to meet Stell myself, acting as Mary's equivocal ambassador to her house—another kind of artistic treasure trove—in North Bennington. All had, however, some kind of Dickinson connection, as of course did Gene and Edward, who continued in their own way the long tradition of loyal hired help of Irish extraction employed by the family, beginning with Margaret O'Brien and continuing with Emily's own noisy but clean-sweeping and dependable "North Wind," Maggie Maher. Emily Dickinson herself was borne to her grave by six Irish workers who tended the Dickinson estates, and it was Maggie who had witnessed her will and then preserved the one incontrovertible photographic likeness of Emily given her by

Lavinia, the now famous 1847 daguerreotype. In the same spirit of collateral family history, Gene O'Neill remembered not only the slaughtered chestnuts but how the Rev. Mr. Parke, the father of Priscilla and the purchaser of the Homestead, had surreptitiously moved the stone gatepost in order to gain an important right-of-way, until Martha had ordered him to put it back in its rightful place on the Evergreens side of the property line. Though Priscilla Parke had accompanied Richard Sewall on his only visit to the Evergreens, ironically it was she who remained one of Mary's most faithful friends, keeping an eye on her and even roasting her a chicken every two weeks when she became too debilitated to eat out comfortably or conveniently. Now effectively retired and ailing, Gene spoke contentedly and familiarly of "my cancer," as if it were a favorite hat that he wore every day or an old dog that he walked regularly. Embedded as she was in this dense web of crisscrossing Dickinson loyalties, betrayals, reminiscences, and slow fade-outs, Mary managed to hold her own while still speaking for the family and occasionally on behalf of Emily herself. "How can people be such fools about Emily—it seems incomprehensible!" she wrote me in January 1981, enduring what she called "the terrible winter of life." And what would have been the poet's reaction to the literary pilgrims who annually walked in pious procession from the Homestead to her grave in the family plot in West Cemetery every May 15 on the anniversary of her death? Mary answered unhesitatingly: "She would have *swatted them*!"

When telling her own story, Mary characterized herself as an absolute skeptic with an unflinchingly clear-eyed view of human destiny, who never suffered fools lightly. In July 1982 she wrote me: "As you know, I am aging—how I hate the fools who answer 'So are we all'—of course we do from birth to death." But "the aging from birth to midlife is one thing, the aging beyond midlife quite another—it is *normal* to die." As a young woman, seeing an exhibit of a human skeleton on display at a natural history museum, she concluded that that was all we were—"a heap of bones"—and that is all we ever would be. Yet like the two doors to the Evergreens, her nature had a double lock that opened to two keys very different in shape and in substance. The outer portal of her soul was most often a grim and spiky portcullis, fiercely barred and lowered to the ground, because its interior castle was perpetually under siege. From this fastness, Mary made periodic sallies against the enemy, a devious collection of "pseudo-scholars" and hired mercenaries headed by a conspiratorial junta she called Todd-Bingham. Because she was the last Dickinson heir and so, as I have previously indicated, the custodian of several copyrights of Emily's poems, there was always a definite litigious aspect to this literary conspiracy against the Dickinsons and the Evergreens, almost as if Todd-Bingham were a savage, disreputable, and self-perpetuating law firm straight out of one of Charles Dickens's massive Victorian novels.

This dimension of her animus ultimately sprang from the historical fact that the notorious "war between the houses," precipitated by Austin Dickinson's death and the ensuing lawsuit over the signing over of part of the Dickinson meadow to his mistress and sister's editor, Mabel Loomis Todd, was a battle over the rights of symbolic as well as real property. Above all, it became a no-holds-barred blood feud over who was truly worthy to be the iconic Emily's latter-day guardian and protector. In the file cabinets of the Dying Room we even found one document that the Dickinsons held in reserve as a legal bombshell just in case all else failed. This was a note kept in an envelope once sealed with wax and bearing the name of the Northampton clerk of courts, marked in Sue's hand "Mrs. Dickinson Personal." It was in turn secreted in a pale lavender envelope that Martha Dickinson Bianchi had labeled "Evidential . . . Kept Back in Lawsuit," for the contents confirmed an assignation between Austin and Mabel at the Parker House in Boston, undeniably proving the sexual nature of their relationship. Mary later burned the original but not before George managed to make a transcript. So even though Austin Dickinson's marriage never ended in divorce and the trial ultimately favored the family, the chief aftereffect of the war between the houses was a continuing and scandalous cus-

Sculptures of Ned and sister Martha made by Ned's fiancée, Alix Hill.

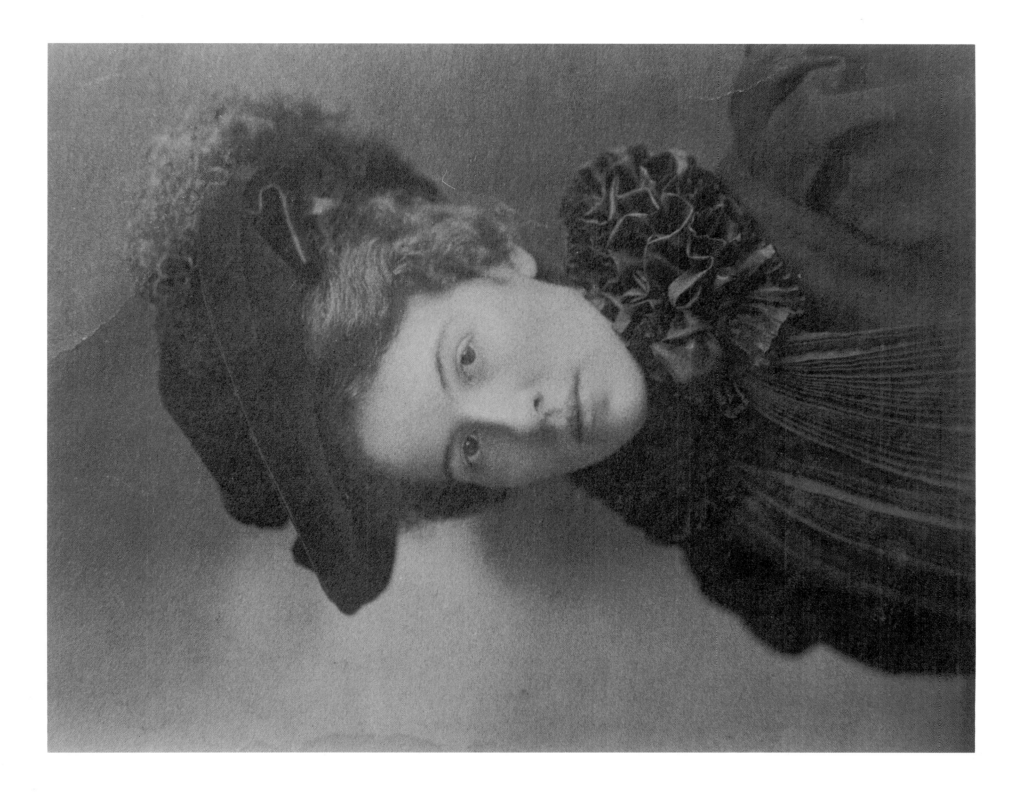

Alix Hill.

tody battle, as bitter as any divorce could possibly be, with Emily as the disputed child whose case was never out of chancery until the late twentieth century and the final establishment of the Martha Dickinson Bianchi Trust.

Martha herself testified, Mary told me, that "I have experienced in my life every imaginable horror." Certainly, one of those horrors was her legal inability to establish Dickinson family ownership to the full literary estate of her late aunt, whose poems had first appeared from the firm of Roberts Brothers in 1890 and 1891. Initially, Lavinia Dickinson herself paid for the plates of these spectral little volumes, which functioned largely as a gratifying public memorial to her dead sister. No one had expected that a series of metaphysical quatrains culled from hand-sewn portfolios and then printed in "dainty" gift book form between gray, green, and white covers ornamented by a cut of Indian pipes, or "ghost flowers," taken from an amateur panel painting by Mabel Loomis Todd would begin to establish Emily Dickinson as a major American poet. Thomas Wentworth Higginson, who was a man of letters to be reckoned with, functioned as coeditor with Mrs. Todd, but he was often thought of as undiscriminating in his radical advocacy of women's literature, in spite of writing the cautionary "Letter to a Young Contributor" that, along with his popular nature essays, prompted Emily Dickinson to write to him in April 1862, beginning a lifelong correspondence. But though the first reviews of Emily Dickinson's achievement as an artist were decidedly mixed, there was enough human interest in her work to warrant reprints of the first and second anthologies and a whole new third series of poems in 1896. Long before this, however, Mrs. Todd had begun collecting Emily Dickinson's surviving correspondence and preparing it for an eventual 1894 publication in two volumes, while also pressing Lavinia, probably with Austin's full support, to share the copyright with her. Proprietary in a very Dickinsonian and fiercely sisterly way, Lavinia refused, saying that she would "never give to another the ownership of her sister's brains," though she placated Mrs. Todd by erasing from the introduction to the second issue of the *Letters* the

misleading idea that she had "gathered" the originals herself. The 1896 poems were also copyrighted by Roberts Brothers for Lavinia Dickinson, but her signed copy of the final contract for the 1894 *Letters* was, as William McCarthy later discovered, "unfortunately filed by Martha Bianchi with the contracts for her own books, and she never realized she had it."

William H. McCarthy Jr. was Mary Hampson's "Bill." At Yale in 1930, he helped to mount an exhibition commemorating the centenary of Emily Dickinson's birth and compiled the catalog for it. Martha Dickinson Bianchi herself wrote the prefatory note to this work, thus ensuring the soundness of Bill's family credentials, and he went on from Yale to Harvard's Houghton Library. After his service at the Houghton, he next went to work for America's foremost rare book dealership, the Rosenbach Company of New York, and after Dr. Rosenbach's death he became curator of the Rosenbach Foundation in Philadelphia. In connection with the eventual sale and transfer of Emily Dickinson's books, papers, and memorabilia housed in the Evergreens to Harvard University in 1950, which he helped to sponsor, he spent much time going over and organizing a great deal of miscellaneous material that Mary and Alfred found when they reoccupied the residence. Chronicling the Dickinson side of Emily's publishing history in a later letter to Mary Hampson's Boston lawyer, he narrated a surprising turn of events that demonstrated that while Todd-Bingham might seem to have lost the war, fortune and nemesis put into their hands a means by which they could wage a continuing guerrilla campaign against the sole remaining representative of Dickinson possessiveness, Martha herself. On October 10, 1960, he wrote:

In 1931, Mrs. Todd and her daughter purchased from Maurice Firuski, a bookseller, a carton of Roberts Brothers' archives, which had been thrown out as waste paper for the mills and was salvaged by a book-hunter. The carton contained the whole of the family-editors-publisher papers about the publication of the Dickinson volumes. These

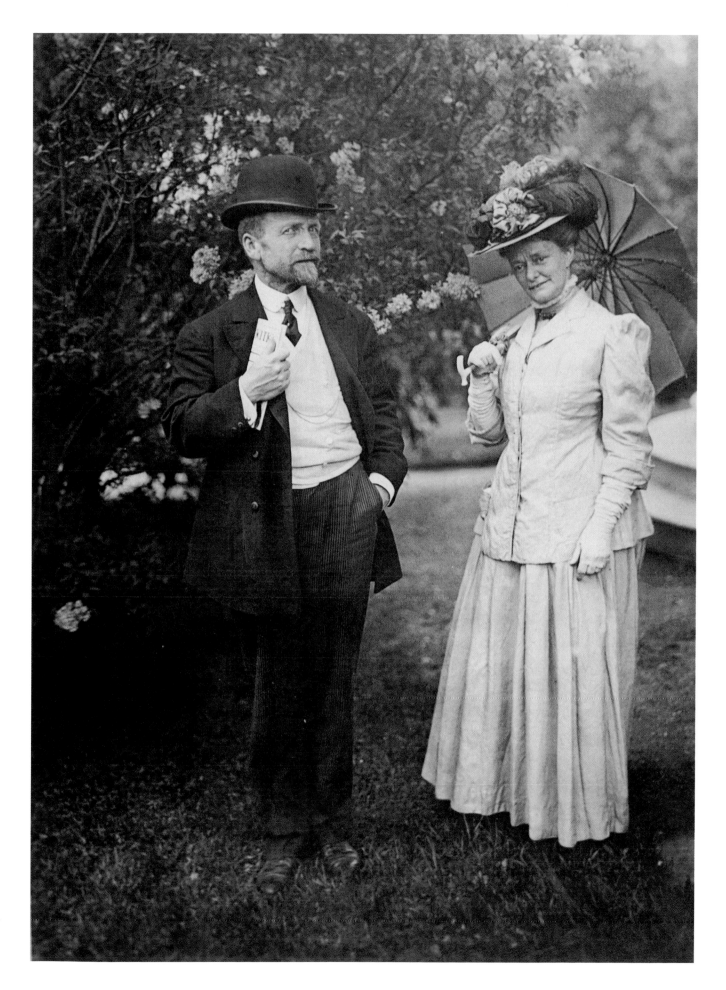

David and Mabel Todd,
Observatory House, 1907.

included a draft paragraph for the contract for the 1894 letters by which the division of copyright would have been made. It included also Roberts Brothers' signed final copy of the 1894 contract: this latter has probably been destroyed. Lavinia Dickinson remained absolutely adamant, and the letters were copyrighted by Roberts Brothers for Lavinia Dickinson alone.

Bill McCarthy's letter was written in connection with the dispute following Millicent Todd Bingham's donation of her Dickinson papers to Amherst in 1957, in order to demonstrate that she had no legal rights to pass on any copyrights to the college and that therefore the college had no grounds for a suit over the matter. The rights were in fact legally purchased by the president and fellows of Harvard University as part of the package underwritten by Gilbert Holland Montague, a Wall Street lawyer and distant cousin of the Dickinsons through Susan, whose maiden name was Gilbert. This transfer included Lavinia's misfiled official signed copy of the 1894 contract, but in 1931, Mrs. Todd's knowledge that she had what Mary Hampson later termed "squatters' rights" to the material in her possession caused her to end a more than thirty-year cease-fire and make a bold opening skirmish in a war that was no longer a public contention between contrary houses but a surreptitious and often devious contest of dueling editors. This duel, it need hardly be mentioned, was now to the death.

It was Susan Dickinson who had originally considered the idea of editing Emily's literary remains and weaving them into an eclectic sampler mixing prose, poetry, and personal reminiscence emphasizing her sister-in-law's elfin sense of humor, but she had been thwarted in this ambition by her own procrastination in opening up a firmly reclusive life to public scrutiny, the deaths of so many people who were close to her, and Lavinia's impatient patronage of Mabel Loomis Todd. Even so, the editing war actually began with Susan sending off copies of her own Emily manuscripts for publication in various periodicals even before the first edition of *Poems: First Series* appeared. In the aftermath of the trial, with Lavinia's recantation of her role in fostering the Austin-Mabel affair, her own death in 1899, and the Todds being driven into social purdah in Observatory House on the Amherst College campus, the family had every reason to believe that the ownership of the copyrights was squarely in its hands. In 1914, Martha Dickinson Bianchi published *The Single Hound*, a collection of some of Emily's poems that, as her preface made explicit, were particularly beloved by Sue because they were personally sent to her. *The Single Hound* appeared in a small, off-white limited edition of 595 copies printed on wove paper watermarked "OLDE STYLE" and was vaguely reminiscent of vellum-bound incunabula or the productions of William Morris's Kelmscott Press. It was also frankly a private memorial not only to Emily but to Susan, who had died in 1913, her editorial yearnings unfulfilled. By issuing these poems illustrating "my Aunt's peculiar genius" and using Sue's notes and taste as a guide, Martha reasserted, through the wealth of personal anecdote in the preface, the family's public control over the primordial Emily and of the precious "treasury" of belletristic material by her that still remained to them. Ironically, Martha herself had begun publishing her own erotically sensual poetry, made respectable by a heavy application of late Pre-Raphaelite goldleafing, in the last year of the same decade of the 1890s, whose first year had seen the appearance of her aunt's more ascetic posthumous productions.

There followed three more books of passionate lyrics and four cosmopolitan novels, but increasingly "Madame" Bianchi, who had married into the minor Russian nobility and salvaged little but an honorific title from the misalliance, found herself devoting more and more time to editing her aunt's poetry and assuming the role of her official biographer. "I was well on my way to becoming an author, when I was forced to become a niece!" she later complained, but the fact is that the growing national interest in Emily Dickinson brought in some much-needed income. As we have seen, Martha was forced to sell the Homestead in 1916, making up for some of the inroads made on her inheritance by her husband's clandestine activities as an undercover munitions

agent for the czar. At the same time, her publication of *The Single Hound* kept the flame of public attention alive after the first flurry of reaction to the 1890s volumes slowly faded, and it was the only bright spot in what might be called the dark age of Emily Dickinson's literary reputation in the early twentieth century, until she was at last rescued and rehabilitated by the Imagists and early Modernists. As Mary Hampson herself remembered, "Emily Dickinson had been completely forgotten by 1915. The 1890 books were soon out of print. I was one of well over a generation of students who had never heard of Emily Dickinson either in High School or in College. I was Smith 1918. It was not until 1925 or 1926, when I joined an evening class in poetry given by Alfred Kreymborg at N.Y.U., that I finally met Emily Dickinson."

Although she maintained her reputation as an important poet in her own right and was often solicited by editors and anthologists to submit a new contribution or to reprint an already published piece, after *The Single Hound* and its 1915 reissue of 293 copies Martha Dickinson Bianchi authored only one book of poetry and two more novels. Her own autobiography, "Life before Last," remained unpublished at her death in 1943, as her authorial energies were increasingly taken up by work on *The Life and Letters of Emily Dickinson* and *The Complete Poems of Emily Dickinson*, both published in 1924, and *Further Poems of Emily Dickinson*, 1929, which she coedited with her secretary, companion, and protégé, Alfred Leete Hampson. The subtitle of this book, *Withheld from Publication by Her Sister Lavinia*, once more emphasized family control and provenance. However, in 1931, while Martha was in Europe, Harper and Brothers issued Mabel Loomis Todd's expanded version of the 1894 *Letters of Emily Dickinson*. Understandably upset at the publication of this "piratical" edition of what she firmly and rightfully believed to be inalienable family property, Martha Dickinson Bianchi consulted various lawyers, but as William McCarthy noted, "Since she did not produce the official contract for the 1894 publication, the Harper volume was not attacked in the courts for suppression." Mrs. Todd and her daughter, Millicent Todd Bingham, having bought the salvaged scrap

of the original Roberts Brothers contract with Lavinia and encountering no serious family opposition to the trial balloon of the reissued *Letters*, were gradually strengthened in their resolve to begin their own campaign of editing and publishing the Dickinson materials they still retained.

This meant that just as Martha Dickinson Bianchi was forced by fate and circumstance to give up her own original literary pursuits, Millicent Todd Bingham, who had earned a doctorate in geography from Radcliffe in 1923, was compelled to give up a promising scholarly career in order to satisfy her mother's demand that her cache of appropriated Dickinson manuscripts be brought into the full light of print. The Chinese camphorwood chest in which these poems, letters, and miscellaneous bits lay since 1898, stored first in a barn and then in a bank vault, was finally unlocked. Millicent gave up her teaching, writing, and translating and reinvented herself as a Dickinsonian, turning her back "on the world of nature—the whole living landscape, the mystery of earth and sea and sky—to take up the life and work of one woman in a New England village." Although her mother died in 1932 and their *Letters of Emily Dickinson* stood unchallenged, Millicent judiciously waited until Martha's death in 1943 to begin what was a veritable publishing blitz out of the blue of materials she had long been preparing, starting in 1945 with the significantly titled *Bolts of Melody: New Poems of Emily Dickinson*. Although Mrs. Todd had been dead for thirteen years, her name was listed first as coeditor. That same year the Todd-Bingham version of the publishing history of Emily's poems, *Ancestors' Brocades*, came out, with the Furiski purchase buried in a footnote and assigned to 1936. It was followed by *Emily Dickinson: A Revelation* in 1954 and *Emily Dickinson's Home* in 1955. Along the way there appeared a number of important articles that dealt with Emily's handwriting and that showcased her remaining poems and prose fragments in the *New England Quarterly*, an impeccably respectable scholarly journal.

Announcing that "Emily Dickinson's family is now extinct," in this way Millicent made good on her grudging vow, which left her with a "heavy heart," to trade the larger world

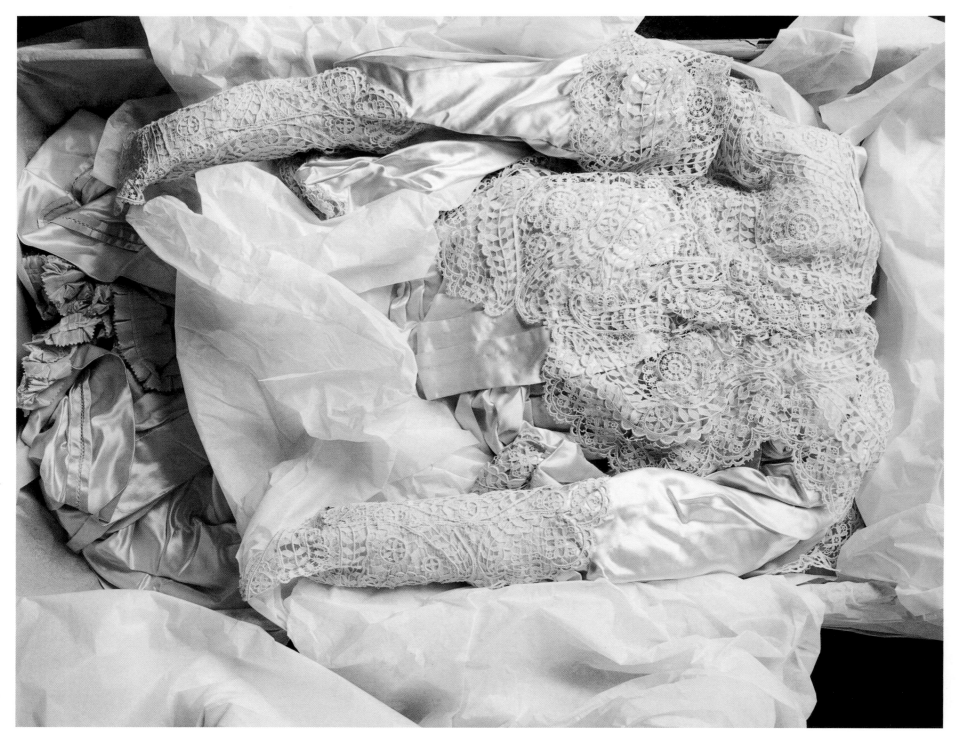

Martha Dickinson
Bianchi's wedding
gown.

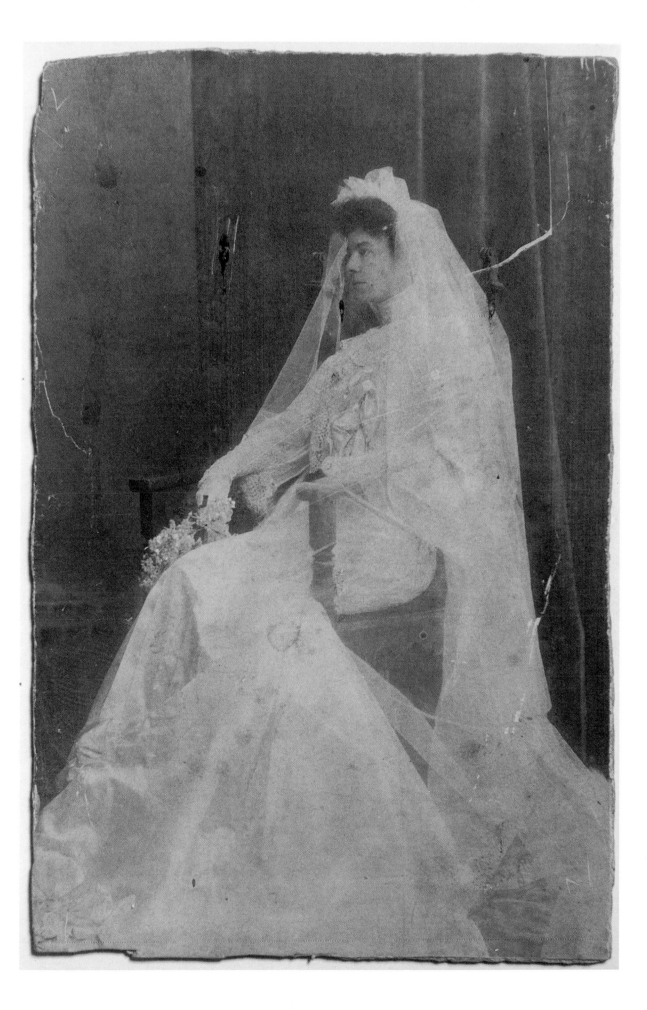

Martha Dickinson Bianchi's
wedding photograph, 1903.

Count Bianchi in
Russian military
uniform.

Martha Dickinson
Bianchi's wedding shoes.

of geographical research for the narrower but more intense domain of proprietary Dickinson studies. The fervor of her appropriation is again reflected in the exclusivity and intimacy of her choice of titles. Yet as Bill McCarthy commented, "These subsequent volumes published by Mrs. Bingham were illegal invasions of the Dickinson family rights," and according to Mary, Lavinia had "many times" demanded that the purloined papers be returned to her, but "each request was ignored." Mary was also outraged that, when everything of value in the chest had been published, Millicent at last persuaded Amherst College to accept "the big theft" of Emily's manuscripts, after trying to "peddle" them for cash to two universities in Washington, D.C.; she was informed by them that "we cannot buy these papers from you because they do not belong to you—they belong to Harvard University according to the contract made between the University and Mr. Hampson." Even the Library of Congress refused to accept them as a gift for the same basic reason, the lack of a clear title, though Christopher Benfey has told me that while working in the library's Manuscripts Division, he "noticed—in the old card catalog—that Millicent's material was briefly housed there before being 'withdrawn.'" "Whereupon," Mary bitterly recalled, "Mrs. Bingham offered the papers to Amherst College, and Mr. Cole, about to leave office, accepted them. Dr. Plimpton, the incoming President, concurred in this decision." In 1957 the transfer of eight hundred poems and more than four hundred letters and fragments by Emily Dickinson, along with the original 1847 daguerreotype once given to Maggie Maher, was completed, and that same year Millicent Todd Bingham received an honorary doctorate of letters from the new academic owners.

Ironically, Martha Dickinson Bianchi had received the same degree from Amherst College in 1931, the very year, according to Bill McCarthy, that Todd-Bingham purchased the Roberts Brothers archive and the "new and enlarged edition" of Emily's letters appeared. Her own *Emily Dickinson Face to Face: Unpublished Letters with Notes and Reminiscences* came out a year later, rubbing in the fact that, unlike family members, Mabel Loomis Todd had never actually seen the poet in person, but she was powerless to "suppress" by present action or future control of copyright the poised assaults of the opposing camp. Although Amherst and Harvard later reached a *concordia amicabilis* over their Dickinson holdings, in which Amherst acknowledged Harvard's claim to copyrights and Harvard acknowledged Amherst's right to receive permission for the use of the Dickinson material then in their possession, no such friendly harmony ever reconciled the feuding editors or their followers. Ultimately, the Todenites, with Modernist rather than Romantic scholarship on their side, were to prevail in appropriating Emily Dickinson for their own uses in the late twentieth century, which is why Mary Hampson so reviled Richard Sewall as the latter-day heir of Todd-Bingham, and why she looked so desperately to George and myself to keep the balance true, since she herself was gradually weakening from the effects of a plethora of illnesses associated with aging. This did not stop her from telling Martha's story as an integral part of her own, and as late as March 1980 she was still firing off corrective letters insisting on the fact that Mabel Loomis Todd had sworn on the witness stand "that she had never known nor spoken to Emily Dickinson" and inviting misinformed authors and publishers "to call on me and learn more of the story of the publication of Emily Dickinson's poems." The rise of the house of Todd-Bingham inevitably seemed to imply a fall of the house of Dickinson, and this winter's tale of debility, dilapidation, wills, trusts, legacies, bequests, and terminations of all kinds seems to me to entwine integrally so many threads from so many different lives and conflicting human purposes that I consciously choose to tell it now from what might be called a compound posthumous perspective, the perspective of Mary Hampson's own death. And though this abbreviated narrative cannot escape being saturnine in essence, part of its compound nature actually promises both a new start and a new birth of concord for the actual physical sites of so much of the Dickinson drama to which we always instinctively return, those remarkable Amherst houses themselves, the Homestead and the Evergreens.

Mr. Brink's Story

Right before Christmas 1979, I got an early-morning call from Mary, who told me that a week or so earlier she had been feeling very low and had spent a great deal of time in bed, which was unusual for her. One day she woke at about five in the morning to find a figure standing by her bed. It was just light enough to see, but Mary was not frightened, for she felt as if whatever it was belonged in the house and had been there before and was in fact very familiar with the place. The figure was dressed in dark robes, so Mary could not distinctly see the face, save that it did have one, which glimmered white against the black. The figure spoke to her very kindly and said it had not come for her but that "all would be well." But it warned her that she must get back "on track" and that she would fall back to sleep and feel much better when she awoke at seven and then would return to her normal routine. Mary said that she felt a sense of her grandfather's presence and that the whole experience represented something quite beautiful, peaceful, and wonderful. She then asked me what I thought, and I said I felt it was "a reprieve." She replied that she thought it was "Mr. Brink," the name that death took as a character in a popular play she had seen years ago (actually Paul Osborn's 1938 fantasy *On Borrowed Time*) and called it "my specter." She had talked to Mrs. O'Neill, Gene's wife, who was half French and half Scottish, and she said that she had seen the same figure during the birth of her child. After this she was told by the nurses that she had almost died during the delivery.

Because it was so close to the holiday, I mentioned the famous ghosts in Charles Dickens's *Christmas Carol*, but Mary immediately laughed and said, "I'm no Scrooge," insisting that this was a purely personal guiding spirit. The experience of seeing "Mr. Brink" by her bedside was very real to her, and I found this fact quite strange because Mary was usually such a confirmed skeptic and materialist. Her voice on the phone, however, was very strong, and she sounded as chipper as ever, but then she had never personally been afraid of death for herself. Indeed, on our first visit to the Evergreens there was a medical book on physiology on the floor opened to a picture of the portions of the brain that she was studying in order to figure out what part of her mind might be affected by a stroke, in case there was a stoppage of blood in her carotid arteries. She also assured us that "everything was arranged if anything happens" and she had to go to the hospital, laughing about the prospect in the same rather carefree but eerily morbid way in which she later spoke of "Mr. Brink" and his uncanny mission. Mary ended her conversation with a typical squib against Sewall, but I was left to ponder this seemingly new and unexpected turn toward the occult. I later found that Mary's interest in weird premonitions and ghostly returns was a vital part of her own family history, which is no doubt why she felt "Mr. Brink" was so familiar and unthreatening a presence. The ghost of a man named Stickland Reese had appeared shortly after his death to her grandfather, in order to tell him exactly where a very important document had been misfiled in a company safe, and her father had died with a smile on his lips, and "I'm curious" were his last words. Mary said she was curious herself about what Henry James called "the distinguished thing" and that because "death is inevitable, we rather look forward to it."

Perhaps the only thing Mary Landis Hampson really feared was that she would not remain faithful to the promises she had made to Martha to tell the Dickinson side of the story and "take care of Alfred" a day before Madame Bianchi died on December 21, 1943. Martha, too, was known to be something of a free spirit, adhering mainly to a Paterian religion of beauty; but in spite of being, as John Erskine remarked, "allergic to dogma and ritual," her funeral services in New York City took the form of a solemn Requiem Mass at the Church of St. Mary the Virgin. She had other, plainer rites back in Amherst. Mary as well, in spite of being no churchgoer, received a traditional memorial service at Amherst's Grace Episcopal Chapel in April 1988, three months after her death at the Franklin Medical Center in Greenfield and the subsequent burial of her ashes in the Landis family plot in Vineland, New Jersey. She had long

Alfred and Martha (snapshot), the Riviera, 1930s.

thing in people's lives. She repeated the fact that this triumvirate were all "born bachelors," and I said that Emily Dickinson often thought of herself as one, too. As for Alfred's own personal financial situation, his father had owned a huge forest and lumber concern in the far West. She had talked to Alfred's sister Alice on the phone, and Alice had exclaimed, in a rather melodramatic, secretive, and breathless voice, "In other days, Mary, they would have called it an empire!"

Martha and Alfred, who met in 1921 or 1922 at the National Arts Club after he had returned from studying voice in Milan, renewed the tradition of spending summers in Amherst and wintering abroad or at the club. Martha's diligence as editor and biographer helped to recoup her finances, though she told the poet Conrad Aiken, whom she met in London in 1923, that she "was not in the least like my repressed Aunt Emily. I, Mr. Aikin, am burnt out!" Whether or not it was Captain Bianchi who had lit that all-consuming fire, she continued to move in the artistic international circles of those who frequented the club, which she and Susan had joined earlier in order to escape provincial Amherst and to pursue a more cultured literary life together. Mary herself was well traveled, and her own abiding love of music, art, and literature eventually caused her to become the third person of a new Dickinsonian trinity. She had spent the summer of 1930 in Europe with her closest female friend, the mystical artist Harriet Blackstone, whom she had rescued from near starvation and exhaustion in her rooms in the Chelsea Hotel after attending one of her exhibitions. Harriet had begun as a teacher of elocution and had edited a number of books on oratory but then turned to painting, studying in Paris with Jean-Paul Laurens and in Belgium with William Merritt Chase. She became a leading society portraitist, traveling widely to execute commissions, attempting in her own way to communicate psychically with the spirit of Leonardo da Vinci and so capture the elusive essence of her sitters through his technique of using *sfumato*, or a cloudy, ghostly, impressionist aura that radiated outward from the soul itself. Harriet was especially fond of painting opera celebrities like Galli-Curci in elaborate ball gowns that evoked Verdi's *Traviata* or the Second Empire court of the Empress Eugenie. Mary herself sat for a grand, full-length portrait of this type that was never completed, though there were several of her by Harriet in the Evergreens, one of which was a Greek-like head in an antiqued gold frame hand-carved by the artist, called "Little Horse," Harriet's pet name for her. Mary insisted I take it and keep it for myself. There was also a red chalk "sanguine" of a sad-eyed Martha and the phosphorescent pastels of Mary's parents, who both died in 1949 within two or three months of one another, that appropriately hung in the Dying Room.

So Mary lived intimately with artists of all kinds, being introduced to them through Harriet, who, in spite of her apparent success, was at a low point both spiritually and financially when they first met. One of Harriet's most successful portraits was of the visionary poet Mrs. Edward Gay, who was married to an artist. Deprived of Mary's loving protectiveness, Harriet was, in her opinion, more or less commandeered by the McCullough family of North Bennington, Vermont, who had commissioned her to paint their portraits, aided by another mutual friend, Stell Andersen. Stell was a concert pianist who later became the ultimate guardian of the contents of Harriet's studio, and while Mary maintained what on the surface seemed to be cordial relations with her, she also told me privately, in a phone conversation of September 10, 1984, that she felt that Stell Andersen and the writer Esther McCullough had "killed" the fragile and vulnerable Harriet by mercilessly forcing her to go back and forth between New York and Vermont so many times in order to finish a portrait of Mrs. McCullough. Even so, I was commissioned by Mary to take to Stell a seedling magnolia tree from the Evergreens when visiting my friend, the poet Stephen Sandy, who taught at Bennington College. Stell was completely blind by that point, but with unerring finesse our hostess herself served us a delicious lunch on a set of precious Flora Danica china. Then she invited us into her huge living room, flicked on a hidden switch, and illuminated a whole gallery of radiant Blackstone portraits that she had preserved in pristine condition.

Shoes in Mary Hampson's closet, 1993.

Mary Hampson (left)
and a friend,
Elizabeth Bernhard,
in front of the
Evergreens, 1980s.

Susan and Austin Dickinson gravesite, Wildwood Cemetery, Amherst, Massachusetts.

Mabel and David Todd gravesite, Wildwood Cemetery, within 150 yards of Susan's and Austin's grave.

cases this was literally true, for the camera could capture events too quick or too drawn out to register on the retina. Eadweard Muybridge's stop-action studies of the gait of a horse proved centuries of painters wrong in their assumptions: a galloping horse's legs *do* all leave the ground at once. Conversely, a longer exposure allowed astronomers to record planetary phenomena—the poles and "seas" of Mars, for example—only intermittently perceptible to the impatient eye. The great astronomer Percival Lowell (a frequent visitor in Amherst, as we shall see) praised the "plodding perseverance" of the camera: "Far less sensitive than the retina, the dry plate has one advantage over its rival,—its action is cumulative. . . . Thus the camera is able to record stars no human eye has ever caught and to register the structure of nebulae the eye tries to resolve in vain." Edgar Allan Poe celebrated the first birthday of photography, in 1840, by predicting that "the drawing of a correct lunar chart will be at once accomplished, since the rays of this luminary are found to be appreciated by the plate."

But the camera's affinity for the invisible ran deeper still. Almost from the start, people sensed something ghostly and uncanny in photography. There was, as the cultural historian Alan Trachtenberg has noted, an "aura of alchemy" surrounding the procedures of the daguerreotype. The daguerreotypist in his studio knew the secrets of an "alchemical hierarchy of metals"—the copper plate coated with polished silver bearing an image developed in mercury and gold—all brought to fruition in the mysterious laboratory of the "dark room." The finished daguerreotype, with its flickering surface and illusion of depth when turned to the light, was mysterious, too. The camera, far from merely recording passively the appearance of things, seemed to go beneath or behind appearances.

In *The House of the Seven Gables* (1851), written during the heyday of daguerreotypy, Nathaniel Hawthorne made his hero, Holgrave, a daguerreotypist. Descended from a Salem wizard burned at the stake, Holgrave pierces the dark secrets of the ancient house. "There is a wonderful insight in heaven's broad and simple sunshine," Holgrave says of his bewitching craft. "While we give it credit only for depicting the merest surface, it actually brings out the secret character with a truth that no painter would ever venture upon, even could he detect it." Photography, in the mythology of Hawthorne's novel, reveals people's secrets: their past crimes, their guilty knowledge, their true feelings. In the same spirit, Walter Benjamin writes, "Does not the photographer—descendant of augurers and haruspices—uncover guilt in his pictures?"

On the face of it, "uncovering guilt" would seem to have little to do with what is called "documentary" photography—where the photographer, whether Brady or Evans, is an eyewitness to history and social change. In the United States at least, this just *is* the major tradition of photography. And yet the documentary photograph can be seen as a logical extension of the mug shot or the forensic snapshot of the murder victim (of the sort that the photographer Weegee made famous). Viewed in this way, the documentary photographer is a collector of evidence, and the crimes are those of a society or a nation. Around 1890, Jacob Riis followed a police detective on his nocturnal rounds of the immigrant neighborhoods of the Lower East Side to find out "how the other half lives." Riis's photographs documented a nation that shoved its newest citizens into crowded tenements unfit for habitation. A couple of decades later, Lewis Hine revealed the crimes of child labor—and the strangely enduring spirit of child workers. Riis and Hine were reformers, and their photographs—social work by other methods—really helped to bring about social change.

Everyone who cares about the history of photography knows that Jerome Liebling is in the great procession of documentary photographers, those eyewitness masters of subject and frame that include Mathew Brady and his assistants: Riis and Hine; Paul Strand and Walker Evans. When Liebling photographed derelict buildings and fields of rubble in the South Bronx in a 1977 series, he was in the business of "uncovering guilt." (A hundred years after Riis, and America still doesn't know how to house its citizens.) In his

extraordinary shots of pompous politicians (George Wallace running his racist campaign in 1968, Truman grinning after the bombing of Hiroshima) some kind of national guilt is undoubtedly on view. When Liebling places the famous daguerreotype of Emily Dickinson next to an archival photograph of women working in the Hills hat factory just a few steps from Dickinson's door, he is looking at the world of women's work with a documentarian's eye not to criticize Emily Dickinson's life as somehow elitist but to register an analogy between her labor with words and the factory workers' labor with their hands. Such photographs are squarely in the domain of the visible. The whole point is that the photographer was there and saw these things. "I am the man, I suffer'd, I was there," as Walt Whitman said.

The public phases and venues of Liebling's distinguished career have tended to emphasize some aspect of this "documentary" orientation. In 1947 he joined the New York Photo League, a loose confederation of socially concerned photographers, as an executive officer and worked closely with such members as Aaron Siskind, Lisette Model, and Dan Weiner. Liebling's work was featured in an exhibit titled "The Camera as Witness" at Expo '67 in Montreal. A decade later, he was appointed the first Walker Evans Visiting Professor of Photography at Yale. At Hampshire College, where he has taught since 1969, Liebling has trained many photographers and filmmakers, including the documentary filmmaker Ken Burns, who makes abundant use of still photographs in his own work—"he was and is my mentor," says Burns. Along the way, Liebling, working in conjunction with Allen Downs, has himself made award-winning documentary films—on American Indians in Minnesota (*The Tree Is Dead*, 1955) and on a university marching band rehearsing in the rain (*Pow Wow*, 1960).

And yet there is something limiting and slightly patronizing in the whole notion of documentary photography. It is as though the photographer is enlisted merely to provide illustrations, or "documentation," of social history. It was to avoid that impression that James Agee, in the opening section of his great portrait of the Depression-era South, *Let Us Now Praise Famous Men*, was so intent on denying that Walker Evans's photographs were illustrations for Agee's text. "If I could do it, I'd do no writing at all here," Agee wrote. "It would be photographs; the rest would be fragments of cloth, bits of cotton, lumps of earth, records of speech, pieces of wood and iron, phials of odors, plates of food and of excrement."

To label a photographer's work "documentary" stresses the ostensible subject of the work, reducing it to its social content or perceived "argument." What is idiosyncratic and private and artful in the photographs is too often given short shrift. This is a particular danger in relation to Liebling's work. While they often have a documentary aspect, Liebling's photographs have an intensely personal angle of vision hinting at private concerns, pleasures, and sorrows. In terms of formal organization, they are steeped in such non-documentary aesthetic traditions as the Bauhaus, with its stripped-down commitment to functional form, and the kindred American Shaker vision of simplicity. Liebling is always exploring how we see things—how we frame them, arrange them, include and exclude—and not just what we see.

Among Liebling's private visual preoccupations is his abiding concern with what might be called the afterlife of things—the strange expressiveness of the dead or inanimate object. He likes untenanted clothes, hanging from pegs in Shaker dwellings, in shop windows, in the bedrooms of the dead. During his fifty years of work, he has returned again and again to corpses and cadavers, skeletons and slaughterhouses, manikins and masks. Like Emily Dickinson, he is constantly wondering what happens to us after we die. Liebling: "In the body that remains, is there some residue of the spirit, of the soul?" Dickinson: "Do People moulder equally, / They bury, in the Grave?" Liebling's photographs are always asking where the line is between life and death. What of our feelings lingers around the objects we loved? Why is grief, even when "tongueless," so palpable?

Liebling, a child of the city, is a poet of the afterlife of buildings and their peculiar sorrows—the music of smoke stains, graffiti, rubble. If these walls could talk . . . But they

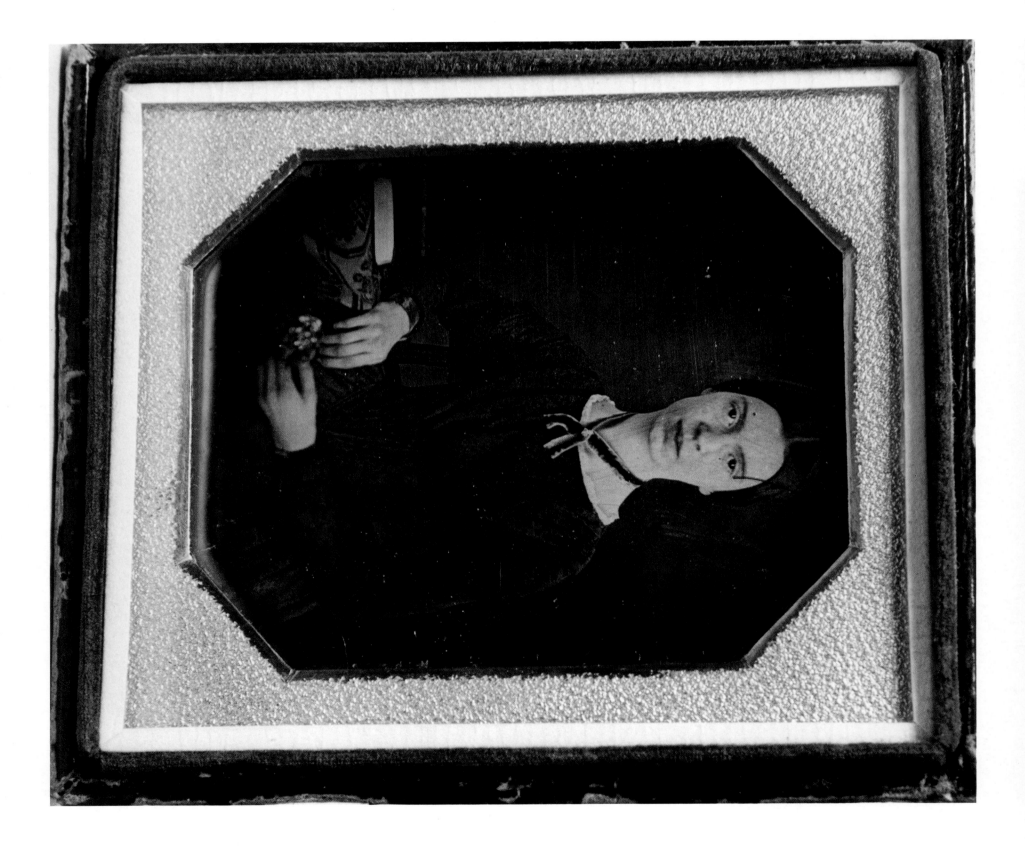

A change in social class and a change in portraiture. The daguerreotype of Dickinson is frontal, formal, stark, memorializing one of the privileged few. Half a century later, the factory girls—down the hill from the Homestead—are at ease with a faster film and a portable camera.

The dismantled fence.

It is hardly surprising, then, that interest in spirit photography crested during times of war. Mumler's rise coincided exactly with the Civil War, and his portrait of Mary Todd Lincoln and the ghost of her husband was the perfect culmination of his career. One of the most familiar spirit photographs, an obvious fake, was taken—or manufactured —in 1923. It depicts a myriad of young men's faces swirling in fog above a London war memorial. Spirit photography found one of its most passionate and articulate defenders in Arthur Conan Doyle, who had lost a son in the battle of the Somme. Doyle, trained as an ophthalmologist, had made money instead by writing mystery stories and taking photographs. Photographs figure prominently in several of Doyle's best-known Sherlock Holmes stories, including the first published one, "A Scandal in Bohemia," in which a photograph of a beautiful woman is used both for blackmail and as a reward. (Doyle, by the way, lectured at Amherst College in the fall of 1894, entrancing the students with his reading from Sherlock Holmes stories.) It is interesting that the inventor of the most famous sleuth and detector of fraud and fakery should have embraced the accuracy of spirit photography, convinced that the passive plates had captured fairies and the spirits of dead young men. We are back in Hawthorne's realm, where photographs are believed to reveal a deeper, truer reality.

Accuracy was the issue then, when Mumler and his followers had to vouch for their probity, in court if necessary. Accuracy is hardly the issue now, however, when we can see that spirit photography was just another chapter in photography's enduring concern with memory and the dead. Mumler and company were photographing grief, the emotion that Emily Dickinson called "Tongueless," even if you "Burn Him in the Public square." There have been photographers in the twentieth century who had a mystical confidence in photography's capacity to reveal an immaterial world. The New Orleans photographer Clarence John Laughlin was one of these, in his images of dilapidated plantation houses, redolent of the Civil War, collected in *Ghosts along the Mississippi*. Jerome Liebling is as interested in dilapidation and

houses with a history as Laughlin was, but he doesn't believe in ghosts any more than Emily Dickinson did. "Nature is a Haunted House –" Dickinson wrote, "but Art – a House that tries to be haunted."

Dickinson and Liebling share an abiding faith in the momentary hauntedness of landscapes and rooms. In his photographs of the Dickinson houses, Liebling is confident that this haunting is there in every shot, that Emily Dickinson is somehow present in this dress, this window, this patch of melting snow. He lingers over the Dickinson graves —"hollowed out like fireplaces," as Walter Benjamin said of early daguerreotypes of gravestones, "showing in their hearts the strokes of letters instead of tongues of flame." One of the most arresting of Liebling's cemetery shots is a back view of the graves of Emily and Lavinia Dickinson, where the shadows on the grass seem like "shades" in the ancient sense of the word: revenants or ghostly presences. "Presentiment," wrote Emily Dickinson in a famous poem, "is that long shadow – on the Lawn – / Indicative that Suns go down – / The notice to the startled Grass / That Darkness – is about to pass –." Liebling's sense of this hauntedness explains why he is so attentive to the extraordinary effects of light and shade, sparkle and crackle, decay and dust.

Liebling's use of color is important in this regard. The archival photographs of Dickinson's Amherst—streetscapes, the factory girls down Main Street, the daguerreotype of Emily Dickinson at seventeen—are black and white. When we turn to Liebling's color shots, especially of the Homestead, there is still a great deal of black and white in them, forming a sort of afterimage of the nineteenth century as we helplessly imagine it. A striking image in this regard is Liebling's photograph of the steps in the Homestead garden partially covered with snow. This black-on-white composition looks like five brushstrokes of a Japanese calligrapher. The steps, as Liebling has taught us to notice, bear the impress of thousands of visitors and of Emily Dickinson herself. "Is there ever residue of the past in physical property?" Liebling asks. While the evocation is of invisible presences, the mood, as in Dickinson's poetry, is skeptical—"maybe,

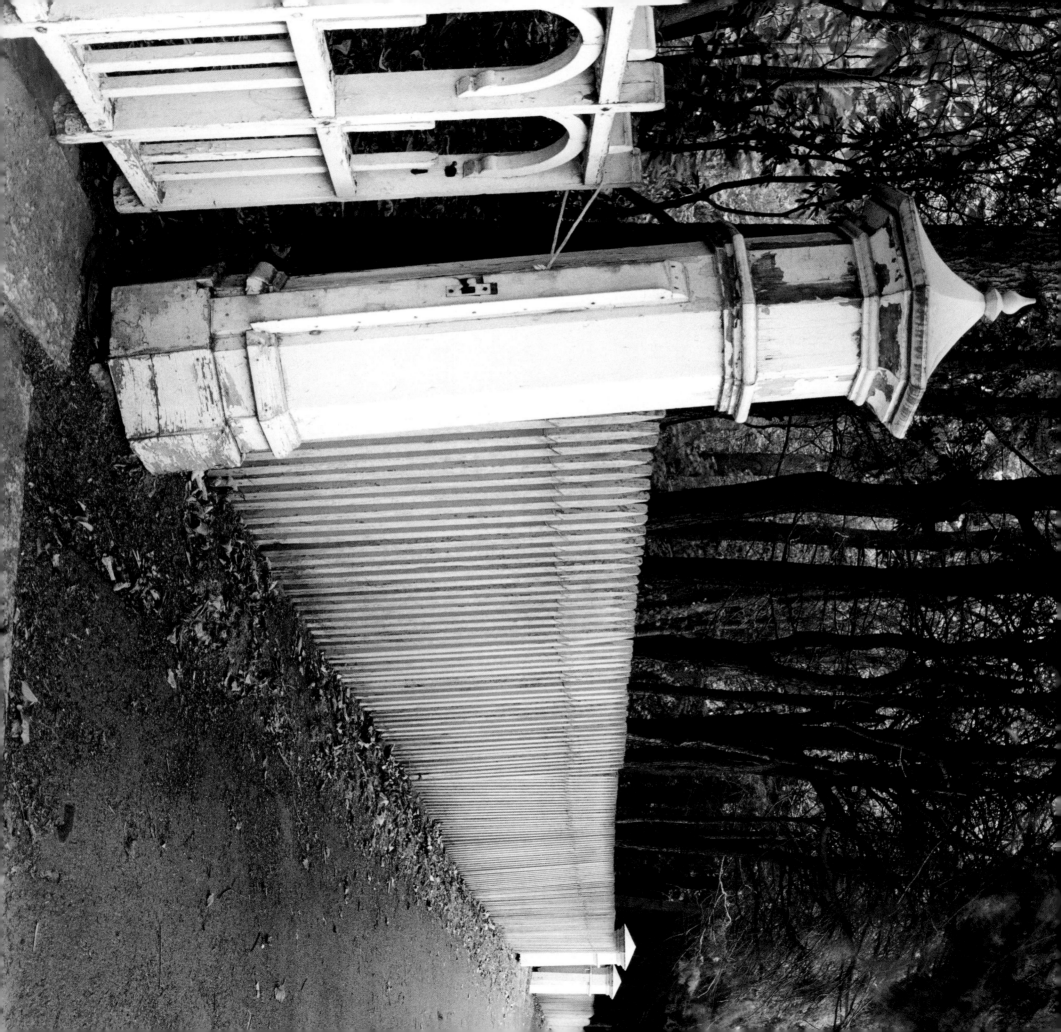

Millicent Todd Bingham's memories of her childhood:

"I can say no more of that house as I never really looked at it. If I walked along Main Street, which I always avoided if possible, because I might meet a member of the Squire's family if I did; so I kept my eyes straight to the front and walked as steadily as possible till I was safely past. To be sure, they always walked up town on their side of the street, although it was only a gravel walk. On the other side it was a tar walk where the common herd walked."

A door in the Homestead: an explosion of angels.

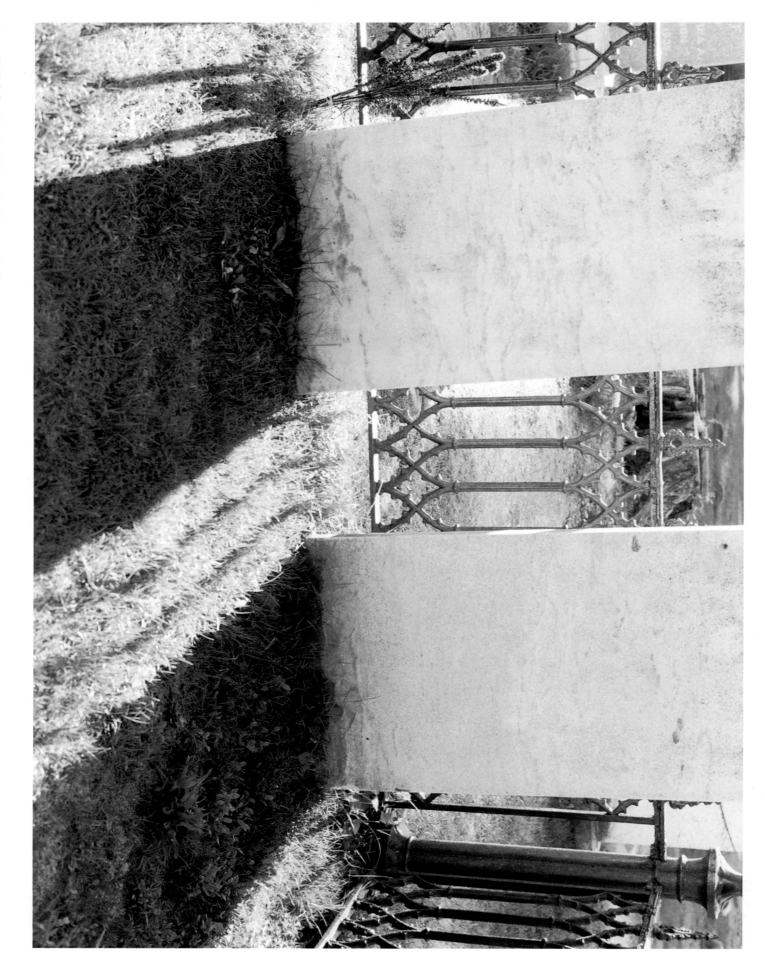

Graves of Emily (*left*) and Lavinia Dickinson (*back view*), side by side to the end. West Cemetery, Amherst.

Garden steps, the Homestead.

Master bedroom window, the Evergreens, 1994.

just maybe." "My life in photography," Liebling has written, "has been lived as a skeptic."

Liebling's photographs bring us into the Dickinson houses. Photography, though, was already there. All three houses in the Dickinson triangle—the Homestead, the Evergreens, and the Dell—are haunted by photography. In fact, each of these houses had a distinctive, and contrasting, attitude toward the medium. The Dickinson family and their associates give us a vivid sense of how widespread the interest in photography was and of how varied the uses of photography were during the second half of the nineteenth century. For the inhabitants of the Evergreens, photography was an art (or, as Liebling might say, photography, for Susan and Austin, was "arty"). For the Todds, photography was a handmaiden to science and a factual record of travel. For Emily Dickinson and for her father, photography—potent and uncanny—was part and parcel of the spirit world. Of these three attitudes, I think that Liebling's photographs are closest to Emily Dickinson's temperament.

Photography was particularly prominent in the Dell, the Queen Anne cottage on Spring Street that Austin Dickinson built for his mistress, Mabel, and her husband, David Todd, on the southern edge of the Dickinson pasture. Mabel Todd sometimes complained of the piles of photographic plates and apparatus that accumulated there. In the Dell the mimetic and scientific uses of photography to which Baudelaire wished to consign the medium—astronomy, travel, and the like—reigned supreme. David Peck Todd, the Amherst College astronomy professor, was a pioneer in developing machinery for photographing solar and planetary phenomena. In 1882, a year after his arrival in Amherst, Todd and the Amherst photographer John L. Lovell were hired by the Lick Observatory in California to photograph the transit of Venus. One of their images received special mention at the Chicago World's Fair in 1893. Since the transit of Venus will not occur again until well into the twenty-first century, these photographs remain the best ever taken of the phenomenon.

The Venus expedition was the beginning of Todd's conspicuous career in astronomical photography.

The Todds made two trips to Japan, in 1887 and again in 1896, to photograph solar eclipses. For the second trip, David Todd developed a sophisticated apparatus for taking multiple photographs of the sun, in rapid succession. The machine, the innards of which resembled the roll and pins of a music box, was called an electric commutator. As Mabel explained in her book *Corona and Coronet* (1896), the commutator made it possible "to take between four and five hundred pictures of the corona [the luminous ring around the sun during an eclipse] in two minutes and a half . . . without having to depend upon fluctuations of the nervous systems of a crowd of observers." Todd's machinery, which bears some relation to Muybridge's stop-action studies of animal locomotion, was one of the important forerunners of the movie camera. (Thomas Edison and Todd were friends, by the way, and Todd turned down an opportunity to work for Edison, preferring a career in astronomy.)

There is a wonderful archival photograph of Mabel Todd in Japan, standing at the open door of the makeshift building that houses telescope and camera apparatus. Impeccably dressed as always and holding a Japanese fan lightly in her hand, Mabel seems almost to be stepping out of a gigantic camera. She was an enthusiastic and knowledgeable participant in all her husband's professional endeavors. She helped set up David Todd's various pieces of photographic apparatus; she accompanied him on balloon trips to photograph Halley's Comet; she wrote popular accounts of his expeditions for the *Nation* and other magazines. When the astronomer Percival Lowell (brother of the poet Amy Lowell and namesake of the planet Pluto) hired Todd to lead an expedition to the Andes in 1907 to photograph the so-called canals of Mars, Mabel went along to document the trip and help with the cameras. Lowell and the Todds were convinced that the shadowy lines they detected on Mars were proof of intelligent life.

Mabel Todd was completely at home (literally and figuratively) with her husband's technical apparatus, but she

had her own love affair with the camera. A striking and stylish woman, eager to be the center of attention and admiration, she was always ready to have her photograph taken. She liked to perform in public, as lecturer and pianist, and photographs were another way to attract an audience. Mabel was herself an ambitious and enthusiastic photographer, constantly taking photographs of friends and family and documenting her extensive travels. A risk taker and an adventurer, in private and in public life, Mabel was the first Western woman to climb Mount Fuji and to visit the remote villages of the indigenous Ainu people of Hokkaido, the northernmost island of Japan. She took excellent photographs on her travels—of Japanese temples and shrines and of the Ainu and their households.

Mabel had a particular interest in photographing the lives of women, especially those aspects of their lives usually hidden from view. She took arresting images of Ainu women with their tattooed upper lips—"mustaches," as she called them. With a shrewd sense of the corseted discomforts of nineteenth-century American women, she wrote of the painfully inflicted mouth decorations with an interesting mixture of admiration and disgust. "The Ainu women have borne it heroically," she wrote, "sustained by their happy certainty of its beautifying result." In 1900, when she accompanied David on an eclipse expedition to Tripoli (again funded by Percival Lowell), Mabel photographed women in harems, and she described the experience in her book *Tripoli the Mysterious* (1912). At one point she was given permission to photograph an Arab bride and her entourage—without veils—as they prepared for the ceremony. The host of the wedding party, a "distracted Arab gentleman," arrived at the Todds' hotel that night and claimed his life was in danger. "The husbands of all the ladies who were guests at his wedding festivities had each taken an alarm lest his particular wives might have been photographed when I turned the camera on the various balconies and groups." Mabel wondered why they should "take my innocent little camera so seriously." Because, the man explained, "a *man* might develop the negative . . . and so see their faces."

To put his fears to rest, Mabel gave him the undeveloped film.

Mabel Todd had an avid interest in the history of photography as well. She became a strong advocate of the gifted Amherst photographer John L. Lovell, who had accompanied David Todd to photograph Venus. She wrote a life of Lovell and helped to preserve his work. Born in 1825, J. L. Lovell had a varied and conspicuous career. Working with the great Amherst College geologist Edward Hitchcock, he took a series of photographs of the geology of the Connecticut River valley for publication by the Smithsonian Institution. He was hired during the 1890s to photograph mining camps around Santa Fe. And he was for several decades the class photographer at Amherst College. Lovell's professional practice had moved from the daguerreotype, in 1849, through the dry-plate process, in which he specialized after his return with David Todd from the California trip to observe Venus. He had a keen eye for landscape, for the play of shadow and light, and for arresting points of view. (His aerial views of Amherst are well known and often reproduced.) Though Lovell was not a spirit photographer—his interests ran more toward the scientific—he was nonetheless drawn into the spiritualism craze that swept through Amherst during the 1870s. Amherst historian Dan Lombardo reports that when the popular mind reader J. R. Brown came to town in February 1875, he obtained a pile of photographs from Lovell. Blindfolded, Brown held the hand of a young lady and selected the photograph of her "dearly beloved."

John Lovell was a beloved figure in Amherst. A close friend of the Todds and of Austin Dickinson (who nonetheless complained to Mabel of "how slow Lovell is in his work"). Lovell was also, interestingly, a pallbearer at Edward Dickinson's funeral. When Lovell himself died in 1903, Mabel Todd hastened to his photography studio on Main Street, just up the road from the Dickinson Homestead, to save the hundreds of historical photographs Lovell had taken of Amherst and its inhabitants through the decades. So, in addition to Mabel's achievements in preserving Emily Dickinson's poetry, she preserved crucial visual documenta-

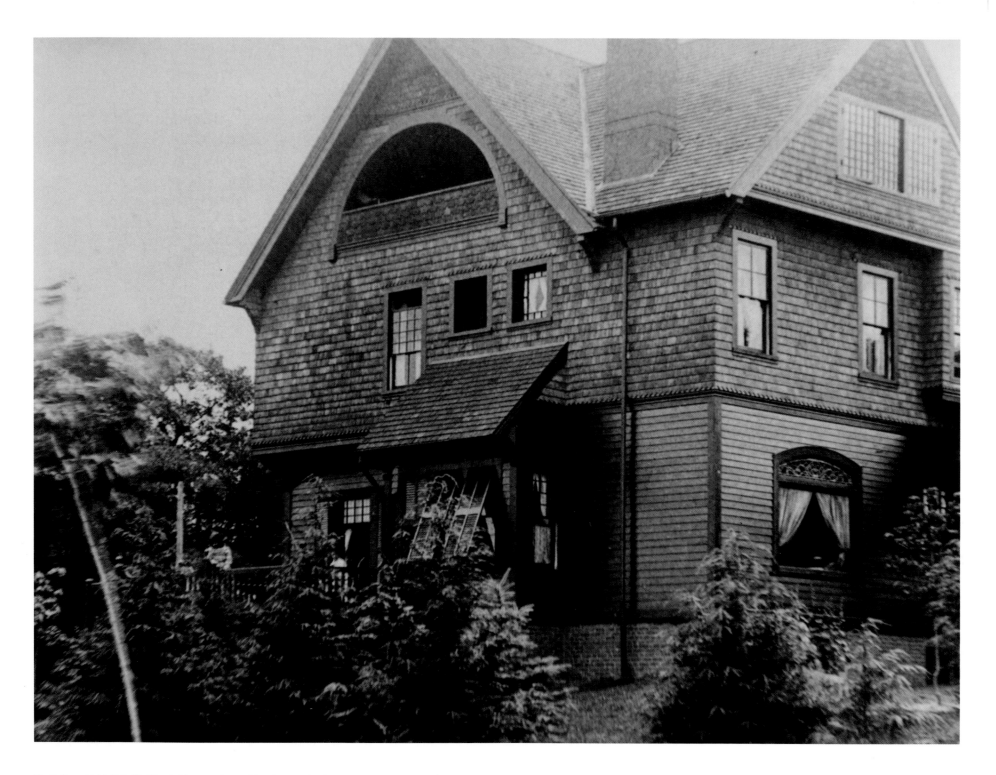

The Dell, past (with Mabel Todd and visitors on the porch) and present (early 1999, soon to be renovated). Spring Street, Amherst.

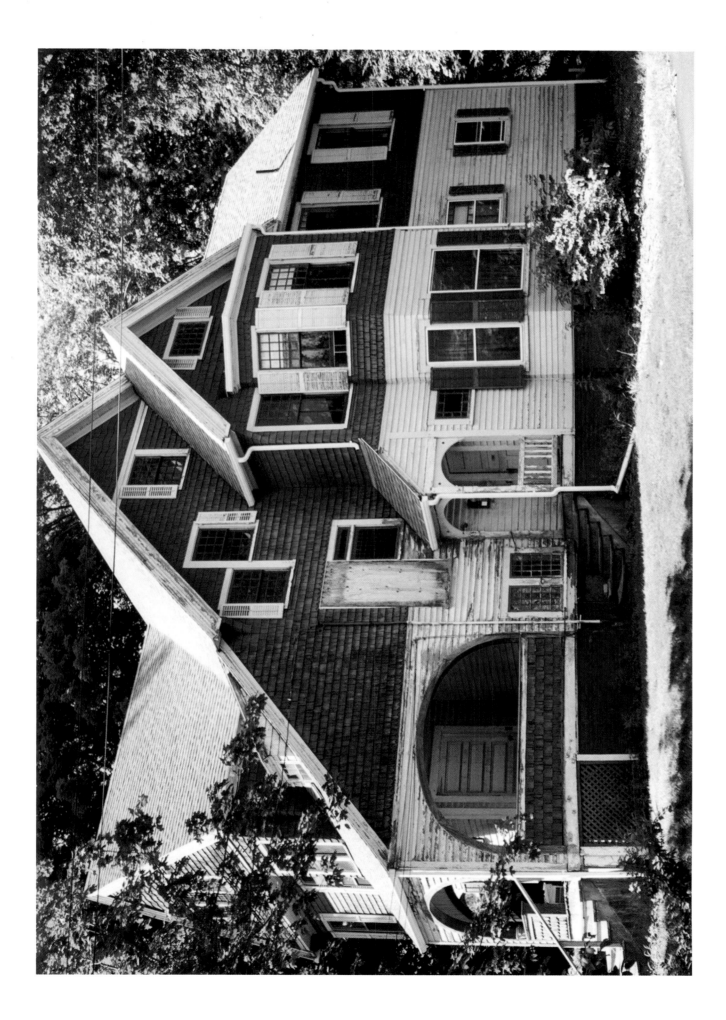

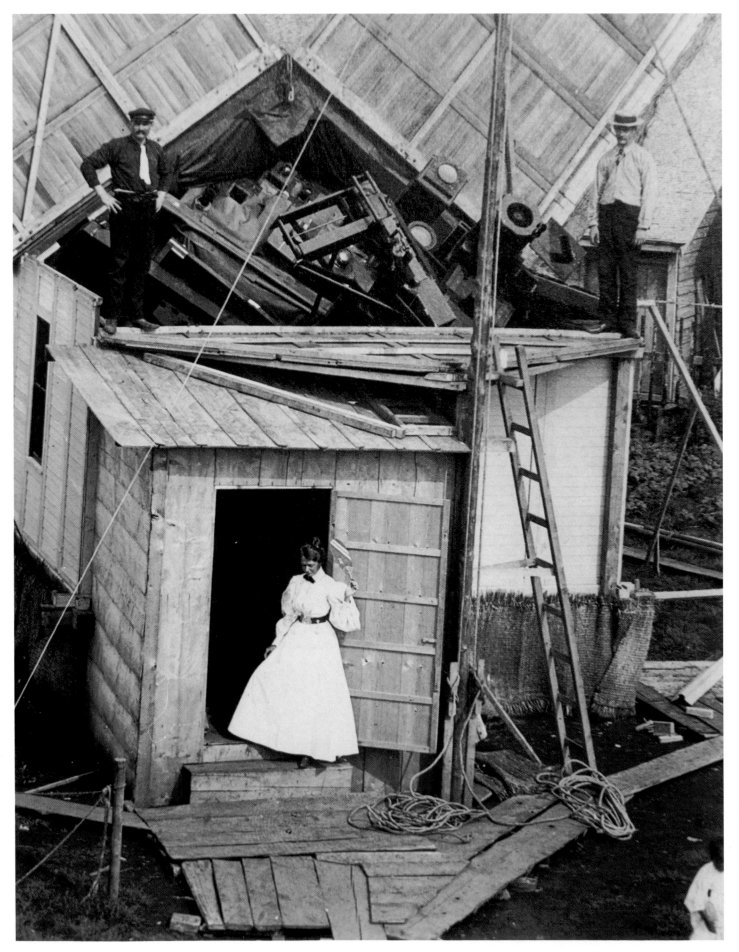

Mabel Todd emerging, fan in hand, from a shack housing equipment to photograph solar eclipse. Shirakawa, Japan, 1887.

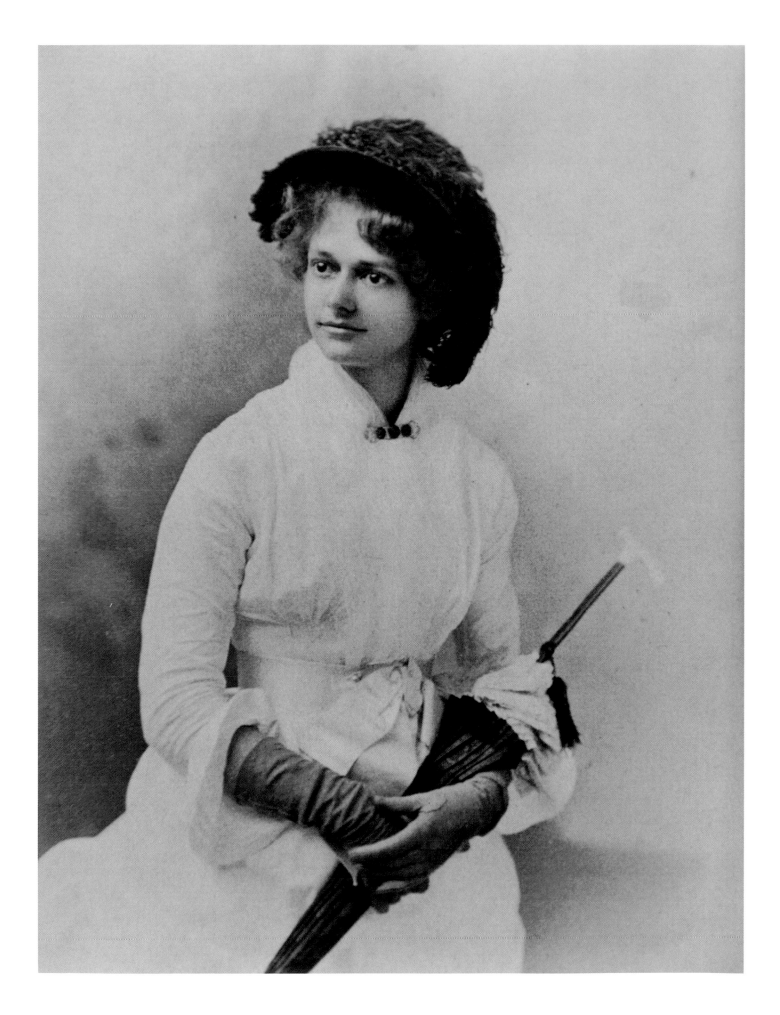

Mabel faces the
camera.

J. L. Lovell's photograph of an outing on Mount Pulaski, a favorite destination of Amherst citizens. Lovell liked
dramatic views; note the woman with the spyglass in the center.

tion to help us interpret the poems and the town in which the Dickinsons lived.

If the Todds and their friend Lovell favored the scientific and documentary use of photography, Austin and Susan Dickinson preferred the artistic—or "arty"—uses of it. Austin collected paintings associated with the dramatic landscapes of the Hudson River School and the Luminist tradition, and his taste in photography ran to the same subjects. A valued possession in the Evergreens was a rare album of Carleton Watkins's photographic views of Yosemite. Some of Watkins's breathtaking prints hung on the walls of the Evergreens, in those ghostly patches, recorded in turn by Liebling, now imprinted on the red wallpaper. The Watkins album may have been a gift from Samuel Bowles, who, in his travel book about the West, reproduced in words the comfortable sublimity of the views of Yosemite captured in Watkins's photographs. Interestingly, Alan Trachtenberg links Watkins and Bowles for the sentimental "effusion" of their images of landscape. Theirs is the "traveler's spectacle —a way of viewing in which the aura, the mystery, arising from sheer distance between viewer and vista, dissolves into the illusion of closeness, of private possession." (Such images, in Watkins's photographs and in Bowles's prose, are precisely the ideas of conventional sublimity that Emily Dickinson was out to reinvent in her poems.)

The attitude toward photography in the Homestead is more difficult to capture. In the Homestead, photographs were neither associated with the scientific recording of natural data (as in the Dell) nor with artistic evocation of conventionally beautiful views (as in the Evergreens). At first glance it seems that the inhabitants of the Homestead, especially Edward and Emily Dickinson, regarded photography with simple hostility. There is only one known photograph of each of them. Edward's alleged hostility toward photography is legendary and is based on an anecdote recorded in Millicent Todd Bingham's *Ancestors' Brocades*: "Once he was persuaded to sit for his photograph. Bolt upright, his head was clamped rigidly in place from behind. His jaw was set—his eye steady. The photographer, taking a step toward

him, faltered, 'Squire Dickinson, could you—smile a little?' To which the Squire thundered back, 'I *yam* smiling.' This depicts the man—held fast by an invisible brace of iron." This story has always been taken to support a view of Edward Dickinson's forbidding temperament—"thin, dry & speechless," in Thomas Wentworth Higginson's phrase. But Edward's remark about smiling also suggests impatience with the sunny and hollow conventions of photographic portraiture. We know that J. L. Lovell, a more sophisticated photographer, was one of those close friends who carried Edward Dickinson's coffin to the grave. Lovell did not particularly like smiling portraits. In his own self-portrait, his demeanor is dignified and serious, and in a promotional newspaper he published in 1868, called the *Amherst Photographer*, he observed that "persons who naturally look sad, or sour, or scowling, should not unreasonably expect to look otherwise in a photograph."

Emily Dickinson's attitude toward photography is similarly complex—hostile at first glance, more nuanced on closer examination. She seems to have had a certain unease about photography, like those "primitive" peoples who are said to believe that photography robs them of some part of themselves. Such a superstitious resistance to photography recalls another great writer, Balzac. Balzac had a "vague dread" of being photographed and believed, according to Nadar, that "every body in its natural state was made up of a series of ghostly images superimposed in layers to infinity, wrapped in infinitesimal films—[and] each Daguerreian operation was therefore going to lay hold of, detach, and use up one of the layers of the body on which it focused."

When Thomas Higginson, clearly intrigued by his mysterious female correspondent, asked for a photograph of Dickinson in July 1862, she replied:

> Could you believe me – without? I had no portrait, now, but am small, like the Wren, and my Hair is bold, like the Chestnut Bur – and my eyes, like the Sherry in the Glass, that the Guest leaves – Would this do just as well?
> It often alarms Father – He says Death might occur, and

Downtown Amherst: a hint of grandeur, a hint of alienation.

Emily's hair, "bold, like the Chestnut Bur."

he has Molds of all the rest – but has no Mold of me, but I noticed the Quick wore off those things, in a few days, and forestall the dishonor –

In a series of striking similes, Dickinson substitutes her verbal powers for anything the camera might do. What is most arresting, however, is the phrase "the Sherry in the Glass, that the Guest leaves"—a miniature poem in itself. Think of the sequence of "eyes—glass—guest." Could this be a little allegory of photography, where the guest, or ghost, is the image that an object "leaves"?

The link of photography and death runs more deeply in the Homestead than in the other Dickinson houses. Edward wants a photograph of his daughter in case death "occurs." Emily associates photography, in turn, with death "molds" (punning on mold as decay), or masks. Her remark, "The Quick wore off those things" means that photographs cease to look "quick," or lifelike, as in "the quick and the dead" in the Apostles' Creed. Dickinson implies that people take photographs to resist death, but in doing so they unintentionally invite it, for the quick wears off. ("Quick" also, as Barton St. Armand pointed out to me, alludes to the use of "quicksilver," or mercury, in early daguerreotype processes and its tendency to wear off over time.)

Liebling's photographs of the Dickinson houses also establish relations between death and photography. They suggest ways in which death sharpens—"quickens"—our perceptions. Emily Dickinson also noted this phenomenon. Writing during the final year of the Civil War, in 1865, she recorded the death of a woman.

> The last Night that She lived
> It was a Common Night
> Except the Dying – this to Us
> Made Nature different
>
> We noticed smallest things –
> Things overlooked before
> By this great light opon our minds
> Italicized – as 'twere.

For Dickinson and Liebling the presence of death does not nudge us toward the great abstractions. Death, on the contrary, makes us focus, with the clarity of a camera, on the here and now. The second quatrain recalls the photographic process: the "great light" that illuminates, or italicizes, the "common" and "smallest" things. In much the same way, Liebling's death-haunted, death-italicized images reveal "things overlooked before."

"I had no portrait, now . . ." When Emily Dickinson died, on May 15, 1886, her self-appointed literary executors were faced with two difficulties one might call cosmetic. One was the look of the poems, and the other was the look of the poet. The first problem was easily taken care of, and Lavinia Dickinson was lucky in her choice of editors for the poems. If Mabel Todd had not been so convinced of the value of the poems, we probably would not know about them today. The contribution of Higginson, whose help Mabel enlisted, is perhaps more ambiguous. He was now free to perform the "surgery" on Dickinson's poems that she had resisted during her lifetime. Todd and especially Higginson, an experienced man of letters, knew exactly what would appeal to readers in the 1890s. They fixed rhymes, diction, punctuation, spelling, meter until the poems looked like and often sounded like genteel magazine verse of the late nineteenth century.

But while the editors had nearly two thousand poems to choose from, they had only one photographic portrait with which to promote the poetry. There was general agreement that the daguerreotype was disappointing. As Mabel Todd's daughter Millicent later remarked: "Both brother and sister objected to it on the ground that it made her look too plain." Lavinia claimed that her sister wore her hair looped over her ears and knotted in back "because it was the way Elizabeth Barrett Browning did." Lavinia had seen a portrait of a cousin of the Dickinsons wearing a white lace ruff at the neck, a style she thought would suit Emily. There followed several months of doctoring, retouching, and "improving" the daguerreotype (of which a negative had been made). The

image of Dickinson in lace ruff and curled hair was first used in 1924 (Todd and Higginson had finally decided against it), and some poetry anthologies still carry it, just as they still sometimes include the "improved" versions of the poems.

Why do we care so much what poets look like anyway? Why is there such a flurry of excitement and speculation whenever a new "photograph of Emily Dickinson" shows up, only to be discredited after much scholarly back-and-forth? Perhaps we have a vestigial belief in the science of physiognomy, by which the inner springs of the soul are detected from the contours of the face. Or perhaps the face gives an illusion of solidity to the words and a body to the voice. As Dickinson wrote, "A Letter always feels to me like immortality because it is the mind alone without corporeal friend."

Dickinson herself cared a great deal about what writers looked like. She had portraits of Thomas Carlyle, Elizabeth Barrett Browning, and George Eliot on her bedroom wall and sent pictures of Barrett Browning to several of her friends. She worried that Lavinia would be disappointed by a likeness of George Eliot she was expecting. "I wince in prospective," she wrote, "lest it be no more sweet. God chooses repellant settings, dont he, for his best Gems?" It has taken many years to restore Emily Dickinson's "settings," and today we find the cosmetic adjustments—to poem and photograph—far more repellent than what they were meant to improve.

It seems peculiarly fitting that there is one—and only one—known photographic image of Emily Dickinson and that this lone image is a daguerreotype. This uniqueness preserves something we all feel about Dickinson, about her own uniqueness and her privacy. As for the daguerreotype, it is as basic to the early history of photography as the ballad or hymn stanza is to early English poetry and to Dickinson's art. Maybe we can push the comparison a bit farther. Isn't there something in the uncompromising nature of Emily Dickinson's poetry that reminds us of the uncanny clarity of early daguerreotypes and, in turn, of the arresting immediacy of Liebling's images of her world? She is so attentive to how a view is framed—by her own window, usually—as though she is seeing things through a lens or viewfinder:

> The Angle of a Landscape –
> That every time I wake –
> Between my Curtain and the Wall
> Opon an ample Crack –
>
> Like a Venetian – waiting –
> Accosts my open eye –
> Is just a Bough of Apples
> Held slanting, in the Sky –

"The Seasons – shift – my Picture," she writes later in the poem:

> I wake – to find no – Emeralds –
> Then – Diamonds – which the Snow
>
> From Polar Caskets – fetched me –

This is precisely the seasonal shift recorded in Liebling's twin images, spring and winter, of the boughs in the Dickinson yard—exactly the view that Dickinson would have seen. Of course, the snow-decked bough is an image of death, hence the "Polar Caskets." But there's another kind of witchery at work in those diamonds from another kind of casket—a multifaceted visual richness exploding on the scene.

Susan Sontag sees a connection between the "Daguerreian operation" and Balzac's project of realism: "The Balzacian operation was to magnify tiny details, as in a photographic enlargement, to juxtapose incongruous traits or items, as in a photographic layout." Couldn't the same be said, even more emphatically, of Emily Dickinson? Isn't much of her poetic art one of magnifying and enlarging details, letting death and winter guide our vision? "The missing All, prevented Me / From missing minor Things."

Photography in a minor key, you might call it. The effort to capture those elusive slants of light that conceal as much as they reveal: "Heavenly Hurt, it gives us – / We can find

"The Seasons – shift – my Picture": Emily's garden, the Homestead.

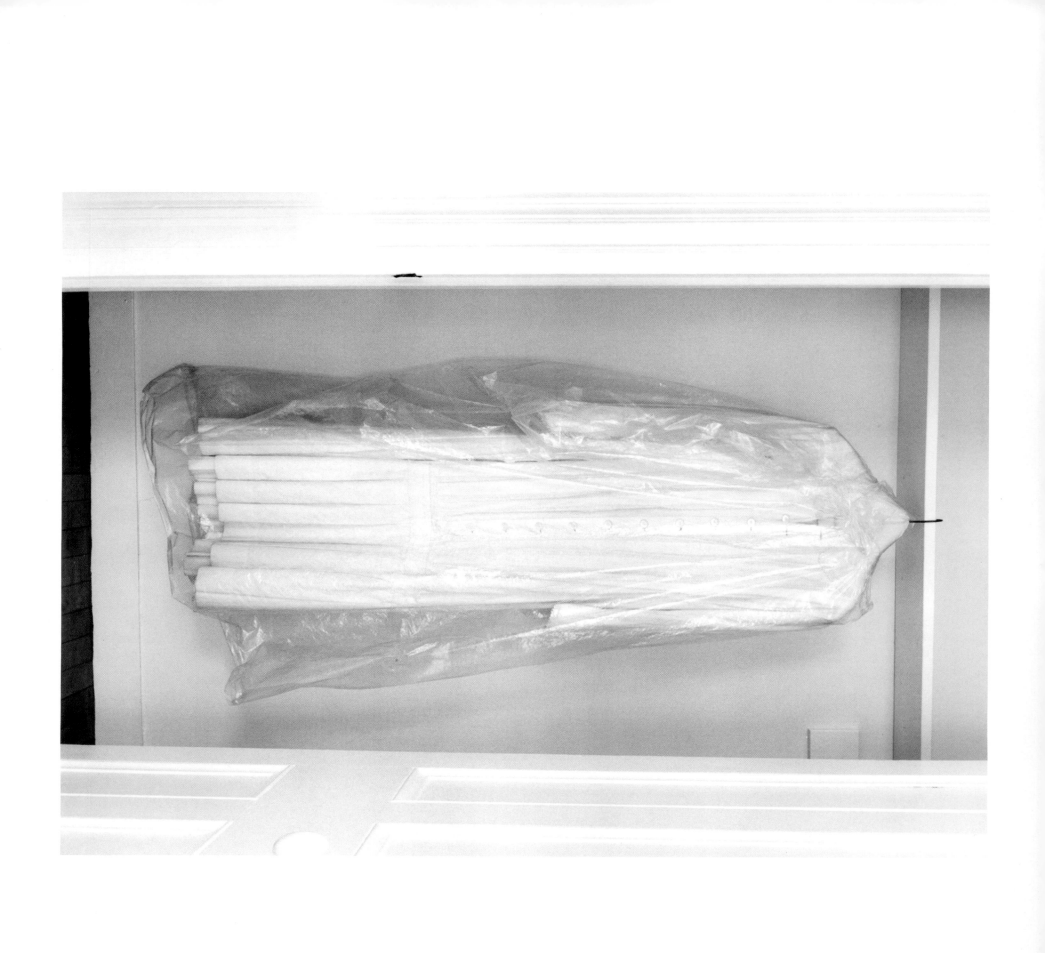

no scar. / But internal difference – / Where the Meanings. are –." Dickinson writes of a particular quality of light in spring "That Science cannot overtake / But Human Nature feels." This is the elusive quality that Liebling has captured. again and again. in the very landscapes and rooms in which Emily Dickinson lived and looked and wrote.

Let us linger for a moment in front of Jerome Liebling's photograph of Emily Dickinson's white dress. Somehow this image. in its simplicity and finality. seems to sum up Liebling's "take" on Dickinson. We know something of the meaning of this dress—how Dickinson took to wearing white as early as the 1860s and. by the time of her father's funeral in 1874. seems to have worn white exclusively. For others. black may have been the color of mourning; for Dickinson. it was white. a positive to their negative. Liebling's geometrical white-on-white photograph has a Bauhaus clarity. like Josef Albers's concentric squares. It also recalls Liebling's images of clean-lined Shaker interiors. And in the middle of the shot hangs the dress. like a sacred relic. In Liebling's photographs. clothes always imply the bodies that wore them. Here is Dickinson closeted. with the door. as she always preferred it. ajar. Any other photographer would have begged to have the dry-cleaning bag removed. But Liebling revels in its ghostly shimmer. its time-traveling clash with the past. its suggestive glint of other worlds. Sewing with white. without a light. he reminds me of Dickinson's ghostly artist:

> A Spider sewed at Night
> Without a Light
> Opon an Arc of White –
>
> If Ruff it was of Dame
> Or Shroud of Gnome
> Himself himself inform –
>
> Of Immortality
> His strategy
> Was physiognomy –

Note

I owe a special bibliographical debt to the historical works of Daniel Lombardo. longtime curator of special collections at the Jones Library in Amherst. For making sense of Lovell and other key figures in Amherst. Lombardo's *Tales of Amherst* (Amherst: Jones Library. 1986) and *A Hedge Away* (Northampton: Daily Hampshire Gazette. 1997) are essential. Essential too are Millicent Todd Bingham's *Ancestors' Brocades* (New York: Harper. 1945) and Polly Longsworth's "visual biography" *The World of Emily Dickinson* (New York: Norton. 1990). On the history of photography. I am indebted to Alan Trachtenberg's *Reading American Photographs* (New York: Hill and Wang. 1989). his anthology of *Classic Essays on Photography* (New Haven: Leete's Island. 1980. including essays by Poe and Walter Benjamin). and Susan Sontag's *On Photography* (New York: Farrar. Straus. 1977). Trachtenberg's catalog essay in *Jerome Liebling Photographs* (New York: Aperture. 1982) was also of great help. On spirit photography I consulted Fred Gettings's *Ghosts in Photographs* (New York: Harmony. 1978) and Arthur Conan Doyle's *The Case for Spirit Photography* (New York: George H. Doran. 1922). Conversations with Jerry Liebling. Polly Longsworth. and Bart St. Armand made my experience of Liebling's photographs far richer than it would otherwise have been.